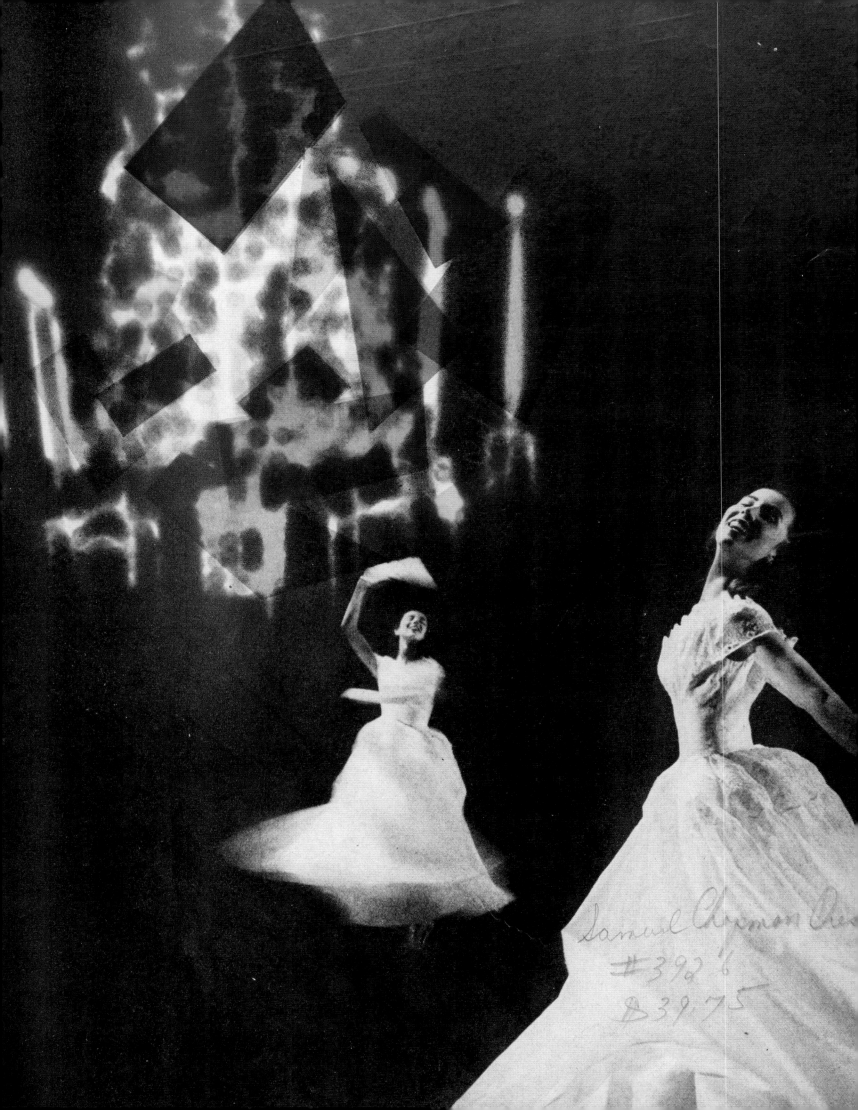

Erwin Blumenfeld, *Kathleen Blumenfeld (a test shot)*, New York, c. 1956, gelatin silver print

MODERN LOOK

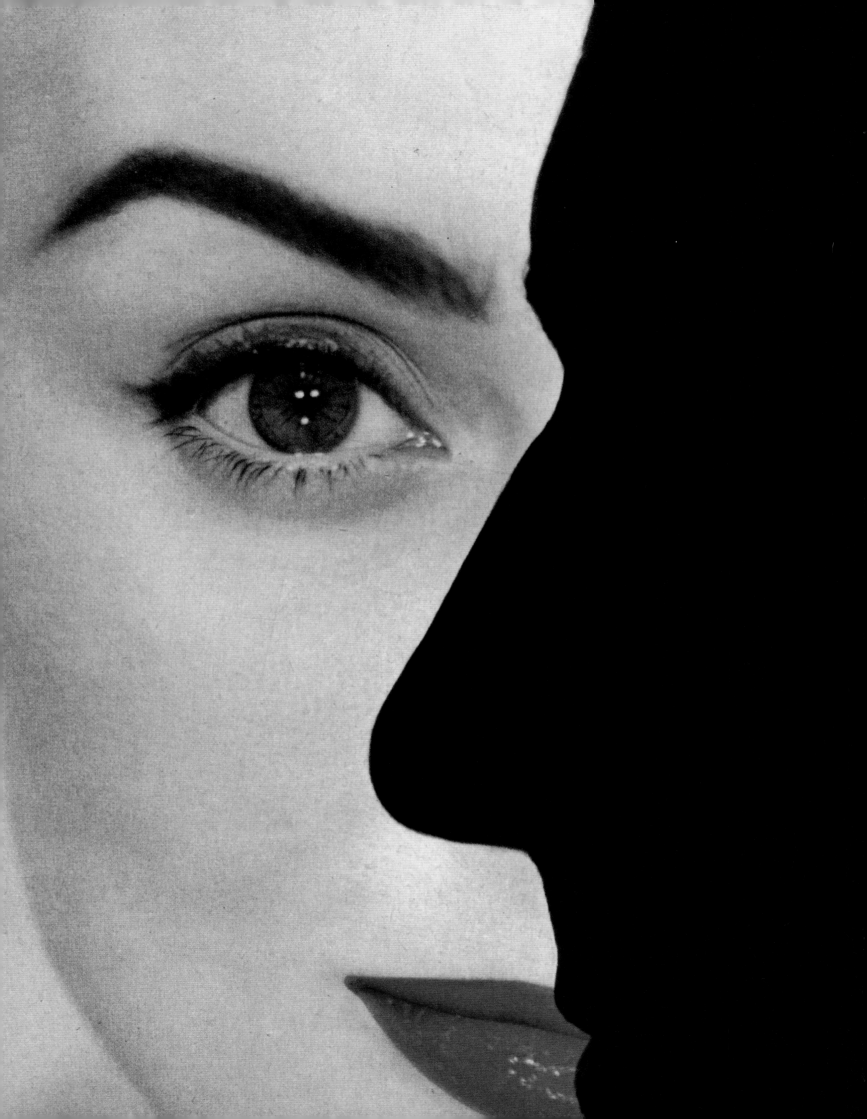

MODERN LOOK

Photography and the American Magazine

MASON KLEIN

with essays by
Maurice Berger,
Leslie Camhi,
and Marvin Heiferman

Jewish Museum, New York
Under the auspices of the
Jewish Theological Seminary of America

Yale University Press
New Haven and London

This book has been published in conjunction with the exhibition *Modern Look: Photography and the American Magazine*, organized by the Jewish Museum, New York, May 1, 2020–September 13, 2020.

Essay, "'In Our Lives We Were Whole': Gordon Parks, Picture Magazines, and the Struggle for Identity," copyright © Maurice Berger.

Essay, "Propriety and Provocation: Women, Émigrés, and Outliers in American Magazines at Mid-Century," copyright © Leslie Camhi.

Essay, "Astonish Me! Photography, Graphic Design, and Mid-Century Visual Culture," copyright © Marvin Heiferman.

See page 184 for image credits and copyrights.

The Jewish Museum
Director of Publications:
Eve Sinaiko
Editor: Susan Higman Larsen

Yale University Press
Publisher, Art and Architecture:
Patricia Fidler
Editor, Art and Architecture:
Amy Canonico
Production Manager:
Sarah Henry
Assistant Managing Editor:
Heidi Downey

Designed by Chad Kloepfer
Set in Theinhardt
Printed in China by
1010 Printing
International Limited

The Jewish Museum
1109 Fifth Avenue
New York, New York 10128
thejewishmuseum.org

Yale University Press
P.O. Box 209040
New Haven, Connecticut
06520–9040
yalebooks.com/art

Library of Congress Control
Number: 2019940783
ISBN 978-0-300-24719-0

A catalogue record for this book is available from the British Library.
The paper in this book meets the requirements of ANSI/NISO Z 39.48-1992 (Permanence of Paper).
10 9 8 7 6 5 4 3 2 1

Front cover: detail of Frances McLaughlin, *Nan Martin, Street Scene, First Avenue*, 1949, gelatin silver print (see page 143).

Back cover: detail of Herbert Matter, *Abstract Overlay of Harry Bertoia; Chairs*, undated, gelatin silver print (see page 63).

Front and back images:

page 1: detail of "It Looks Like Spring," *Junior Bazaar*, March 1946, photographs by Leslie Gill, art direction by Alexey Brodovitch and Lillian Bassman (see page 141).

page 2: detail of cover of *Direction*, April 1940, designed by Paul Rand (see page 66).

page 3: detail of cover of *Scope*, Summer 1952, designed by Will Burtin (see page 67).

page 4: detail of "Cattlebrands," *Portfolio* 2, Summer 1950, designed by Alexey Brodovitch (see page 77).

page 5: detail of cover of *What's New*, February 1941, art direction by Lester Beall (see page 173).

page 6: detail of cover of *Harper's Bazaar*, April 1951, photograph by Richard Avedon, art direction by Alexey Brodovitch (see page 82).

page 7: detail of "Smooth Office Routine: The Jersey Dress," *Charm*, September 1957, photographs by Carmen Schiavone, art direction by Cipe Pineles (see page 131).

page 10: detail of cover of *Vogue*, November 1944, photograph by Erwin Blumenfeld, art direction by Alexander Liberman (see page 79).

page 185: detail of cover of *Junior Bazaar*, January 1947, photograph by Ernst Beadle, art direction by Alexey Brodovitch and Lillian Bassman (see page 47).

page 186: detail of *Atomic Head*, cover of *Arts & Architecture*, December 1946, designed by Herbert Matter (see page 41).

page 187: detail of Edward Steichen, *Matches and Matchboxes (Fabric Design for Stehli Silk)*, 1926, gelatin silver print (see page 57).

page 188: detail of Herbert Matter, *White Pins on Black Background*, undated photogram, gelatin silver print (see page 62).

page 189: detail of cover of *PM: An Intimate Journal for Production Managers, Art Directors, and Their Associates*, October–November 1938, designed by Paul Rand (see page 65).

page 190: detail of details of a drip painting by Jackson Pollock, from *Portfolio* 3, Spring 1951, designed by Alexey Brodovitch (see page 76).

page 191: detail of cover of *Harper's Bazaar,* February 1952, photograph by Richard Avedon, art direction by Alexey Brodovitch (see page 83).

page 192: detail of *Westvaco Inspirations for Printers*, no. 210, 1958, photograph by Rollie Guild, designed by Bradbury Thompson (see pages 68–69).

C O N T E N T S

Cover of *Harper's Bazaar*,
June 1940, photograph by
Herbert Matter, art direction by
Alexey Brodovitch

FOREWORD

The story told in *Modern Look: Photography and the American Magazine* begins in Weimar-era Germany, where throughout the 1920s the emerging discipline of graphic design was being shaped by the innovative Bauhaus school of design.

Many artists and designers of the German avant-garde were Jewish. When the Nazis came to power in 1933, their opposition to modernist and experimental art, and persecution of its practitioners, drove a generation of photographers and designers to safety in the United States. There they were exposed to America's robust mass media, exemplified, in an era before television, by large-circulation magazines— *Life* and *Look*, *Vogue* and *Harper's Bazaar*, and others.

These magazines offered an ideal platform for the work of talented, visionary, and often impoverished émigrés to flourish creatively and commercially. In turn, the interaction pushed the magazines and their editors, photographers, and designers to reach new heights of ingenuity. Seminal art directors such as Alexey Brodovitch, Cipe Pineles, and Alexander Liberman worked with exceptional photographers, including Erwin Blumenfeld, Saul Leiter, Irving Penn, and Richard Avedon.

These influential European-trained art directors and editors were also willing to employ talented photographers whose work had previously been excluded from the mainstream, including Gordon Parks, who was African American, and women such as Louise Dahl-Wolfe, Lillian Bassman, and Lisette Model.

These collaborations led to a golden age in magazine photography and design that extended from the 1930s through the 1950s, producing images of exceptional beauty and inventiveness while contributing to—and reflecting—the rapid development of American mass culture.

At the Jewish Museum we strive to connect Jews with their heritage and to illustrate the many cultural exchanges between the Jewish people and the broader communities in which they live. In this remarkable publication and the exhibition it accompanies, we are proud to tell the story of this era of refugee innovators and to explore the ways in which they expanded the horizons of photography.

I am grateful to the wonderful, talented staff of the Jewish Museum for their hard work to make this publication and exhibition possible. Mason Klein, Senior Curator, organized this fascinating and enlightening project.

Ruth Beesch, Senior Deputy Director, Programs and Strategic Initiatives, provided crucial assistance. Thanks to Darsie Alexander, Susan and Elihu Rose Chief Curator, and to Elyse Buxbaum, Sarah Supcoff, and their colleagues on the development, marketing, and communications teams. I also extend my gratitude to David Goldberg and Sabina Avanesova in the Director's Office.

The exhibition is beautifully presented by Leslie Gill. Eve Sinaiko, the Jewish Museum's Director of Publications, did her usual stellar job in coordinating this publication, as did Chad Kloepfer in designing it. Al Lazarte, Senior Director of Operations and Exhibition Services, along with his staff, expertly installed the exhibition.

I thank the donors whose support has made this book, and the exhibition it accompanies, possible: The Mimi and Barry J. Alperin Family Fund, a gift from the estate of Gaby and Curtis Hereld, Phillip and Edith Leonian Foundation, Heidi Rieger and Richard Rieger, Wyeth Foundation for American Art, Ronit and Bill Berkman, LSP Family Foundation, John and Helga Klein, Ellen Schwartz Harris, The Skirball Fund for American Jewish Life Exhibitions, Horace W. Goldsmith Exhibitions Endowment Fund, The Alfred J. Grunebaum and Ruth Grunebaum Sondheimer Memorial Fund.

Many private collectors and institutions have been generous with loans, and we offer them our heartfelt gratitude. As always, the Jewish Museum is sustained and encouraged by the enthusiastic support of its Trustees, under the capable leadership of Board Chairman Robert A. Pruzan and President Stephen M. Scherr.

— Claudia Gould
Helen Goldsmith Menschel Director
Jewish Museum

DONORS TO THE EXHIBITION

The exhibition *Modern Look: Photography and the American Magazine* is made possible by The Mimi and Barry J. Alperin Family Fund, a gift from the estate of Gaby and Curtis Hereld, Phillip and Edith Leonian Foundation, Heidi and Richard Rieger, Wyeth Foundation for American Art, LSP Family Foundation, Ronit and Bill Berkman, John and Helga Klein, and Ellen Schwartz Harris.

Additional support is provided by The Skirball Fund for American Jewish Life Exhibitions, Horace W. Goldsmith Exhibitions Endowment Fund, The Alfred J. Grunebaum & Ruth Grunebaum Sondheimer Memorial Fund, and other generous donors.

PHILLIP AND EDITH LEONIAN FOUNDATION

LENDERS TO THE EXHIBITION

Addison Gallery of American Art, Phillips Academy, Andover, MA
Vince Aletti
Dotty and Eli Attie
Deborah Bell Photographs, New York
William and Ronit Berkman
Merrill C. Berman Collection
The Bluff Collection
Cary Graphic Arts Collection, Rochester Institute of Technology
Center for Creative Photography, University of Arizona, Tucson
David Dechman and Michel Mercure
Keith de Lellis
Beth Rudin DeWoody
Display, Graphic Design Collection
J. Paul Getty Museum, Los Angeles
Gitterman Gallery, New York
Howard Greenberg Gallery, New York
Claudia Gropper and Jay Gayner, California
Harvard Art Museums, Cambridge, MA
William Talbott Hillman Collection
Eric and Lizzie Himmel, New York
International Center of Photography, New York
Sir Elton John Photography Collection
Cyril Lefevre, London
Saul Leiter Foundation
Louisiana Museum of Modern Art, Humlebaek, Denmark
Herb Lubalin Study Center of Design and Typography, Cooper Union, New York
Museum at the Fashion Institute of Technology, New York
Museum of Fine Arts, Boston
Joshua and Beth Nash
National Gallery of Art, Washington, DC
National Gallery of Canada, Ottawa
The Gordon Parks Foundation
The Phillips Collection, Washington, DC
R. Roger Remington, Vignelli Distinguished Professor of Design, Rochester Institute of Technology
Bruce Silverstein Gallery, New York
Stiftung F. C. Gundlach, Hamburg
Private collections

When Edward Weston attended the landmark 1929 exhibition *Film und Foto*, in Stuttgart, he was wowed by the diversity he encountered. American photography, he wrote, was "anemic" in comparison. International in scope, the showcase represented Germany's position of power within Europe in the fields of photography, printing, and publishing. All of this, however, would soon change. European artists who, with the coming of World War II, had fled to the United States, joined with their American colleagues to revolutionize the nation's visual culture. They began to create the future.

Modern Look explores the fruitful era from the late 1930s through the 1950s, during which photography became instrumental in the growth of large-circulation mass-media publications, such as *Life* and *Look*, patterned after European news magazines. As the United States began to recover from the Depression and enter World War II, a new aesthetic emerged that drew on the country's reputation for innovation, inclusiveness, and pragmatism.

Through the currency of mass media, artists had access to the most advanced means of communication, which they used to conjure novel visual ways of expressing ideas to an audience unprecedented in size and scope. Within the confines of the page and a given idea, the polemics of what was and was not art ceased to matter for an established photographer like Edward Steichen. This new graphic design–driven American aesthetic took hold in popular magazines like *Harper's Bazaar* and *Vogue*, whose art directors, Alexey Brodovitch and Alexander Liberman, respectively, were émigrés and accomplished photographers. So, too, were other figures: Herbert Bayer and Herbert Matter were polymaths who, as teachers, photographers, artists, and designers, joined ranks with their American counterparts, such as Paul Rand, graphic designer and art director at *Esquire* and *Direction*, or the likes of German-born Will Burtin, an art director who transformed the business journal *Fortune* into a sophisticated and vital cultural magazine. For all of them, what mattered was to make the concept of a particular cover, layout, or page visual and new, with originality, clarity, and efficiency.

Modern Look considers connections and mutual influences in the work of these figures and others, as well as of numerous photographers who, while not part of an organized group, had worked for or studied with Brodovitch at his Design Laboratory.

Irving Penn and Richard Avedon fulfilled their magazines' mandates to fuse art and fashion; both also altered the genre of portraiture across a spectrum that ranged from staged elegance to unadulterated objectivity. Erwin Blumenfeld, who had transformed Gothic cathedrals into filigreed lace, became, according to Brodovitch, "*the* master of color." Louise Dahl-Wolfe, with the help of Carmel Snow, her editor at *Harper's Bazaar*, also pioneered the use of color and natural settings, and enlivened an American sense of fashion and taste. Lillian Bassman literally pushed the limits of fashion, ultimately dematerializing the garments her models wore into strokes of paint or attenuated forms.

Others expanded the political and aesthetic boundaries of photography, employing it to advance a new image of modern American society, as Gordon Parks did for the African American magazine *Ebony* and later as a staff photographer for *Life*, or redefined documentary photography, as did Lisette Model, publishing many of her sociological portraits, including her pictures of the blind, for *Harper's Bazaar*. Whether working independently or on assignment, Saul Leiter, Louis Faurer, and William Klein did it all, exploiting the possibilities of commercial work while elevating street photography almost to the level of abstraction. Robert Frank turned away from the comfort and complacency of storytelling and asserted his independent and

sequential, nonnarrative photo-book voice in response. In their willingness to approach work from numerous vantages without disciplinary restrictions, these figures allowed their audience to understand what photography could do as a medium.

I wish to thank Claudia Gould, Helen Goldsmith Menschel Director, who encouraged the idea of this exhibition from the outset. Along with her, I express my gratitude to all of our lenders and sponsors. In bringing *Modern Look* to fruition, I have relied on the labor and goodwill of many colleagues at the Jewish Museum: Ruth Beesch, Senior Deputy Director for Programs and Strategic Initiatives, provided sage advice, and Darsie Alexander, Susan and Elihu Rose Chief Curator, unwavering support. I would also like to thank my colleagues: Claudia Nahson, Senior Curator; Dr. Stephen Brown, Curator; Marisa Kurtz, former Curatorial Department Coordinator; Elyse Buxbaum, Deputy Director, Development; Sarah Supcoff, Deputy Director, Marketing and Communications; Nelly Silagy Benedek, Senior Director of Education; Aviva Weintraub, Associate Curator and Director, New York Jewish Film Festival; Allison Curran, Director, Institutional Giving; Julia Pehrson, Associate Development Officer, Exhibitions; Will Fitzgerald, Audiovisual Coordinator; Elizabeth Abbarno, Exhibitions Manager; and Julie Maguire, Senior Registrar.

Preface and Acknowledgments

I have also been aided by several curatorial fellows and interns: Hannah Braun, Curatorial Assistant, deserves much credit for managing numerous logistics, while also serving as the coordinator of loans. We were ably assisted by interns Olivia Rodriguez, Jessie Alperin, and Annie Roberts, all of whom engaged in outstanding research.

In its survival, it is the catalogue that comes to displace and represent an exhibition. For their expertise and judgment, I am beholden to Eve Sinaiko, Director of Publications, who oversaw the catalogue preparation; Amelia Kutschbach, Curatorial Assistant for Publications, for her tenacity in following through with all exhibition-related text; the manuscript editor, Susan Higman Larsen, for her skillful editing of the catalogue; and Taylor Catalana, Rights and Reproductions Coordinator. Thanks also to Chad Kloepfer, who created the striking and distinctive design of the book.

My deep gratitude goes to the exhibition designer Leslie Gill and her talented assistant, Ines Yupanqui, for their imaginative and elegant exhibition installation. Al Lazarte, Senior Director of Operations and Exhibitions Services, oversaw all details and fabrication, and proved, as he does for all exhibitions at the museum, to be an indispensable problem solver.

Many people have contributed to this project. I extend my gratitude to my essayists Maurice Berger, Leslie Camhi, and Marvin Heiferman, who were helpful collaborators, generously offering a variety of insights.

Thanks also go to Nadia Charbit; Keith de Lellis Gallery; Tom Gitterman and Tom Cowey at the Gitterman Gallery; Howard Greenberg, Karen Marks, David Peck, Alicia Colen, Apollonia Colacicco at the Howard Greenberg Gallery; Richard and Ronnie Grosbard; Newell Harbin, Curator, Sir Elton John Collection; Edwynn Houk, Julie Castellano, Alexis Dean, Julia Hartshorn, at the Edwynn Houk Gallery; Margit Erb at the Saul Leiter Foundation; Kristen Gresh, Estrellita and Yousuf Karsh Curator of Photographs, at the Museum of Fine Arts, Boston; Elizabeth Cronin, Assistant Curator of Photography, The Miriam and Ira D. Wallach Division of Art, Prints and Photographs, the New York Public Library; Peter MacGill, Margaret Kelly, Kimberly Jones, Lauren Panzo, at the Pace/MacGill Gallery; Peter W. Kunhardt, Jr., Executive Director, and Amanda Smith, Assistant Director, at the Gordon Parks Foundation; Ivan Shaw, Corporate Photography Director for Condé Nast Editions.

I wish to recognize the important contributions of other art and graphic design historians, especially Andy Grundberg, Steven Heller, and, in particular, R. Roger

Remington, the Massimo and Lella Vignelli Distinguished Professor of Design at Rochester Institute of Technology, whose groundbreaking research gathered in the graphic design field has benefited so many. I also would like to thank the staff of the Cary Graphic Arts Collection at R.I.T., for its generous assistance: Dr. Steven Galbraith, Curator; Amelia Hugill-Fontanel, Associate Curator, and Lauren Alberque, Archivist. Similarly, I am indebted to Alexander Tochilovsky, Curator of the Herb Lubalin Study Center of Design and Typography, Cooper Union; and to Greg D'Onofrio and Patricia Bellan, for their generosity and largess. And, lastly, to Vince Aletti for his long-standing support of such exhibitions, lending so generously from his collection of fashion magazines. The many works borrowed from these collections have significantly enhanced the exhibition.

I also am indebted to the network of information provided by auction houses, especially Darius Himes, International Head of Photographs, Christie's; Shlomi Rabi, Head of Photographs, Christie's New York; and Vanessa Hallett, Deputy Chairman, Americas, and Worldwide Head of Photographs, Phillips.

To all who have helped in immeasurable ways I wish to express my appreciation, especially to friends and family: Mimi and Barry J. Alperin, Alice Attie and Royce Howes, Maurice Berger and Marvin

Heiferman, Deborah Bell, Ronit and Bill Berkman, Anouk Cezilly, Rebecca Dreyfus, Joy Harris and Michael Brod, Lizzie Himmel, John and Helga Klein, and Jill Silverman van Coenegrachts.

In particular, I thank my wife, Elizabeth Sacre, for her inexhaustible patience and love.

—Mason Klein
Senior Curator
Jewish Museum

MODERN LOOK

Photography,
Innovation,
and
the

American

Magazine

Mason Klein

22

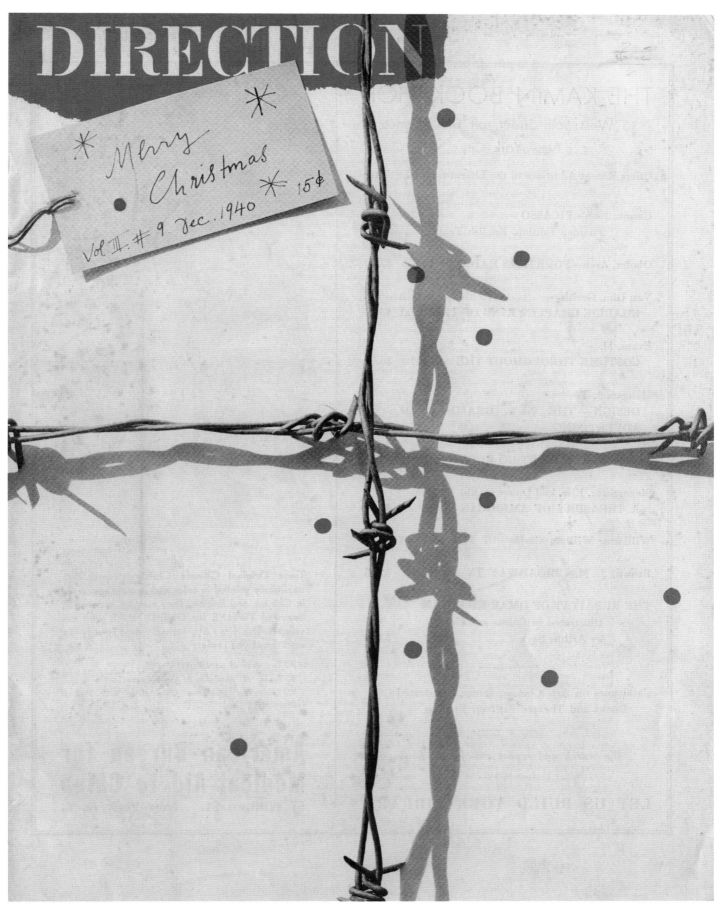

Cover of *Direction* 3, no. 9,
December 1940, designed by
Paul Rand

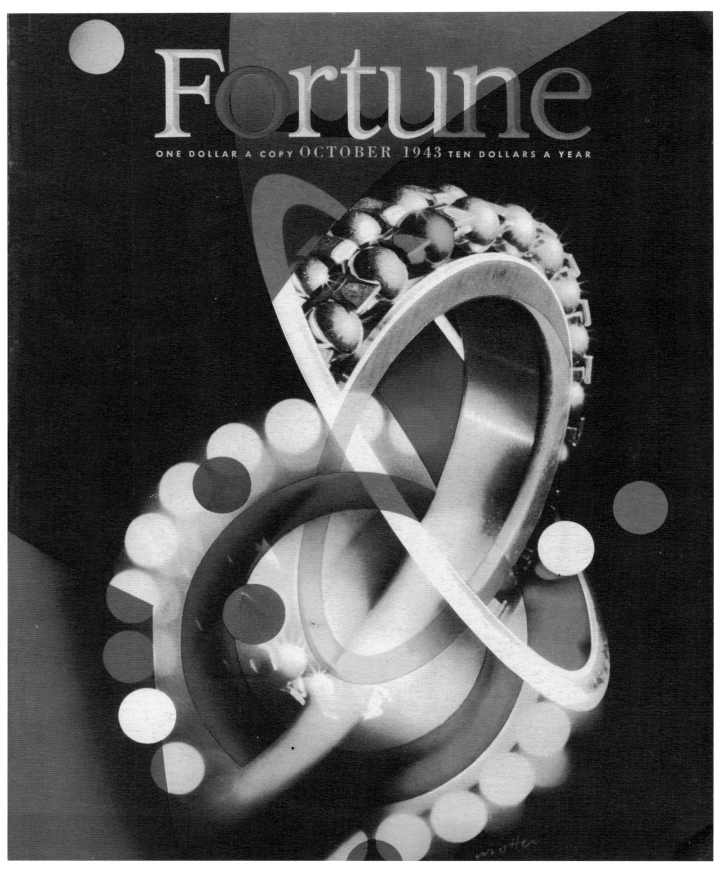

Cover of *Fortune*, October 1943,
designed by Herbert Matter

Modern Look

Art transforms us, and we become capable of transforming our surroundings.
—Lajos Kassák

When the traumatic events of World War I began to appear as photographs in newspapers with the precision of mechanical reproduction, the real world suddenly appeared on the page. This phenomenon would propel advances in the integration of word and image, especially in Germany, the birthplace of photojournalism and the graphic arts. There, the brilliant Hungarian émigré Stefant Lorant, a filmmaker as well as editor-in-chief of the *Münchner Illustrierte Presse* (Munich Illustrated Press), applied his cinematic instincts to the nascent photo-essay, thereby inventing the modern layout. Likewise, the New Vision of László Moholy-Nagy and his colleagues at the Bauhaus championed the idealistic melding of art and industry. And just as the Bauhaus theater, or its notions of architecture, showed new models of spatial organization that enlightened "the living and working conditions of the environment," the democratization of the formal elements of design also represented the potential for a culture of collaboration and innovation. Under the influence of these artists, the conception, creation, and reception of the medium of the page underwent nothing short of a revolution.

Within a decade, as World War II loomed, noted European artists and designers—from the Hungarians Moholy-Nagy and György Kepes to the Swiss Herbert Matter—began to immigrate to the United States. With their American counterparts, they ushered in a period of unprecedented advancement in the visual culture of the United States. This era, from the late 1930s through the 1950s, during which photography became a dominant force in the nation's culture, was propagated by a burgeoning mass media. Photo-driven magazines, such as *Look* and *Life*, enjoyed wide circulation in the United States, emulating the appeal and impact of European periodicals, such as the *Berliner Illustrierte Zeitung* in Germany and the vanguard *Vu* in France. As the country lifted itself out of the Depression and entered the war, a modern American aesthetic emerged that drew on what this country had long been known for—innovation, inclusiveness, and pragmatism. As Kepes would write in 1944: "Posters on the streets, picture magazines,

picture books, container labels, window displays . . . could disseminate socially useful messages, and they could train the eye, and thus the mind, with the necessary discipline of seeing beyond the surface of visible things, to recognize values necessary for an integrated life."[1] In this period of enlightenment and disillusion, America remade its aesthetic landscape, albeit in the service of an unfettered consumerism, one ultimately defined by the socially contested pages of the magazine.

The emergence of photography's multiple identities began in the Weimar Republic and was revealed to the world in 1929 through an international exhibition called *Film und Foto*, mounted in Stuttgart. The organizer—the Bauhaus-affiliated Deutscher Werkbund, an association of artists, architects, and designers—was well aware that photography could be a medium of propaganda as well as a source of information. One reviewer remarked on the gallery "Photography as Means of Propaganda," noting the commercial potential for such compelling images: "One finds that the most effective shots are those of jewelry, fabrics, ceramics, matches, fountain-pen holders, and other objects, which could easily come to replace the current drawn and painted versions. And it is here that montage of various shots has garnered new unity, sense and the right to exist."[2]

It was no coincidence that, although photography had been a part of the Bauhaus, especially the printing and advertising workshop, it became an official part of the curriculum only in 1929, with Walter Peterhans as teacher. The photographers Grete Stern and Ellen Auerbach, known as Ringl + Pit, studied privately with Peterhans, a proponent of the school's philosophy that photography be used as a medium for advertising in the service of an industrial society.[3] Their work speaks to the conflict inherent in the very notion of commercial art, and much of it insists on reframing the subject of advertising photography, stressing, with irony, nuanced issues of femininity and artifice.

As photography placed together with print became a universal medium, picture magazines proliferated, spurred by the success of the pioneering *Berliner Illustrierte Zeitung*, which helped Germans navigate the trauma of World War I and armed them for the cultural upheaval of the Weimar Republic. As the magazine's editor Kurt Korff stated: "Life has become more hectic and the individual has become less prepared to peruse a newspaper in leisurely

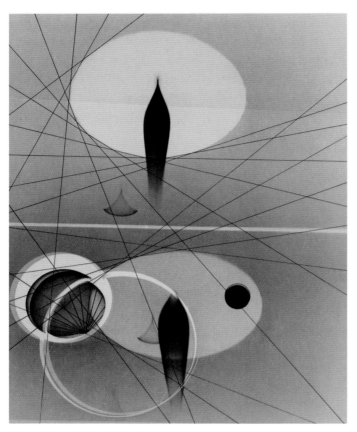

György Kepes, *Untitled (Abstract, Ovals, Crossing Lines)*, 1939. Ink on vintage collaged gelatin silver print from a paper negative

Weston exhorted his fellow Americans, many of whom were still preoccupied with photography's status as art, to recognize its inherent capacity to reveal "things in themselves . . . clearly, powerfully."[5]

Weston had spent the early part of the decade methodically introducing graphic-design elements into a series of attic photographs, which, while inching toward the modern, remained mired in romantic, painterly composition. *Sunny Corner in an Attic*, 1921—ostensibly a portrait of friend and fellow photographer Johan Hagemeyer—at first appears to be at odds with itself. The formalist use of geometry to convey light literally foreshadows the sensuous close-up studies of nature and objects, as well as the nudes, for which Weston would become known. It was at this experimental juncture, as he sought his artistic footing in the wake of an antiquated pictorialism, that Weston began to realize a balance between the evocation of a modern subject and a formalist move toward abstraction.

As Weston succeeded in cultivating a visual sense more consonant with the photographic zeitgeist in Europe, by 1929 he was expressing frustration with the American public and critics who still could not see beyond the impressionist fog of the past.[6] The pace of visual experimentation in America was at best cautious, as was the country's reception of modernism in general. American photography's growing pains lingered for several reasons, including the sobering effects of World War I, the overriding realities of the Depression, the distrust of European modernism, and parochial attitudes toward any tainting of art by commerce.

While high modernists such as Moholy-Nagy, Kepes, Bayer, and Matter pursued multiple interests—painting, photography, design, art education—nonspecialized practice was unusual for American artists. Even rarer was an engagement with both art and commerce. Steichen, who came to the United States as a child, was more familiar with European trends than were many of his American colleagues. "I hate specialism," he said. "That is the ruin of art. . . . I am no specialist. I believe in working in every branch of art."[7]

Weston and Steichen reflected a healthy, divergent view of the field. Steichen felt no compunction over entering the commercial fray or experiencing every artistic possibility. For him, as for Weston, it was important to acknowledge photography's unique qualities, "one being the delineation of

reflection. Accordingly, it has become necessary to find a keener and more succinct form of pictorial representation that has an effect on readers even if they just skim through the pages. The public has become more and more used to taking in world events through pictures rather than words."[4]

As we shall see, some of the principal players in *Film und Foto* were looking toward the photography of the future even as the exhibition exhaustively assessed the present. One gallery, for example, was devoted to graphic design, demonstrating a prescient understanding of what was to come. American photographers, however, were still nostalgically looking to the past. Edward Weston deplored his peers' "facile approach" to the medium, "their technical tricks and incoherent emotionalism." After visiting the exhibition, for which he and Edward Steichen had selected the American contributions,

Modern Look

Edward Weston, *Sunny Corner in an Attic*, 1921, gelatin silver print

Klein

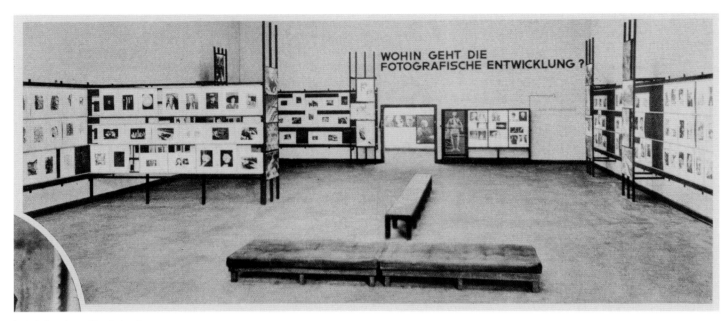

Installation view of the first gallery,
designed by László Moholy-Nagy,
of the *Film und Foto* exhibition,
Stuttgart, 1929

detail." Weston asked, "Why limit yourself to what
your eyes see when you have such an opportunity
to extend your vision?" [8] As we know, Weston even-
tually resigned himself to the lens's superiority,
acknowledging that the best he could do was to
"previsualize" the final image. The questions he was
posing were consistent with those being explored
in Germany. It should come as no surprise, then, that,
while Weston's reception in America at the time
was lukewarm, he was taken seriously—even sought
after—in Europe.

Any discussion of the development of photography
within the context of popular culture and mass media
must acknowledge the significance of the advanced
visual culture of Weimar Germany, a crowning
moment of which was *Film und Foto*. The exhibition
provided an extraordinary survey of the artistic and
utilitarian achievements of its media, an unprece-
dented diversity of ways to picture and see the world.
Moholy-Nagy, a key organizer and major exhibitor,
used the occasion to systematically align all man-
ner of genre, technique, and style—portraiture,
high-speed reportage, photograms, and scientific
and abstract photos. The displays emphasized the
ubiquity of the medium, with the work of established
artists placed next to that of unknown amateurs.
And, in casually tacking unframed prints to the walls,
the exhibition designers presented the New Vision
of the Bauhaus not so much as an artistic movement
but as a platform on which to consider the complex

identities that photography had developed as an
integral part of the modern technological world, from
science to commerce.

Having taught at the Bauhaus since 1923, Moholy-
Nagy had forged his New Vision ideas throughout
the decade while also becoming an exemplar—as a
painter, photographer, designer, filmmaker, writer,
and teacher—of the school's conception of the
artist as multiply skilled. He designed and curated
the large introductory gallery, which offered a
comprehensive overview of new photography, much
of which he had addressed in his 1925 treatise
Malerie, Photographie, Film (Painting, Photography,
Film). In the wall text, in large block letters, he wryly
alludes to the media's future: "Where is photogra-
phy headed?" [9]

Together with photography, film, by now ensconced
in modern life, had a strong presence in the exhi-
bition under the guidance of Hans Richter, whose
own pioneering efforts in abstract film were
presented. In addition, the Russian gallery, orga-
nized by El Lissitzky and his wife, Sophie Lissitzky
Küppers, distinguished itself by showing film
excerpts from Dziga Vertov's *Kino Eye* and *Man with
a Movie Camera* and Sergei Eisenstein's *Battleship
Potemkin* alongside Russian photographs, demon-
strating that both media provided the viewer with
novel ways of seeing and experiencing the world.
Images, close-ups, long-distance shots, and even

Modern Look

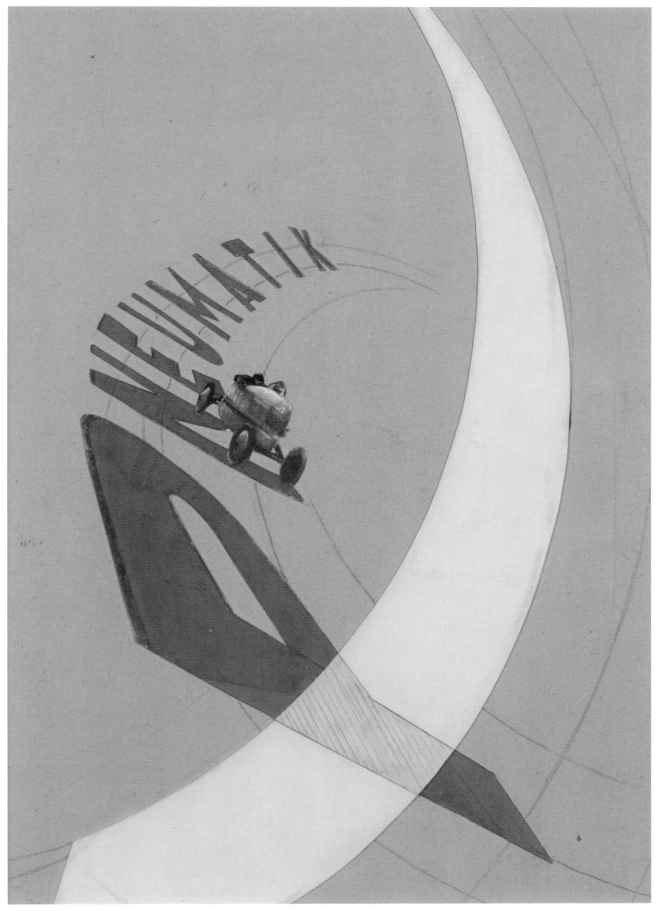

László Moholy-Nagy, *Pneumatik*,
1924, pencil, gouache, and collage
on paper

Klein

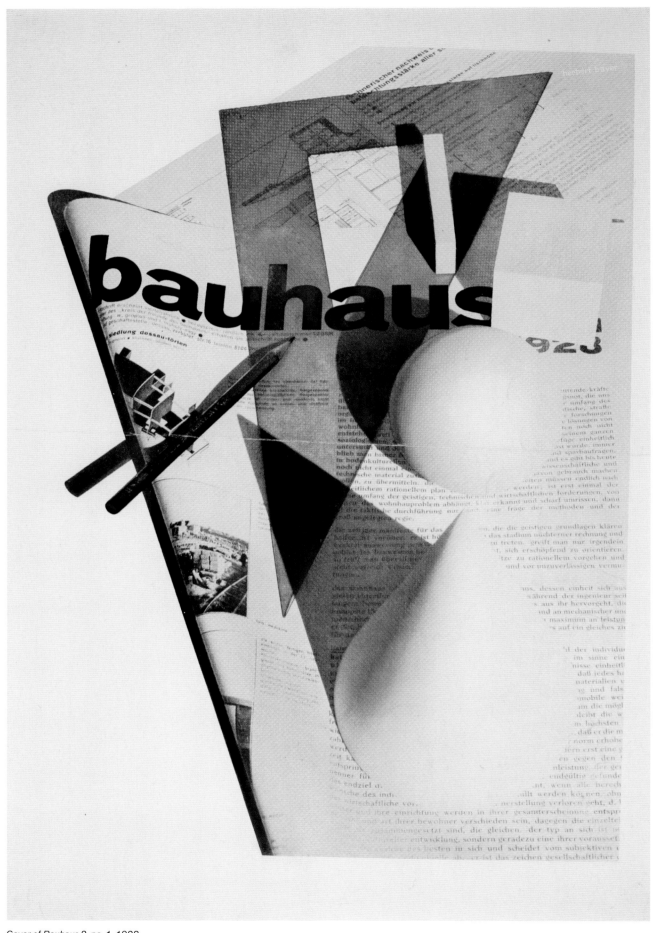

Cover of *Bauhaus* 2, no. 1, 1928,
art direction by Herbert Bayer

Moholy-Nagy's cameraless images, made purely from light, redefined the eye-opening possibilities of photography and film.

Moholy-Nagy wanted to show not only how far photography had come but also how the medium might evolve and serve society. While the combination of typography and photography was an outgrowth of Futurist and Cubist art, at the Bauhaus, language began to assume greater value in the new world of advertising and commerce, technology and mass media. Exemplifying the Bauhaus's functional, rather than expressive, formalist value, Moholy-Nagy called this integration of image and text "typo-foto," or graphic design, with typography and photography functioning as equal partners on the printed page. The typo-foto, he wrote, governs the changed tempo of the new visual literature.[10]

Similarly, Herbert Bayer, who headed the first typographic workshop at the Bauhaus, democratized the elements of design in his famous cover of *Bauhaus* magazine in 1928. He employed geometric shapes (a cone, ball, and cube) positioned around the graphic designer's tools (a transparent set square and a sharpened pencil) and placed everything on top of a folded issue of *Bauhaus*. This realistic combination of type and photo, of two- and three-dimensional forms, provides an early example of how the page could be laid out to convey an idea.

Photography seen as "visual literature" opened up a new way of communicating in a vastly changing world. Its potential was emphasized by the two significant photo books that accompanied the exhibition: Werner Gräff's *Es Kommt der Neue Fotograf!* (*Here Comes the New Photographer!*) and Franz Roh and Jan Tschichold's *Foto-Auge / Oeil et Photo / Photo-Eye*. In addition to cataloguing the exhibition, the books codified and archived photographic and graphic practice and, perhaps most important, provided a way for the medium to be understood and taught, thus illustrating how photography could be put to wider use.

By 1929, Bayer, who had been integrating a variety of media within advertising design while also considering its psychological impact, had been forced out of the Bauhaus as a result of political upheaval. He quickly became the art director of *Vogue* magazine's Berlin office. He left for the United States in

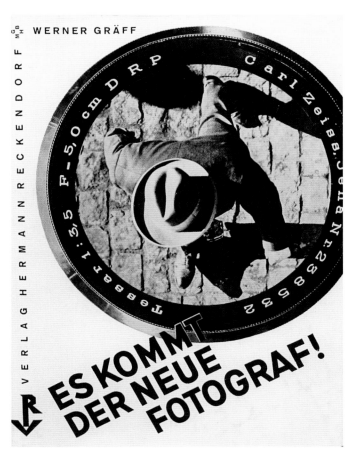

↑ Cover of Werner Gräff's book *Es Kommt der Neue Fotograf!* (*Here Comes the New Photographer!*), Berlin, 1929

↓ Cover of Franz Roh and Jan Tschichold's book *Foto-Auge / Oeil et Photo / Photo-Eye*, Stuttgart, 1929

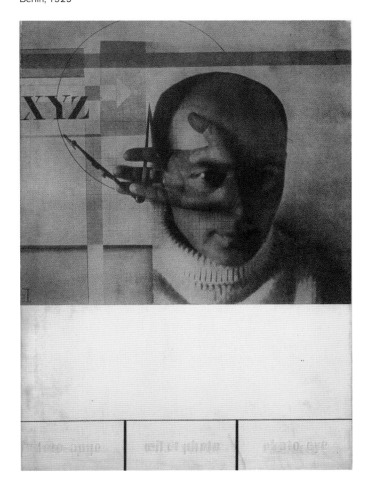

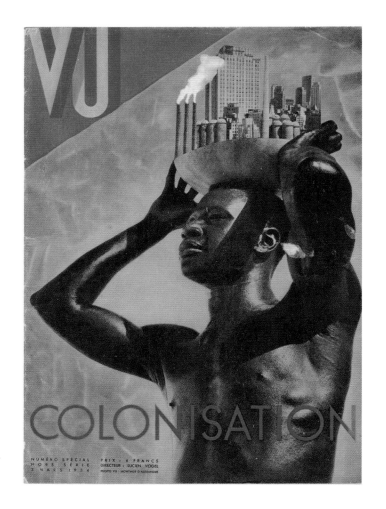

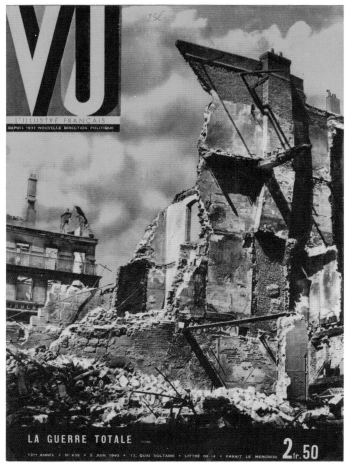

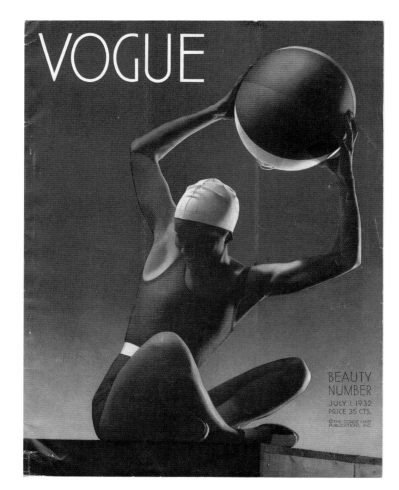

↑ Cover of *Vu*, "Colonisation,"
March 1934

↗ Cover of *Vu*, "La Guerre Totale,"
July 1940 (final issue)

→ Cover of *Vogue*, July 1932,
photograph by Edward Steichen

Modern Look

1938 in order to design (along with Walter and Ise Gropius) an exhibition for the Museum of Modern Art titled *Bauhaus 1919–1928*. The show consolidated the philosophy and practice of the school, whose principles of art and design were foundational to the museum. The utopian principles of the Bauhaus were new to an American audience fresh out of the Depression.

Film und Foto functioned as a bellwether for the primacy of European photography and aesthetic theory in the Weimar period, when liberal democracy and a flourishing culture coincided. Its cultural supremacy also marked the apex of Germany's position of power within Europe in the fields of photography, printing, and publishing.

Throughout the 1930s, many of the figures associated with the Bauhaus, forced by the Nazis to uproot themselves, moved to the United States, where they would radically advance pedagogy in art and design programs. Among those invited to assume major positions in American institutions were Josef Albers, who taught at Black Mountain College in North Carolina and, later, Yale University; Moholy-Nagy, who established the New Bauhaus in Chicago in 1937; and Gropius and his protégé Marcel Breuer, who moved to Cambridge, Massachusetts, to teach at Harvard University's Graduate School of Design. The merging of émigré and native art directors, artists, and designers and the wave of magazines and journals created a breeding ground for the graphic arts in a resurgent America and provided an opportune moment for American modernism to develop.

Becoming American

One of the earliest and unquestionably most daring and influential examples of the new illustrated press was *Vu* magazine, a large-format weekly launched in Paris in 1928. Edited by Lucien Vogel, *Vu* set the standard for eye-catching photography, dynamic double-page layouts, and outstanding journalism. Vogel, a worldly aesthete, savvy photographer, and experienced editor, as well as a vocal anti-fascist, pioneered—together with Alexander Liberman as graphic designer and then art director—what has since been regarded as the first avant-garde photo magazine, featuring a range of modern topics, including world affairs, social concerns, and the arts. Among its eleven principal figures, eight were Jewish.[11] Before its run ended in 1940, it was one

of the most outspoken anti-fascist news publications. As France turned vehemently to the right, *Vu*'s advertising revenue declined until Vogel was forced to sell the magazine and, shortly thereafter, during the Nazi invasion, flee Paris.

Unlike Vogel and Liberman, who had emigrated from Europe under duress, Mehemed Fehmy Agha was brought to the United States by Condé Nast in 1929. Agha, who had been working for the European edition of *Vogue*, was tapped to breathe new life into the staid American edition, as well as Nast's other publications, *Vanity Fair* and *House and Garden*. Agha streamlined *Vogue*'s outmoded appearance, simplifying its design, removing ornamental treatments (borders around photos and column rules), and replacing italic lettering with modern sans serif fonts. He also widened the margins, creating more white space, and introduced double-page spreads and full-bleed images, in which the photo extends to the edge of the page.

With Austrian-born Cipe Pineles, Agha remade *Vogue* into America's premier fashion magazine. Agha astutely hired the leading photographers: Cecil Beaton, George Hoyningen-Huene, and, most important, Steichen, whose inventive color cover in 1932—of a woman with a beach ball—was the magazine's first. Steichen's photographs of common objects, such as his glorification of scattered tacks, and matchsticks and matchboxes, for the Stehli Silk Corporation, were also published in the magazine in 1927 (see pages 56, 57). In "The Camera Works Out a New Theory of Design," a double-page spread, four of Steichen's images were shown, revealing their sources of abstract design.

Frank Crowninshield, editor of *Vanity Fair*, had described Steichen in 1923 as "the greatest of living portrait photographers." For the next fourteen years, the artist helped advance the magazine through his photos of celebrities, intensifying the public's interest in them. Steichen's portrait *Gloria Swanson*, which appeared in *Vanity Fair* in 1924, was part of a lineage that would soon give way to images like those of émigré wunderkind Erwin Blumenfeld, whose *Voilettes de Montezin* was published in the French edition of *Vogue* in 1938. At *Vogue*, Steichen set a new standard, creating images that were groundbreaking in their melding of art and fashion. "Condé Nast extracted every last ounce of work from him," wrote the curator Carol Squiers. "Steichen was a one-man industry for the

Catalogue cover for the exhibition
Advance Guard of Advertising Artists
at the A-D Gallery, New York,
1942, designed by György Kepes

magazines, so he had to work quickly. But he had a great eye for where everything should be."[12]

One unlikely participant in the New York graphic arts movement was the physician Robert Leslie. From an immigrant family himself, Leslie was an extraordinarily generous man, welcoming newly landed foreigners and helping them acclimate to the city. Doc Leslie, as he was called, would provide designers and artists with space to show their work in his Gallery 303, and he also published them in his bimonthly periodicals *PM* (production manager) and, later, *A-D* (art direction). Whether introducing accomplished artists, like Bayer and Matter, or the photographs of unknown artists, such as Arnold Newman and Ben Rose, he was instrumental in giving exposure to generations of graphic artists and photographers.

In 1942 Leslie mounted *Advance Guard of Advertising Artists* at his A-D Gallery, after its initial opening at the Katharine Kuh Gallery in Chicago. The exhibition announcement, designed by Kepes, reflected the assimilation of the European avant-garde into mainstream American advertising. For the first time, Bauhaus refugees Bayer and Moholy-Nagy, as well as Ladislav Sutnar and Kepes, were placed on equal footing with such local talent as Lester Beall and Paul Rand, generally considered the most influential American graphic designers. The covers and pages of *PM* and *A-D*, and the walls of Leslie's galleries, became home bases for forward-thinking graphic design and fostered a new crop of American art directors and designers. Although Rand is best known for his corporate logos, some of his most creative work from the late 1930s and 1940s was for *Direction*, a left-wing arts and culture magazine.[13] As a disciple of the Constructivist style, Beall succeeded, according to the design professor Roger Remington, in "bring[ing] American design of the thirties and forties to a higher level of visual communication." He introduced "the kind of spontaneity that he felt was absent in commercial illustration" and integrated his designs through an idiosyncratic kind of layering. In his 1941 cover for Abbott Laboratories' in-house magazine, *What's New*, for example, Beall was able to effectively advance the sophistication of photomontage by adding boxes of text, along with refined shadowing to enhance the illusion of depth (see page 173).[14] Other biomedical companies, such as Upjohn Pharmaceuticals, which put out the magazine *Scope*, reflected the shrewdness of corporate enterprise's self-promotion through appropriately futuristic and sophisticated design treatment. *What's New* not only employed the leading graphic designers of the day, but it also published the work of American artists and scientists, as well as essays, poetry, and short stories from such authors as Robert Frost, Edna St. Vincent Millay, Carl Sandburg, and William Saroyan.

Among the countless graphic arts publications that grew out of the booming advertising industry, none was as consistently inventive as *Westvaco Inspirations*, under the aegis of Bradbury Thompson. Between 1939 and 1962, Thompson designed sixty-one issues, and the publication gradually focused less on advertising and more on the fine arts. *Westvaco Inspirations*, which was sent to art directors throughout the country, functioned in its day not only as a conduit for the modernism that was taking root in major U.S. cities but also as a forum for its reinterpretation.[15]

Along with the encouragement and creative opportunities provided by *Westvaco*, *PM*, and *A-D*, another, and improbable, source for artists and designers was the Chicago-based Container Corporation of America, owned by the progressive philanthropist Walter Paepcke. Best known for founding the Aspen Institute in the early 1950s, Paepcke had learned of Bayer when the latter had designed the Museum of Modern Art's Bauhaus exhibition in 1938. Paepcke became an important patron of Moholy-Nagy, financing the New Bauhaus when it was struggling to establish itself in 1939. Among their numerous efforts, begun in the 1930s, "to serve [the] public interest as well as our own," Bayer, Paepcke, and his wife, Elizabeth, decided in 1945 to develop an unconventional advertising series that would promote humanism in postwar America. "Great Ideas of Western Man," a "non-advertising advertising campaign," appeared in such magazines as *Time* and *Fortune*. It continued for twenty-five years, until Bayer realized his long-professed ideal "to see his work," as he wrote in 1962, "in its totality [as] a statement about the integration of the contemporary artist into an industrial society."[16]

By the end of the 1930s, the high-stakes publishing world had experienced much intrigue and tumult as a result of the competition between William Randolph Hearst and Condé Nast. This drama was only heightened when Hearst hired the Russian artist/designer/photographer Alexey Brodovitch

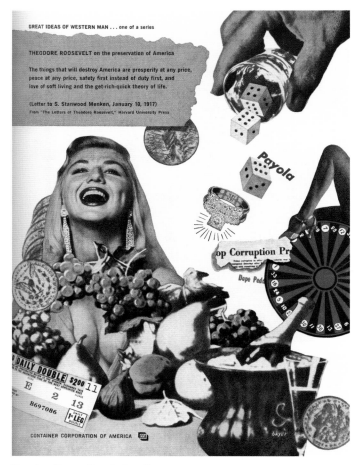

Theodore Roosevelt quote, from the
series "Great Ideas of Western Man,"
designed by Herbert Bayer, 1959

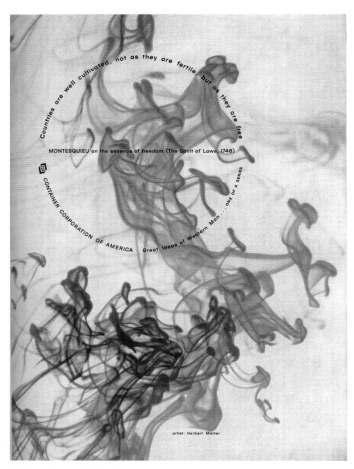

Montesquieu quote, from the
series "Great Ideas of Western Man,"
designed by Herbert Matter, 1958

to raise the profile of *Harper's Bazaar*. Brodovitch's
arrival was the doing of Irish-born Carmel Snow, the
magazine's editor-in-chief, and the person primar-
ily responsible for persuading Hearst to hire an art
director who could create a truly modern magazine.
She had shocked her colleagues at *Vogue* by jump-
ing ship to join its rival, and with the appearance
in 1933 of Martin Munkacsi's photographs of real
women running on the beach—another example of
Snow's clairvoyant brilliance—the stodgy vestiges of
the American fashion magazine born of the Victorian
age began to evaporate (see page 142). Munkacsi's
innovative contributions to the magazine were
equally sweeping. His extensive experience as a
sports photographer, honing his skill and facility with
improvisation, served his fashion photography well.

Before he would begin his illustrious career as
an art director and teacher in the United States, the
Russian-born Brodovitch had also had to flee his
homeland. Going first to Paris, he took up residence
in the émigré neighborhood of Montparnasse, home
to Russian artists and writers. Soon he was painting

backdrops for Sergei Diaghilev's Ballets Russes,
whose consummate spectacles were among the
most far-ranging and provocative artistic disrup-
tions of the first quarter of the twentieth century.
Employing a multitude of media—from costumes,
sets, and choreography to music, each component
either shockingly original or utterly scandalous—
the collective effort culminated in the creation of
theatrical unity, a total work of art. This represented
a bold, lasting standard for Brodovitch, and he
could not have had a better mentor than Diaghilev.
Later, he would urge his own students to outdo
themselves with Diaghilev's famous exhortation,
"Étonnez-moi! [astonish me]."

Although he never professed to be a photographer,
Brodovitch's teaching at his Design Laboratory con-
centrated on the medium for decades.[17] Brodovitch
was unique, however, in his dual attention to pho-
tography and graphic design, developing the former
as the animating force of the latter. Indeed, the
camera's infusive symbolism in his work reaches
an incisive and typically droll presence at the

Modern Look

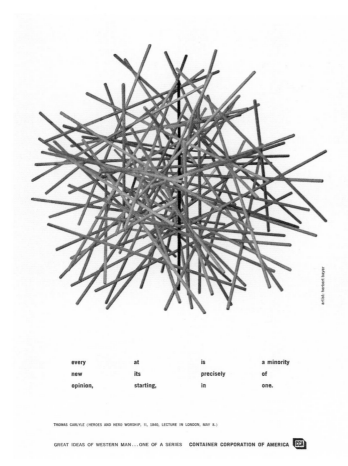

every at is a minority
new its precisely of
opinion, starting, in one.

THOMAS CARLYLE (HEROES AND HERO WORSHIP, II, 1840, LECTURE IN LONDON, MAY 8.)

GREAT IDEAS OF WESTERN MAN...ONE OF A SERIES CONTAINER CORPORATION OF AMERICA

Thomas Carlyle quote, from the
series "Great Ideas of Western Man,"
designed by Herbert Bayer, 1961

end of his celebrated photographic book *Ballet*.
With his inimitable discernment, Brodovitch
extends his photographic meditation on the dance
to the book's concluding image. Its pinched view
of the dancers suggests a metaphoric relationship
to the photographic process in its allusion to the
shape and action of a shutter's diaphragm.

Ballet reveals, above all, how attached he was to
the performative idea of movement. Brodovitch shot
the series between 1935 and 1937, after he had
become familiar with the extraordinary dynamism
of Munkacsi's sports pictures. But Munkacsi was
essentially arresting movement while Brodovitch
was extending it and celebrating its elusiveness.
Although Brodovitch stated that the photographs
were initially taken "for souvenir purposes," they
mark a kind of insurrection in the field that "spat in
the face of technique and pointed out a new way
in which photographers could work."[18]

Brodovitch's typography on the cover is so consid-
ered that the serifs and attenuation of the letters of

"BALLET" assume a choreography of their own—an
extraordinary example of the heightened purpose
of such design elements to evoke their subject.
Each letter's serifs are dramatically extended to
suggest an architectural capital, which, along with
each letter's columnar verticality, conjures a clas-
sical temple. The horizontal format also allowed
Brodovitch to endow the book's interior with the
spatial sense of the proscenium and to heighten the
viewer's perception of the sequence of scenes—
that is, to mimic dance movement itself. By bleeding
the images to the gutter of the book, Brodovitch
accentuated the spatial extension and movement
of the dancers, conveying a series of balletic move-
ments and landings. His bleaching of negatives
minimized focus and clarity, a way to dematerialize
the dancers. *Ballet* embodied the dance, as per-
haps no other book had, in its gravity, speed, and
precision of movement. Brodovitch was perhaps
realizing, in book form, the myriad sensuous effects
that the Ballets Russes had had on its audience
(see pages 72–75).

Such startling choreographic effects would engen-
der another of Brodovitch's imposing productions.
In 1950 he designed what is generally considered
to be the most exquisite and extravagantly pro-
duced large-format (and, not surprisingly, short-
lived) graphic arts magazine, *Portfolio*. Its costs
were unsustainable, but in the view of most graphic
arts historians, its three issues "have never been
matched in magazine design."[19] For its inaugu-
ral cover, he made the unusual choice to use only
white type on a black background and to place two
color filters over the *Portfolio* title. In reducing the
elements to their absolute minimum—text; black,
white, and color—Brodovitch made clear the lofti-
ness of his goal. His visual strategy was to achieve
a sense of flow, of continuity, while enlivening every
page with a jolt of astonishment. As was always
his preference, Brodovitch employed many of the
photographers who admired him or who had stud-
ied with him in his Design Lab: Richard Avedon,
Henri Cartier-Bresson, Hans Namuth, Irving Penn,
and Rose.

The idea of creating a magazine solely about art and
design came from the art director Frank Zachary.
He recruited Brodovitch, who displayed an unprece-
dented ability to create a panoply of popular culture,
high and low. "He started," Zachary observed, "with
a big picture . . . then modulated to a smaller pic-
ture and then a kind of an interval then bam-boom

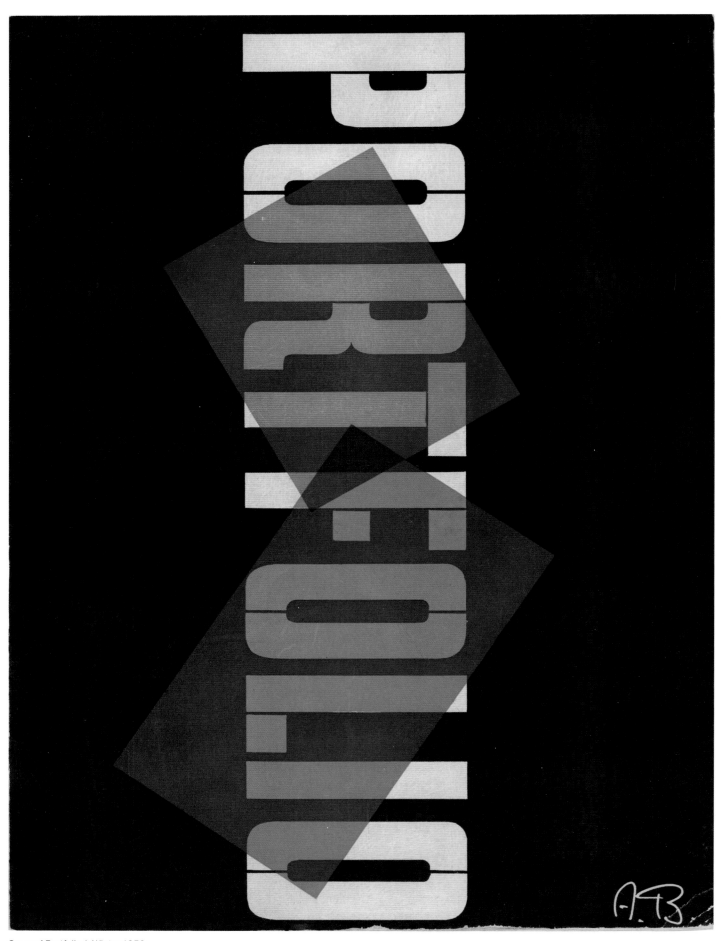

Cover of *Portfolio* 1, Winter 1950,
designed by Alexey Brodovitch

Modern Look

again. He paced it in terms of peaks and valleys of eye interest . . . not for just one story, but the whole magazine . . . as a unity."[20] He had no compunction over mining his own visual vocabulary or that of anyone else (often using the work of his students). In a two-page spread, Brodovitch enlarged four segments of a painting by Jackson Pollock, whose method of splashing or dripping household paint onto paper or canvas was highly controversial (the two outside segments are the same, but their colors are inverted). It was a brilliant acknowledgment of Pollock's work, and by cropping the enlargements, Brodovitch was able to assemble yet another group of fanciful dancers (see page 76).

Mixing grids of cattle brands, for example, in issue two, Brodovitch played with the vocabulary and design of the brand, creating an endless permutation of letters, numbers, and symbols (see page 77). One grid's exacting patterns become the equivalent of Egyptian hieroglyphs, incorporating everyday objects and animals. Another plays with white signs and symbols on a black background, which is overlain with a photograph or, rather, its photostatic copy, thus converting the photograph's indexical nature one more remove from the truest reference to the brand, the animal's hide itself. Highlighting the vast range of subjects in the three issues of *Portfolio*, as the design historian Kerry William Purcell has observed, "demonstrates Brodovitch's disregard for any calculated distinction of high and low culture in the visual arts."[21]

Such experimentation was the forte of another émigré, Josef Breitenbach, who had arrived in New York in 1941. He had escaped from his native Munich in 1933 and then from France, where he had been interned as an illegal alien. Soon after Breitenbach landed in New York, Walker Evans recommended him to an editor at *Fortune*, who gave the photographer his first assignment, "What About Steel?," on the recycling of scrap metal in the service of the war effort (see page 137). He had already built a reputation as a portraitist in Paris, where he helped raise money for the Resistance. In 1944 he was helped by Albers, who invited him to teach at Black Mountain College, and soon afterward he joined the faculty at Cooper Union and the New School. But his ardent experimentalism with photomontage and special color tinting and printing techniques remains Breitenbach's legacy. This unusual aesthetic is exemplified in *For Ever and Ever*, 1938, which speaks to the catastrophic wave of fascism

that was about to overtake Europe, and in *We New Yorkers*, 1942, a work that speaks to his exuberance at finding himself in the hyperstimulating environment of New York (see pages 70, 71).

The entrenchment of the magazine-publishing world in New York paralleled the shift of artistic and intellectual currency from Paris to New York. This sense of the modernist vanguard spurred the interdisciplinary exchange of ideas, as professional opportunities expanded and publications of all kinds continued to flourish. So did the number of designers and experimental approaches, especially in photography. The photographer Herbert Matter was able to nimbly mine almost any medium to multiple effects. For *Fortune*'s October 1943 cover he illustrated a technically intricate, ultra-complex ball-bearing process, deconstructing it into an abstracted, otherworldly celestial body, combining black-and-white photograms and photographs with a range of orbiting geometries and primary colors (see page 24).[22]

Matter clearly wielded influence with the editors, who gave him creative liberty. In 1943, for example, while all the major magazines were doing their part to mobilize the nation during the war, *Harper's Bazaar* went a step further with an ad by Matter. In his photomontage *The Woman Who Lost Her Head* he depicts a woman striding down an avenue, laden with newly purchased goods; her head lies gruesomely on the pavement behind her, its deep shadow resembling a pool of blood. The following text provided the image's narrative:

> This woman is the national nightmare. At the first scent of victory she walks out on her war job, walks into the shops. She buys by the dozen, yawns at inflation, thinks she's pretty coony to stock up while the going is good. Multiplied by the thousands, she is draining the shops, cornering merchandise needed by others, shooting up prices, paving the way for postwar breadlines. She is a disgrace, the despair of America—this hit and run shopper, this selfish, complacent little woman who has lost her head.[23]

Despite all the trappings of an advertisement, its point is not immediately clear. Apart from its prescient acknowledgment of a postwar American boom in consumerism, this was, perhaps, Matter (and the editorial board) telling women that the war

Klein

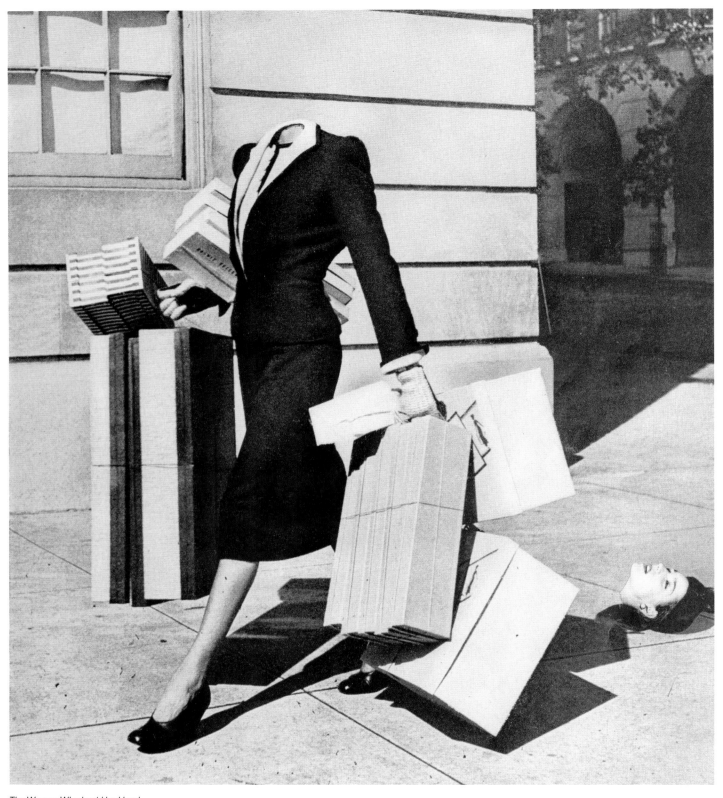

The Woman Who Lost Her Head,
Harper's Bazaar, September
1943, page 89, photomontage
by Herbert Matter

was not over and that they should continue in their patriotic efforts.

Matter's early photomontaged posters for the Swiss National Tourist Office in 1935–36 would be picked up by American graphic designers, like Beall, or appropriated, decades later, as in Paula Scher's Swatch watch ad of 1984 that pays homage to the artist.[24] What was generated in this era anticipated postmodernism, prefiguring both the appropriation and layering of images that resurfaced in late twentieth-century art. In the case of the protean Blumenfeld, who began his career making Dadaist collages and by the 1950s had become one of the most sought-after fashion photographers, the magazines allowed him to experiment without boundaries. He even pushed portraiture to the verge of abstraction, exploiting the Ben Day process.

While Matter and other émigré photographers would contribute brilliant magazine covers throughout the war—especially Blumenfeld, working for *Vogue*—Penn and Avedon in 1944 began taking fashion photographs for *Vogue* and *Harper's Bazaar*, respectively. Until that point, the leading fashion photographers at both magazines had been émigrés, a trend that began to quickly change. Penn and Avedon, who are often linked to their magazine covers, were shaped by their European art directors.

This is confirmed by a drawing from Penn's *Notebook at Random*, published late in his life, that delineates a tree of influence. Within its root system, Penn registered a historical range of mostly Western European painters, with figures such as Fernand Léger and Giorgio Morandi designated in slightly larger type among other prominent modernists. Above ground, the tree's limbs carry the names of photographers, the pioneers and notables that one would expect to find. Within the trunk of the tree, he noted the preeminence of Brodovitch and Liberman.

Penn had attended Brodovitch's famed Design Lab, founded in 1933 in Philadelphia as a weekly gathering of students to focus equally on photography and the graphic arts. When Brodovitch moved to New York, so did Penn, who continued to work as an assistant for his former teacher. In 1940, after freelance designing for two years, Penn took over Brodovitch's position as the art director at Saks Fifth Avenue, where he would remain for a year— long enough for the still-amateur photographer to

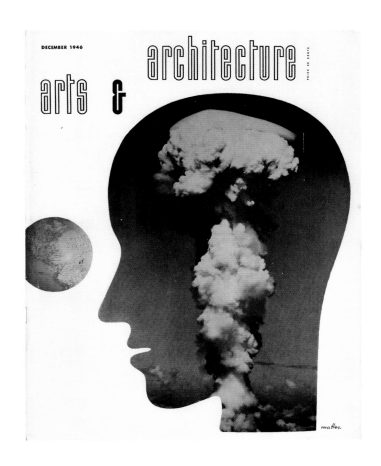

↑ *Atomic Head*, cover of *Arts & Architecture*, December 1946, designed by Herbert Matter

↓ Cover of *Arts & Architecture*, December 1944, designed by Herbert Matter

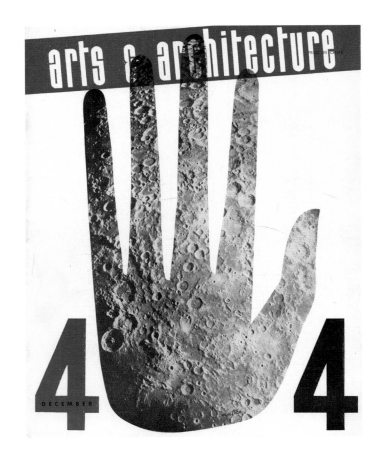

Klein

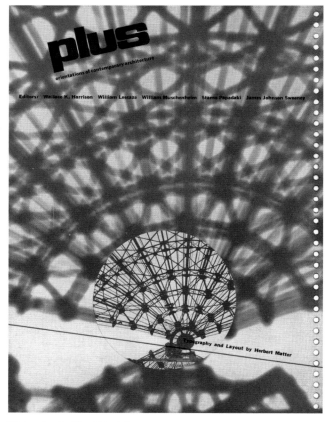

Prospectus for *Plus: Orientations of Contemporary Architecture*, in *Architectural Forum*, November 1938, designed by Herbert Matter

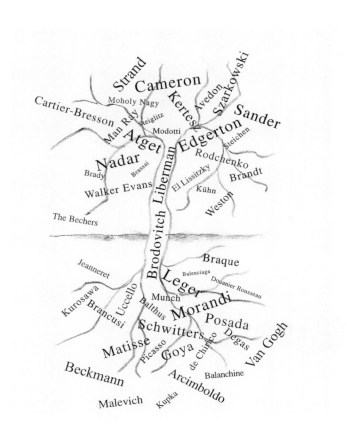

↑ Irving Penn, *Tree of Influence*, 2003, from his book *A Notebook at Random*, New York, 2004, page 107

↓ Irving Penn, untitled still life, 1943, Kodachrome print with markup by Alexander Liberman on the acetate sleeve

travel to Mexico to paint. On his return in 1943, he met Liberman, who hired him to work in *Vogue*'s art department and help with layouts. And before long he was encouraged by his new mentor to begin shooting his first cover for *Vogue*—a still life and play on classic American trompe l'oeil painting—allowing him to make use of what he had learned from Brodovitch and at Saks: how to display objects to their best aesthetic vantage.

Few photographers have been able to sustain the demanding scrutiny and deadlines of commercial work as have Penn and Avedon, both of whom continued throughout their careers to extend their idiomatic styles. This meant initiating a new and varied series of portraits. Alongside the classic ones of celebrities were ethnographic studies of Peruvians, New Guineans, and the Yoruba. Penn's ability to find something visually compelling in most anything—from cigarette butts to egg yolk—allowed him to navigate the worlds of advertising and fashion while still producing portraits and new series of nudes with technical skill and novelty. *Man Lighting*

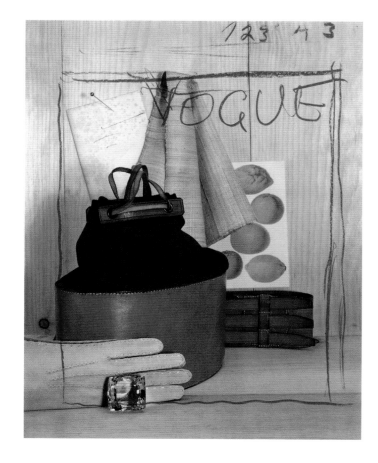

Modern Look

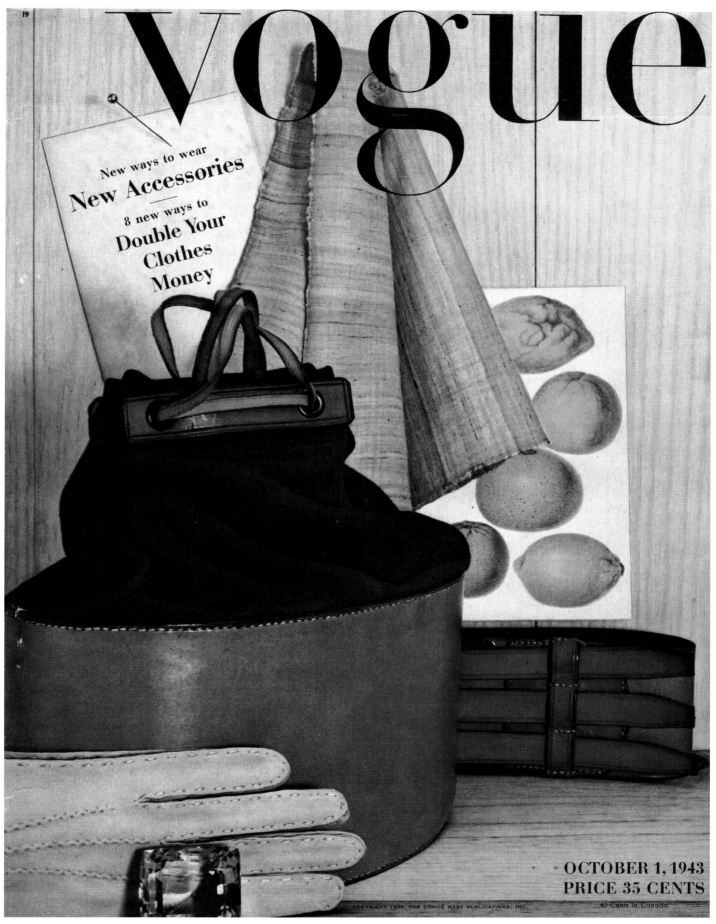

Cover of *Vogue*, October 1943,
photograph by Irving Penn, art
direction by Alexander Liberman

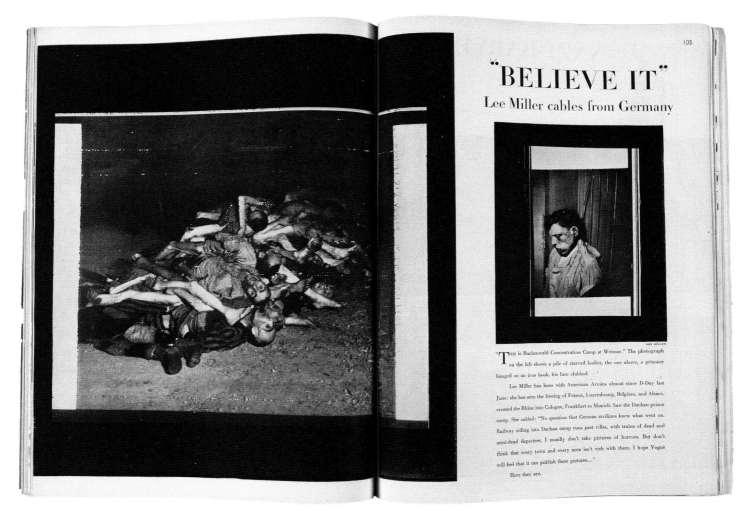

The image includes the following text:

"BELIEVE IT"

Lee Miller cables from Germany

"THIS is Buchenwald Concentration Camp at Weimar." The photograph on the left shows a pile of starved bodies, the one above, a prisoner hanged on an iron hook, his face clubbed.

Lee Miller has been with American Armies almost since D-Day last June: she has seen the freeing of France, Luxembourg, Belgium, and Alsace, crossed the Rhine into Cologne, Frankfurt to Munich. Saw the Dachau prison camp. She cabled: "No question that German civilians knew what went on. Railway siding into Dachau camp runs past villas, with trains of dead and semi-dead deportees. I usually don't take pictures of horrors. But don't think that every town and every area isn't rich with them. I hope Vogue will feel that it can publish these pictures...."

Here they are.

"Believe It," *Vogue*, June 1945, pages 104–5, text and photographs by Lee Miller, art direction by Alexander Liberman

Girl's Cigarette (Jean Patchett), New York, a gesture viewed through a wine bottle, is just one example of Penn's peerlessness in multiple genres (see page 156).

Liberman, a painter and sculptor whose true vocation was the making of "fine" art, never achieved the critical acclaim he coveted. As the editor Tina Brown said, he was "to magazines what Balanchine was to ballet. His genius was to make you better than you are."[25] Nonetheless, Liberman's pursuit of parallel careers continued to vex him, later provoking disparaging comments about "fashion journalism": "I resented," he said, "what was being passed off as art in fashion magazines. Even the term 'art' director is pretentious. . . . I wanted to get the grit of life into this artificial world."[26] But he also took pride in his tenure at *Vogue*, and particularly in the magazine's role during the war:

A big change occurred in *Vogue* with the war. American fashion was on its own. Paris was cut off. The war effort started, women went into war industries, the whole attitude, way of dressing, way of life changed. *Vogue* had a war correspondent and even published Lee Miller's photographs of the atrocities at Buchenwald. Nobody realizes how dramatically serious . . . *Vogue* was always thought of as trivia, an old-fashioned magazine. I couldn't have been involved in a trivial magazine. To this day I feel *Vogue* has a mission of bettering human life.[27]

Whereas his rival across town, Brodovitch, was developing *Harper's Bazaar* to be artful and graphically engaged on every page, Liberman was interested more in real women than in fashion.[28] He wanted to depict his models as modern, complex working women, laden with groceries as they

rushed home from the office. Such women were, for Liberman, more compelling than were members of the Social Register. For him "a fashion photograph [was] not a photograph of a dress; it [was] a photograph of a woman."[29] But, as fashion became more mundane and readers began shuffling familial priorities in postwar America, magazines began to lose their lofty aesthetic goals. The time had come to respond to cultural change by offering more than alluring covers and titillating spreads.

One photographer whose work reflected such changes was Avedon. Celebrated for the exuberant staging of his work, which betrayed his love of the theater and his absorption of Brodovitch's instincts for choreographic performative design, he continued his fashion work into the 1960s, especially as Pop culture emerged. And, as his work had chronicled the final years of haute couture, its ultimate passing perhaps explains his stylistic shift toward a raw, objective portraiture that reflected an America newly beset with social and political discord.[30]

The Contested Page

As a new generation of artists came of age during the 1940s and 1950s, both experimentation and teaching began to assume an interrogative nature that privileged the questioning of assumptions. Certainty gave way to an openness to new experience and discovery. What distinguished the transformation of progressive arts education at places like Black Mountain College, founded in North Carolina in 1933, was a greater emphasis on interrelationships among the arts and a new regard for *all* the senses.

In New York, in addition to Brodovitch's Design Lab, there was the Photo League, whose chief pedagogical voice was that of Sid Grossman. Throughout the 1940s, the League became less doctrinaire as the country pulled out of the Depression, and its membership, especially with the influx of women during World War II, became more diverse. Its well-respected magazine, *Photo Notes*, chronicled much of what was happening in the field, and its gallery exhibited the work of established as well as emerging figures.

Aaron Siskind, leader of one of the League's feature groups, the Harlem Document, was troubled by the fractious debates surrounding the aesthetic

conundrum of the documentary image: the slightest aestheticization was considered by some diehards to undermine an image's social efficacy. The tipping point for Siskind came when he showed some of his experimental, abstract work at the League in the early 1940s and was roundly rebuked. For him, an enforced objective recording meant the loss of the photographer's subjective vision.

The earlier emphasis on a narrow agenda of documentary work was largely the product of the international politics of the worker-photography movement of the 1930s. What is generally overlooked is that the League also began to advocate, principally through Grossman's teaching, for the cultivation of a photographer's eye for a subjective viewpoint, to question both reality and the self. Grossman ultimately insisted that a photographer be in the world in a certain self-aware manner to connect with the subject in an emotional, personal way.

This transformation in documentary photography characterizes the work of many of the figures discussed here—Lisette Model, Gordon Parks, Saul Leiter, Louis Faurer, Robert Frank, and William Klein—who deployed their medium toward personal and meaningful ends. These photographers did not just produce compelling, aesthetically inventive images that changed mass media's relationship to photography; they also challenged viewers to reconsider their own relationship to the world and their place within it. By approaching their work from numerous vantages, without disciplinary restrictions, these figures, especially Parks and Model, allowed audiences to understand how photography could effect empathy and social change.

A few years before she would immigrate to the United States in 1937 and settle in New York, Austrian-born Model, while visiting her mother in Nice, made a series of portraits of the local moneyed class who gathered on the Promenade des Anglais. These uncompromising, close-cropped portraits were published in the left-wing photojournalistic magazine *Regards* and sparked her career. She arrived in New York with a solid portfolio, including her portraits of poor Parisians.

In *New York: Capital of Photography*, Max Kozloff cited Model as "the first socially conscious photographer to operate beyond the gravitational field of Lewis Hine, whose faith in progress and the camaraderie of work had had its day."[31] As a

twice-displaced émigré, Model had a refractive view of life that naturally was amplified in her work. The first assignment she received from *Harper's Bazaar* was, unsurprisingly, to photograph Coney Island, the "populist equivalent to the Promenade des Anglais," in which her iconic large and lively female bather was captured in a recumbent position (see page 114). The caption read "Coney Island Today, the Bathing Paradise of Billions—where fun is still on a gigantic scale," a quite daring choice for a magazine that hailed the virtues of being thin. Brodovitch and Snow, as the Model scholar Ann Thomas observed, "were unusual individuals," unafraid of risks. While *U.S. Camera* would publish two versions of the bather, reclining and upright, in its two consecutive issues, other magazines, like *Life*, would not touch them.[32] "My photographs were such a contradiction to the elegance of the magazine," Model once said, "that Brodovitch, the extravagant art director, put them in for that reason alone."[33] For a fashion magazine, *Harper's Bazaar* often published unexpected, progressive pieces, many of them illustrated with Model's photographs.

When Model's photographs of the blind first appeared, in 1944, the subject was rare (see page 121). Model would also illustrate Aldous Huxley's "A Note on Blindness" in *Harper's Bazaar* in 1951.[34] She worked on various pieces that encouraged greater awareness of others who were marginalized, as in "The Right to Beauty," about a "salon de beauté" established by a member of the New York City Police Athletic League for inner-city youth. The police officer Marguerite Browning Hult came up with the idea, believing that "a girl's early discovery of the possibilities for beauty in herself will develop self-respect."[35]

From her start in Nice, Model magnified her subjects' personalities or social caste. Though known for her caricatures, she approached photographic portraiture with a keen sense of objectivity and thought, and she chose carefully whom to exaggerate. Her many portraits of New York's social aristocracy were as sociological as they were artistic. "This obsession of hers," Thomas observed, "was to transform the concept of the heroic portrait in photography. Subjects normally excluded from portraiture, subjects from whom viewers would most often avert their gaze—the blind, fat, derelict, deformed, and aged—were portrayed without condescension or pity. Only faces that bore the marks of the experience of life attracted Model."[36] Her portrait of

Albert-Alberta at Hubert's Forty-Second Street Flea Circus, for example, is sympathetic, presenting her subject as a content and pleasing character (see page 115).

Among his generation of photographers, Parks expanded the political and aesthetic boundaries of photography, employing it to advance a new image of modern American society (see Maurice Berger essay, pages 86–99). A documentary and fashion photographer, writer, and film director, Parks overcame many challenges in his life with intelligence, sage counsel, and unflagging effort. He also relied on common sense. "I feel, sometimes," he said, "that I finally chose photography as a profession partly because it was something I could work at without white consent."[37]

Beginning with his work for the African American magazine *Ebony*, *Circuit's Smart Woman*, and *Glamour*, and later for *Life*, his images brought to light the effects of racial segregation in America. After documenting the poverty on Chicago's South Side he was hired by Roy Stryker to join the Farm Security Administration's project to record the nation's social conditions. There were other African American firsts for Parks: when he was hired by Liberman in 1947 as a fashion photographer at *Vogue*, and when he became staff photographer at *Life* in 1949, based on the significant public reception for his photo-essay "Harlem Gang Leader," which appeared in the magazine in November 1948. With his 1969 film adaptation of his semi-autobiographical novel *The Learning Tree* (1963), he became the first African American to direct a Hollywood feature film.

Parks was not the only one to adapt to the environmental, social, and psychological demands and compromises of fashion and advertising photography and still pursue personal, meaningful work; so did Saul Leiter and Louis Faurer. As a street photographer, Leiter introduced exquisitely calibrated color into black-and-white pictures of streetlights or urban snowscapes. He photographed his many portraits of women with intimacy, extended the street vernacular to include scenes of children, as in his series *Halloween*, and he even frequently painted his photographs. He did all this with a dose of humor, as in his original, fine-spun series *The Wedding as a Funeral*, in which he darkened his figures into graphically silhouetted forms, published in *Life* in 1951 (see pages 162–63).

Although many of his refracted images and his eccentric palette read cinematically, Leiter claimed not to be especially interested in film—unlike his friend Faurer, who was a cinephile.[38] Leiter loved painting, and his graphic and street photography dovetailed with his fashion work, which exhibited an uncanny discernment not only for the abstract texture of urban life but also for the Abstract Expressionist art being made at the time. In a conversation with the curator Lisa Hostetler, Leiter recalled that, in the late 1950s, he discussed his color photography at a talk for The Club (a group of artists who lived near Leiter on Tenth Street and gathered frequently to discuss postwar contemporary art). "His point was to demonstrate that abstraction was not invented by artists (a point that surprised many painters). Instead, it was something real and constantly accessible, as long as one has the capacity to see it."[39] Leiter was able to record with startling regularity black-and-white images whose lyricism was calligraphic, like musical notes on the page. "There are the things that are out in the open," he said, "and then there are the things that are hidden, and life has more to do, the real world has more to do with what is hidden, maybe. You think?"[40]

Ideas like Leiter's were beginning to percolate at *Harper's Bazaar* in the late 1940s and early 1950s. Given his distaste for repetition, Brodovitch had realized that the dynamism of his initial animated layouts from the late 1930s, now uncaged, had to be conveyed by the photographs. This concept was at the core of his teaching to Design Lab students, including David Attie, Lillian Bassman, and Paul Himmel.

A creative accident allowed Attie to generate the kind of images Brodovitch was asking for. According to Attie's son Eli, "One night, my father was developing film for his very first class assignment, when he realized he'd underexposed every single frame. Class was the next day. In other words, he was toast—and so was his new career. In a desperate panic, he started layering the negatives together, to create moody, impressionistic photomontages. His life must have been flashing before his eyes, and at the wrong exposure. Brodovitch loved the montages. He spent the entire class gushing over them."[41] Attie continued to use this technique, which provided a perfect complement to textual narrative, with its multiple imaging and varied emotionalism. In 1958, Brodovitch and Truman Capote gave the photographer his first assignment:

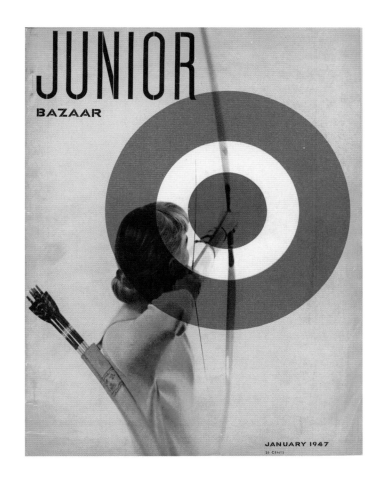

↑ Cover of *Junior Bazaar*, January 1947, photograph by Ernst Beadle, art direction by Alexey Brodovitch and Lillian Bassman

↓ Cover of *Junior Bazaar*, June 1947, photograph by Ronny Jaques, art direction by Alexey Brodovitch and Lillian Bassman

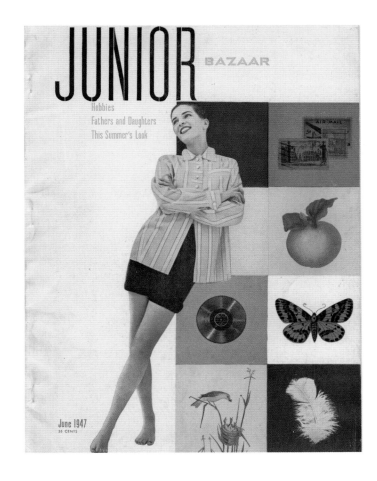

Klein

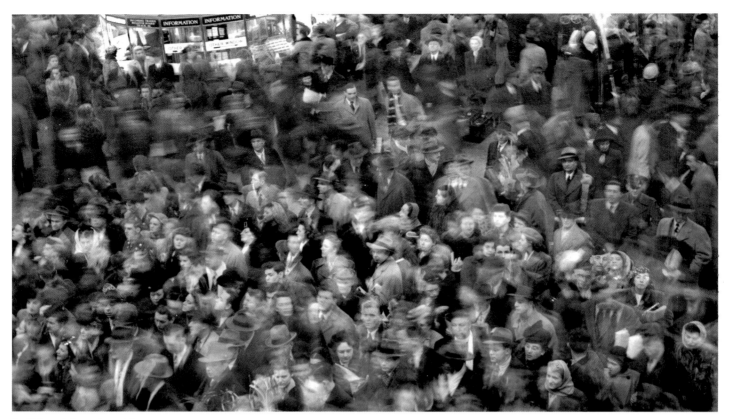

Paul Himmel, *Grand Central Station,*
New York, 1947, gelatin silver print

illustrating Capote's "Breakfast at Tiffany's" for
Harper's Bazaar. After Attie had created a series of
montages, which everyone liked, Capote got into
a wrangle with the editors and ultimately refused
to submit to Hearst, who had found the novella
"unsuitable" for the magazine and one of its major
advertisers, Tiffany and Co. When Capote chose
to publish it in *Esquire*, he specified in the contract
that he "would not be interested if [*Esquire*] did
not use Attie's [original series of] photographs."[42]

A few years later, Brodovitch was asked to design
Bill Manville's *Saloon Society: The Diary of a Year
Beyond Aspirin*, about the excesses of Greenwich
Village's Beat-era bar life. Brodovitch again
chose to use Attie's hazy, atmospheric composi-
tions, which spoke perfectly to the period's
rippling night life, "whose members," as written on
the book jacket, "live in a world where there is
no tomorrow, where the jugs of bourbon pour like

sunshine, where the cigarette smoke is as thick as
dreams, where one rockets through the heightened
moments of life." Attie's multiple narratives, as well
as Manville's text, reflect the increasing influence
of the layering of graphic art and its nonlinearity on
everything from Robert Rauschenberg's *Combines*
to 1950s television (see pages 154–55).

The ambitious Bassman became Brodovitch's first
official assistant in 1941, and she was soon design-
ing her own magazine, *Junior Bazaar*. Although
Brodovitch is usually credited as its sole creator,
it was largely Bassman who designed the mag-
azine. Few photographers pushed the boundary
between art and fashion further than she. From the
beginning, when Brodovitch saw her sketches and
offered her a scholarship for his Design Lab course,
he aimed to cultivate her native sensibility, as he did
with her husband, Himmel, also an artist and fash-
ion photographer. In many ways Himmel's work lent

Modern Look

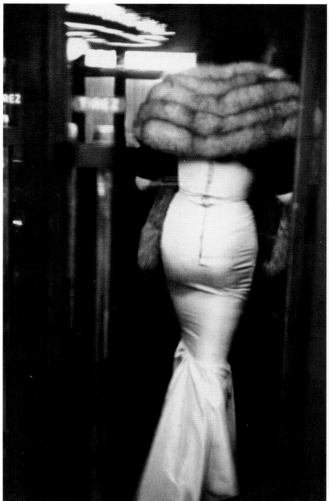

↑ Robert Frank, *Woman/Paris*, 1952, from his book *Black White and Things*, 1952. Gelatin silver print

↗ Robert Frank, *Tickertape/ New York* City, 1951, from his book *Black White and Things*, 1952. Gelatin silver print

itself more to Brodovitch's photographic sensibility and interest in the blur of movement, and in 1954 he even produced his own book on ballet. As he experimented in his nude studies, isolating a model within a crowd of dashing commuters in Grand Central Station, Himmel's figures became increasingly attenuated, almost abstract, assuming an otherworldliness. Himmel's style paralleled his wife's photographic work for Brodovitch, which began while she was still art director of *Junior Bazaar*. In her series for the March 1946 issue, "It Looks Like Spring," Bassman laid out a series of dancing models photographed by Leslie Gill, whose surreal, grayish, and dreamlike character was accentuated by the introduction of linear and geometric forms of pastel primary colors (see page 141).

This move toward abstracting fashion, by reducing its presence on the page as product in order to privilege graphic art, was essentially subversive;

in a series of evanescent images of models, their ghostly presence is only somewhat aided by a stroke of yellow (swaths of color would become a signature design element of Brodovitch). These graphically stunning pictures appeared in the March 1950 issue of *Harper's Bazaar*, and on one of the tear sheets Bassman had given to Brodovitch, he wrote in the margin, "this is dangerous."

While Liberman's *Vogue* was glorifying fashion and the New York art world's assumption of power, Bassman at *Harper's Bazaar* succeeded in joining the two in a daring diminution of fashion in favor of art. Such provocative challenges to the material culture of fashion would continue into the 1950s: the face on the July 1956 cover, though reminiscent of Bassman's graphic photographs, appears no more than rudimentarily drawn and overlaid with swaths of color and just some scrapes of ink to suggest textured fabric (see page 140).

Klein

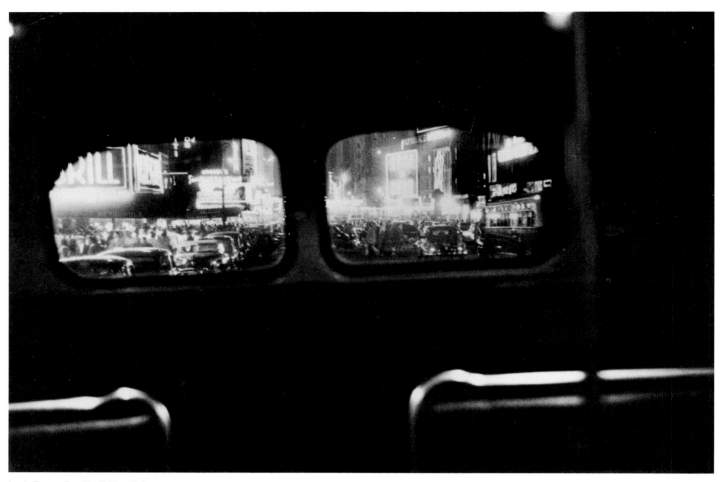

Louis Faurer, *Bus No. 7, New York,
N.Y.*, 1950, gelatin silver print

Faurer, like many photographers of his generation, started out in magazines, but photojournalism did not interest him. As the photography dealer Deborah Bell, who knew Faurer well, has remarked, "He was not a chronicler, but wanted to connect people to states of mind."[43] His interest in film and the cinematic is evident in his often inadvertent use of double- or overexposure, or in the rare nude studies in his work. His gift was not in illustrating a story but in capturing fleeting and potent images of psychological import, as in a deaf couple standing on the street, the woman's slightly quizzical expression echoed silently by random reflected splotches of light that eerily connect the pair (see page 112). Many of Faurer's photographs allude to the human condition, not without a touch of wryness, as with a group of expressionless women apparently waiting for a bus, in front of a poster of a woman on the phone, which reads, "That night, I spent my last nickel to call Steve . . . [to say] that I was going to have a baby. He hung up without saying goodbye!" (see pages 106–7). After 1950, Faurer began to do more work for magazines, specifically *Flair*. The

expensive, short-lived cultural magazine assigned him mainly to fashion shoots, but it did publish a number of his poetic, collagelike images.

The coexisting poles of commerce and art were unmanageable for many photographers, for no one more so than Robert Frank. When he first arrived in New York in 1947, after a short spell in Paris, he sought out Brodovitch, presenting him with a portfolio: a handmade, spiral-bound book, *40 Fotos*, typical of the kind made in Europe. The book was proof that the young Swiss photographer knew his craft and could handle an assignment. Brodovitch immediately recognized that Frank, who had been raised in an educated, bourgeois, Jewish home, had been technically well schooled. He hired him on the spot, though Frank left the magazine within six months.

In Switzerland, Michael Wolgensinger, a reputable commercial photographer who worked with graphic designers, had taught Frank how to edit and group photos by subject. Such training provided Frank with the practical and the critical facility to

discern how and why a photograph had meaning for him. Wolgensinger also introduced Frank to the book-publishing industry and to photo books in general. He learned about photo pairings and narrative sequencing from books like *Factory: A Pictorial Epic of Technology* by the Swiss photographer and filmmaker Jakob Tuggener, who was adept at creating dramatically juxtaposed spreads. "Tuggener," writes the curator Sarah Greenough, "sought to draw out an intellectual and emotional response from his viewers, so that they would not merely read his photographs but, as he wrote, 'experience them.'"[44] Frank's *40 Fotos* derives from those revelatory images that he had absorbed from Tuggener (see pages 104–5). The latter influenced him "enormously," Frank has acknowledged, not least in the cinematic manner in which he addressed his photographs. Indeed, as he later recollected, "without really understanding it, I grasped his point of view. He was like a beacon that warned of the risk of shielding my vision."[45]

Frank is often seen as challenging both the formalism and content in so-called art photography. Rather than celebrating the clarity of the decisive moment, with its obvious narrative content, Frank expressed the ambiguity that informed perception. His photography, then, far from being dedicated to the evidentiary purpose of documentary work, reveals nothing more than his own idiosyncratic observations.

Frank's unusually methodical training as a photographer allowed him to understand the importance of the graphic arts to the medium's visual organization, refining his eye in accordance with certain design criteria—the direction of the gaze, the figures' orientation in space. He would then crop and sequence his photographs, laying them out as carefully as any art director. Through the editing of the images and in his discipline in creating his books, Frank learned how to refine the dismantling of linear narrative. But he was also critiquing objectivity—even, in fact, the reliability of subjectivity, of truth and memory. He ushered in a new mode of experiential, perceptual work.

For his second handmade book, *Black White and Things*, Frank included a prefatory quote by the French writer and poet Antoine Saint-Exupéry: "It is only with the heart that one can see rightly; what is essential is invisible to the eye." Here, Frank expressed his desire to further develop a formal and

conceptual synthesis in his work, one that would require little to no textual explanation.[46] His photographs had to speak for themselves. Like poems, they required the viewer to engage and interpret the work. "Something must be left of the onlooker," Frank said. "He must have something to see. It is not all said for him."[47] This lack of contextualization was deliberate, as was evident in Frank's decision to title his works according to their geographic location, giving the viewer greater subjective latitude.

While he wanted to do more than make artful or interesting pictures, Frank began to doubt that the "decisive moment" was enough, and he became critical, in this sense, of Cartier-Bresson, about whom he said, "You never felt he was moved by something that was happening other than the beauty of it, or just the composition."[48] Instead of a "decisive moment," for Frank, there was the "perceptual moment," a precise distillation of the photograph through graphic cropping to highlight a more compelling observation.

Frank's struggle against sentimentality had little to do with emotion itself. He could not tolerate the complacency of such work, in that it presented the viewer with something expected rather than with an image that challenged one to reflect and, possibly, to reconsider the subject. His photograph *From the Bus, New York* (1958), for example, is straightforward and affecting (see page 111). A young child stands between his mother and slightly older brother, each of whom is holding one of his hands. Frank realized that the picture's strength lay not simply in its candid naturalness. It was not only this that challenged the status quo. Given its positive representation of African American familial responsibility, it was not the kind of picture that would have been easily published at the time. And Frank's work was clearly not what the editors of *Life* wanted, even when he produced a photo-essay, "People You Don't See," in *Life* in 1951. Henry Luce, *Life*'s publisher, favored linear, neatly partisan narratives, and his magazine repeatedly rejected Frank's work, as the photographs were too likely to intimate that life was problematic. "I leave it up to you," Frank said about his photographs. "They don't have an end or a beginning. They're a piece of the middle."[49]

In 1967, when the Museum of Modern Art mounted its *New Documents* exhibition, the curator John Szarkowski wrote: "In the past decade, a new

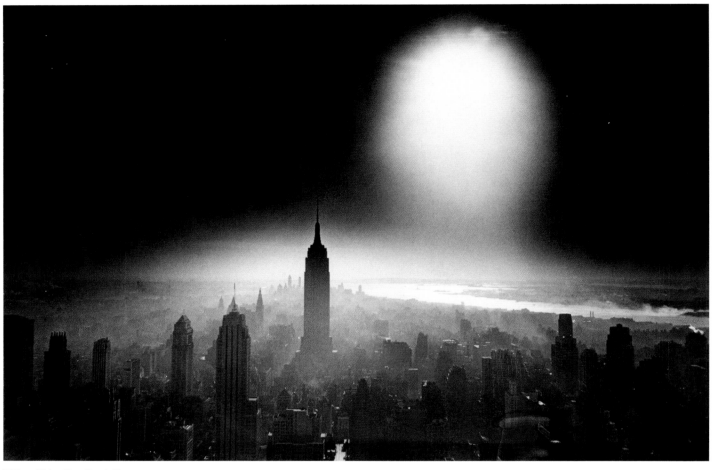

William Klein, *Atom Bomb Sky,*
New York, 1955, gelatin silver print

generation of photographers has directed the documentary approach toward more personal ends. Their aim has been not to reform life, but to know it."[50] The assertion of an artist's identity, proffering the photographic image as experiential and as complex as perception itself, had become critical. It was ironic that, in 1951, when the Photo League was on the brink of redefining itself, it was closed down by the red-baiting forces of McCarthyism. The first show was to be the work of Frank and Leiter, two willful and obstinate figures whose similarly distinctive styles at the time were complementary. Both men would go on to develop in different ways, yet both would, oddly, become relative outliers. It was at this juncture, though, that they were both still quintessentially poetic photographers. Leiter would adopt a life of zenlike indifference and independence; and Frank, driven by different ambitions, would go out and look at America as no one ever had. "I went away from my early lyrical images because it wasn't enough anymore," Frank later explained. "I had used up the single, beautiful image. I was aware I was living in a different world—that the world wasn't as

good as that—that it was myth that the sky was blue and that all photographs were beautiful."[51]

Frank's undeclared reclamation of the power of the photograph to express its meaning without words would seem to reverse the terms set forth by those Bauhaus idealists who believed that the integration of image and text allowed photography to realize its fullest expressive power. The Saint-Exupéry quote above, however, suggests that this insight enabled Frank to refine a nonnarrative, sequential frame for photographic expression that would function as an objective record of reality and as an expression of the artist's intention.

William Klein took this direction even further in terms of experimentation and graphics. An aspiring painter who began his training in Paris after the war, Klein briefly studied at the studio of Fernand Léger. In 1952, Klein received a commission to paint murals on a series of turning panels, and while documenting them photographically he realized that he had discovered a new, vibrant vocabulary of

Modern Look

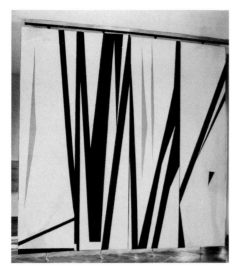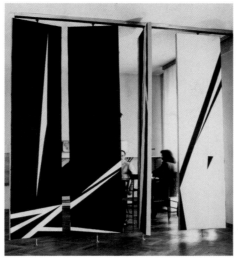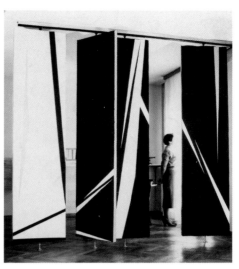

William Klein, *Painted Turning Panels, Milan*, 1952–53, gelatin silver prints

"Mondrian Real-Life: Zeeland Farms," *Vogue*, April 1954, pages 134–35, photographs by William Klein

Klein

graphic abstraction that could be achieved in either medium. When these panels and photographs were exhibited in Paris, in 1953, they impressed Liberman, who hired Klein to work for *Vogue* and agreed to underwrite a photo book on New York. At *Vogue*, while looking through some of Klein's work, Liberman saw photographs of barns that Klein had discovered in the Netherlands, and he decided to publish them. The photographs in "Mondrian Real-Life: Zeeland Farms" were not only reminiscent of Mondrian's linear structure, but, as Klein had learned, the Dutch painter had lived there during World War I. In their exemplary graphic style, these early Klein photos were soon accompanied by an exploration of both abstract photography and his own brand of street/fashion photography, which, in combination with his continued pursuit of painting, and then film, would contribute to his decades-long quest to mix genres and media. Introducing wide-angle and long-focal-length lenses, and employing dramatic motion blur, flash, and multiple exposure, Klein reveled in the rapidly changing mass-media assault of contemporary life, which he felt keenly upon returning to New York after eight years in Paris. His book on New York, however, proved too challenging for the likes of *Vogue*. As Szarkowski commented in 1980, Klein's early photographs were "perhaps the most uncompromising of their time. His pictures weren't that easy to like when they were new."[52] It was a telling moment, when magazine editors were unwilling to support what some felt unpalatable for the well-mannered magazines.

Support was changing in other ways. Throughout the 1940s photographers were able to use *Vogue*'s photography studios for their commercial work, but in 1950 the company ended that practice, citing the "enormous cost of [this] experimental work" to the magazine, whose "resources and generosity were strained."[53] Even those for whom success was well established—like Matter or Penn—and whose diverse, edgy design was equally acknowledged, found that the "experimental" nature of their work had tested clients' expectations. As Penn recalled, when he learned his number of fashion pages had been reduced, it was because his editors had found them "too severe."[54]

As the 1950s progressed, the quality and nature of collaborative innovation began to wane, with certain major exceptions, such as the "Great Ideas of Western Man" advertising campaign.

With decreasing profit margins and rising costs, increased competition with television for advertising revenues, and a more complacent readership, mass media was changing, and magazines were less willing to take risks. They would ripple with the occasional vanguard piece, such as *Vogue*'s "New Photo-Graphic Eye: William Klein" in 1954, but the quivering blur of his *Candy Store, Amsterdam Avenue*, 1955, was already imbued with the buffeting energy of the postwar economic boom and the proto-Pop cultural insurgency of the 1960s.

Notes

Epigraph. Lajos Kassák as quoted in *Émigré Cultures in Design and Architecture*, ed. Alison J. Clarke and Elana Shapira (New York: Bloomsbury Academic, 2017), 175. See also Kassák, "Bildarchitekture (Picture Architecture)" (1922), in *Between Worlds: A Sourcebook of Central European Avant-Gardes, 1910–1930*, trans. George Cushing (Cambridge, MA: MIT Press, 2002), 430.

1
György Kepes, *Language of Vision* (Chicago: Paul Theobald, 1969), 221.

2
Friedrich Matthies-Masuren, "Zur Werkbundausstellung 'Film und Foto' in Stuttgart," *Chronik—Berlin, 11 June 1929, Photographische*, as quoted in Bruce Altshuler, *Salon to Biennial: Exhibitions That Made Art History*, vol. 1: *1863–1959* (New York: Phaidon, 2008), 230.

3
Ringl + Pit were the childhood names of Grete Stern and Ellen Auerbach, respectively. The women knew to choose a name that was both gender- and ethnicity-neutral.

4
As quoted in Jennifer Good and Paul Lowe, *Understanding Photojournalism* (New York: Bloomsbury Academic, 2017), 30.

5
Peter C. Bunnell, *Edward Weston on Photography* (Salt Lake City: P. Smith, 1983), 55.

6
For more on Weston and the 1920s, see Beth Gates Warren, "Edward Weston and His German Connections," in *Object: Photo. Modern Photographs: The Thomas Walther Collection, 1909–1949*, ed. Mitra Abbaspour, Lee Ann Daffner, and Maria Morris Hamburg, 2014, an online project of the Museum of Modern Art, New York, https://moma.org/interactives/objectphoto/assets/essays/Warren.pdf.

7
Weston J. Naef, *The Collection of Alfred Stieglitz: Fifty Pioneers of Modern Photography* (New York: Viking, 1978), 441–42.

8
Edward Weston, *The Daybooks*, vol. 1, April 20, 1923 (New York: Aperture, 1973), 9.

9
The phrase in German, "Wohin geht die fotografische Entwicklung?" has generally been translated as "Where is photographic development going?" I have loosely translated the wording to emphasize a more positive belief in the medium's useful future, which I believe Moholy-Nagy was implying.

10
László Moholy-Nagy, *Malerei, Photographie, Film* (Munich: Langen, 1925).

11
Melanie Abrams, Review of *Vu: The Story of a Magazine*, by Michel Frizot and Cédric de Veigy, *Jewish Chronicle*, November 19, 2009.

12
As quoted in Owen Edwards, "Edward Steichen: In *Vogue*," in *Smithsonian Magazine* (May 2009).

13
Steven Heller and Greg D'Onofrio, *The Moderns: Midcentury American Graphic Design* (New York: Abrams, 2017), 276.

14
For more on Beall, see R. Roger Remington, *Lester Beall: Trailblazer of American Graphic Design* (New York: Norton, 1996), 23.

15
R. Roger Remington and Barbara J. Hodik, *Nine Pioneers in American Graphic Design* (Cambridge, MA: MIT Press), 154.

16
Grace Glueck, "Herbert Bayer, 85, a Designer and Artist of the

Bauhaus School," *New York Times*, October 1, 1985.

17
Kerry William Purcell, *Alexey Brodovitch* (London: Phaidon, 2002), 132. Brodovitch's Design Lab went through several stages of growth. Begun in Philadelphia, in 1933, it would move to the New School in New York, and, later, classes would be held in Richard Avedon's studio.

18
As quoted in ibid., 132.

19
The magazine was intended to be quarterly. Andy Grundberg, *Brodovitch* (New York: Abrams, 1989), 107. Quote from Remington and Hodik, *Nine Pioneers*, 44.

20
As quoted in Purcell, *Alexey Brodovitch*, 218–19.

21
Ibid., 229.

22
Swiss-born Herbert Matter, who had received international acclaim for his innovative use of photomontage for the Swiss National Tourist Office, immigrated to the United States in 1936. He was hired by Alexey Brodovitch at *Harper's Bazaar*, and then at *Vogue* and *Fortune*. From 1946 to 1966 he was design consultant for Knoll Associates, working closely with Charles and Ray Eames, and from 1952 to 1976 he taught photography at Yale University.

23
Harper's Bazaar (September 1943).

24
Scher's "appropriation" of Matter's famous series of Swiss National Tourist Office posters for the watch company caused some controversy in 1985.

25
Lucy Sisman, "Alexander Liberman," *Guardian*, https://theguardian.com/news/1999/dec/07/guardianobituaries1.

26
As quoted in Martin Harrison, *Appearances: Fashion Photography Since 1945* (New York: Rizzoli, 1991), 46.

27
For Liberman quote, see *Bomb*, July 1986, https://bombmagazine.org/articles/alexander-liberman/.

28
Lucy Sisman, "Being Modern: Alexander Liberman," http://vestoj.com/being-modern-alexander-liberman/#fn4-5537.

29
As quoted in ibid. Polly Devlin, introduction to *Vogue Book of Fashion Photography, 1919–1979* (New York: Simon and Schuster, 1979).

30
Harrison, *Appearances*, 74.

31
Max Kozloff, *New York: Capital of Photography* (New Haven: Yale University Press, 2002), 45.

32
Ann Thomas, *Lisette Model* (Ottawa: National Gallery of Canada, 1990), 95. *U.S. Camera* published the recumbent version in October 1942 and the standing one the following year. Ibid.

33
John Flatteau, Ralph Gibson, and Arne Lewis, eds., *Darkroom II* (New York: Lustrum, 1978), 68.

34
Aldous Huxley, "A Note on Blindness," *Harper's Bazaar* (July 1951): 56.

35
"The Right to Beauty," *Harper's Bazaar* (October 1944): 94.

36
Thomas, *Lisette Model*, 167.

37
In what was the first significant profile on Parks, "The Long Search for Pride," *Weekend Telegraph* (September 25, 1964), as quoted in Gordon Parks, *Gordon Parks: The New Tide, Early Work, 1940–1950*, ed. Philip Brookman (Göttingen: Steidl, 2018), 83.

38
Jane Livingston, *The New York School: Photographs, 1936–1953* (New York: Stewart, Tabori and Chang, 1992), 323.

39
Leiter in a telephone interview with Hostetler; as quoted in Lisa Hostetler, *Street Seen: The Psychological Gesture in American Photography, 1940–1959* (Milwaukee: Milwaukee Art Museum and Prestel, 2009), 112.

40
"Postscript: Saul Leiter (1923–2013)," *New Yorker*, November 27, 2013.

41
Eli Attie, *Brooklyn: A Personal Memoir* (New York: Little Bookroom, 2015), 101.

42
Truman Capote papers, Hargrett Rare Book and Manuscript Library, University of Georgia Libraries, box 1, folder 5.

43
As quoted in Anne Wilkes Tucker, *Louis Faurer* (London: Merrell, 2002), 27.

44
Sarah Greenough et al., *Looking In: Robert Frank's The Americans* (Washington, DC: National Gallery of Art), 12.

45
Frank interviewed by Michel Guerin in "Robert Frank raconte sa passion pour Tuggener et 'le miracle Suisse.'" As quoted in Greenough et al., *Looking In*, 13.

46
Sarah Greenough and Philip Brookman, *Robert Frank: Moving Out* (Washington, DC: National Gallery of Art, 1995), 106.

47
As quoted in Edna Bennett, "Black and White Are the Colors of Robert Frank," *Aperture* 9, no. 1 (1961): 22.

48
Eugenia Parry Janis and Wendy MacNeil, eds., *Photography Within the Humanities* (Danbury, NH: Addison, 1977), 56.

49
Nicholas Dawidoff, "The Man Who Saw America," *New York Times*, July 2, 2015.

50
John Szarkowski, wall label for the exhibition *New Documents*, Department of Photography files, Museum of Modern Art, New York, 1967.

51
As quoted in Greenough et al., *Looking In*, 33, and see n. 128. "By 1954, Frank had already thought about making films." Byron Dobell, "The Photographer as Poet," in "Featured Pictures: Robert Frank—The Photographer as Poet," *U.S. Camera* 17, no. 9 (September 1954): 77–84.

52
As quoted in Clément Chéroux, *Henri Cartier-Bresson* (New York: Abrams, 2008), 97.

53
See Maria Morris Hambourg and Jeff Rosenheim, *Irving Penn: Centennial* (New Haven: Yale University Press, 2017), 324. Penn stayed on; on who stayed and who left, see p. 355 n. 2.

54
Ibid., 324.

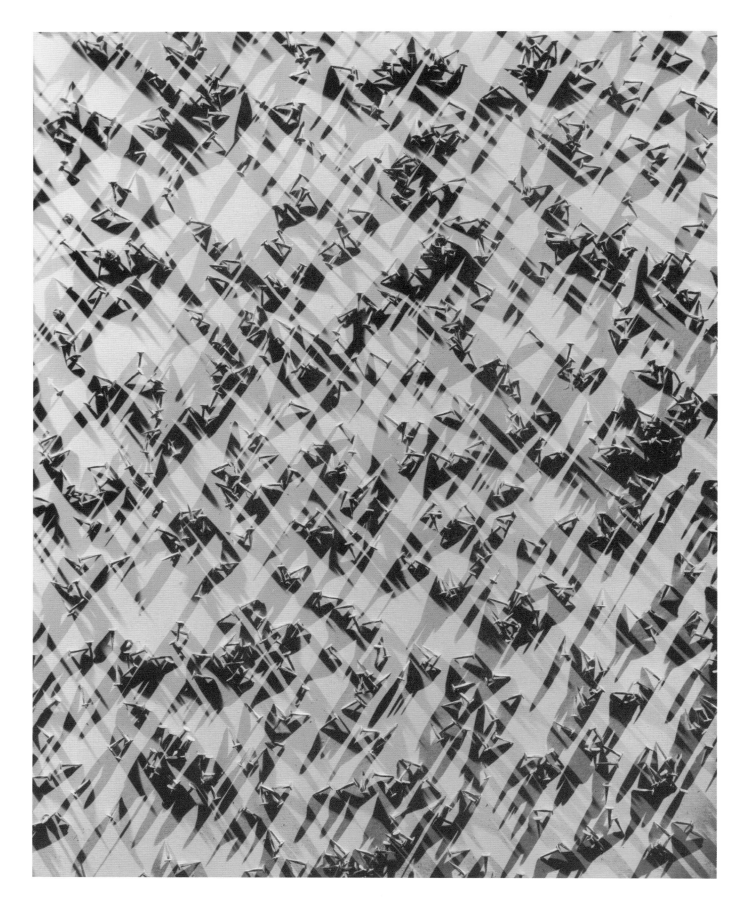

↑ Edward Steichen, *Tacks (Fabric Design for Stehli Silk)*, 1926, gelatin silver print

→ Edward Steichen, *Matches and Matchboxes (Fabric Design for Stehli Silk)*, 1926, gelatin silver print

57

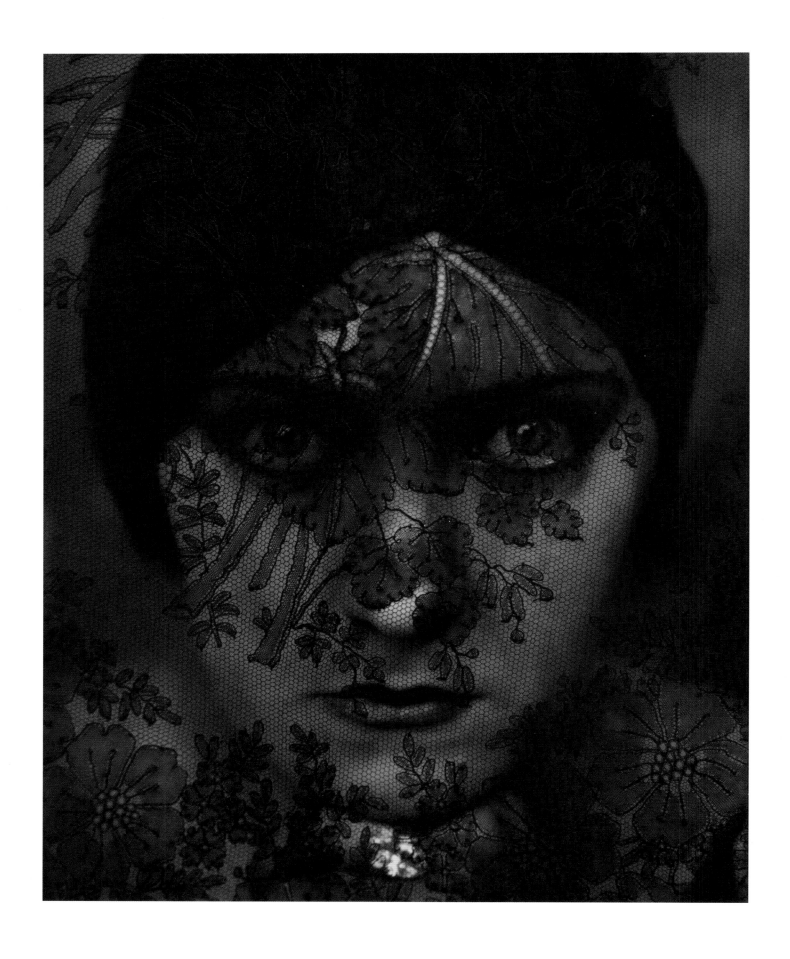

Edward Steichen, *Gloria Swanson,
New York*, 1924, gelatin silver print

58

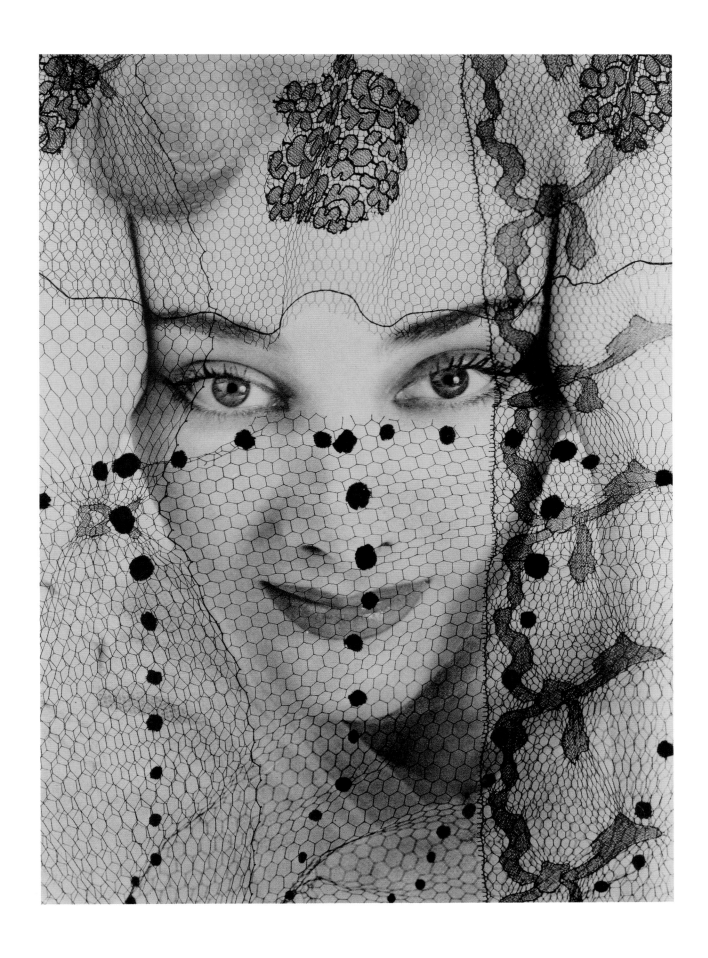

Erwin Blumenfeld, *Voilettes de
Montezin*, 1938, gelatin silver print

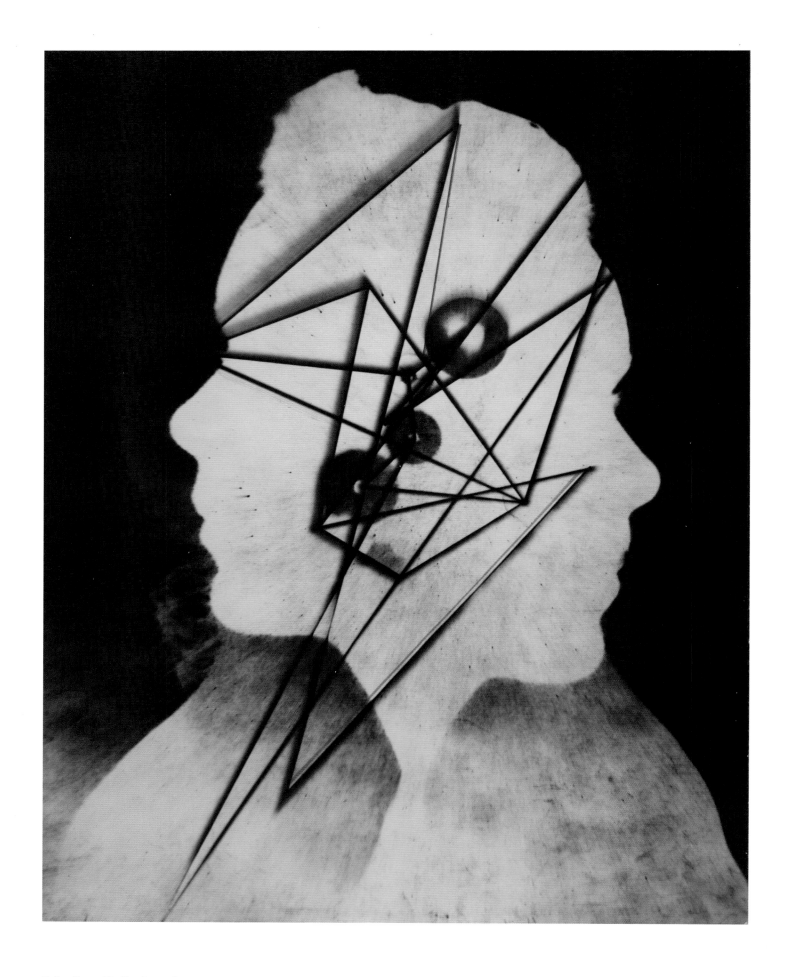

György Kepes, *The Two Faces of Juliet*, c. 1938, gelatin silver print with gouache

Ringl + Pit (Grete Stern and
Ellen Auerbach), *Komol Haircoloring*,
c. 1932, gelatin silver print

↑ Herbert Matter, *Fabric in Circular
Motion*, 1948, gelatin silver print

↗ Herbert Matter, *White Pins on
Black Background*, undated photo-
gram, gelatin silver print

62

↑ Herbert Matter, *Loaf of Bread*,
undated, gelatin silver print

↗ Herbert Matter, *Abstract
Overlay of Harry Bertoia; Chairs*,
undated, gelatin silver print

63

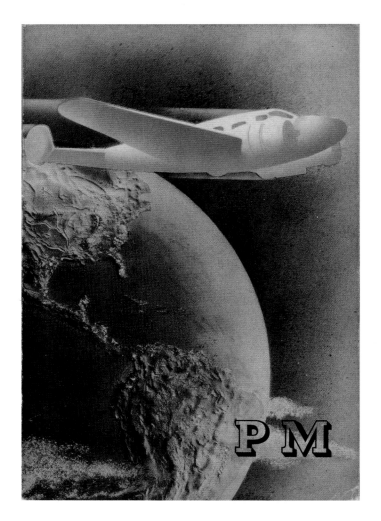

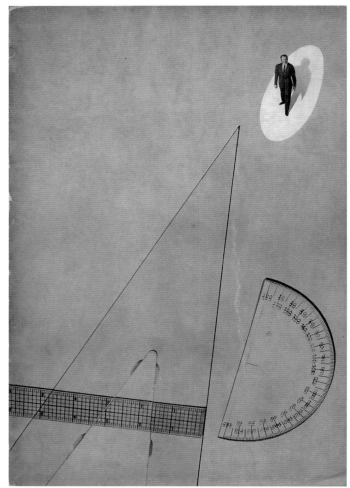

Paul Rand

P/M

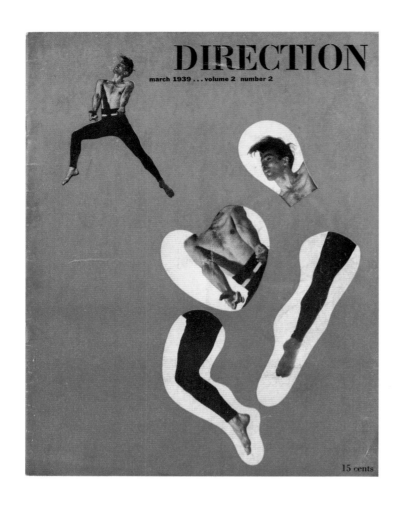

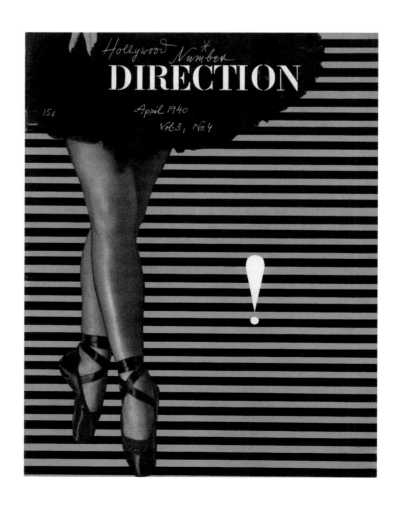

↑ Cover of *Direction*, March 1939,
designed by Paul Rand

→ Cover of *Direction*, April 1940,
designed by Paul Rand

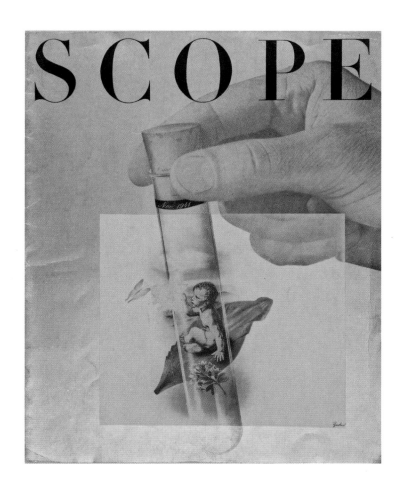

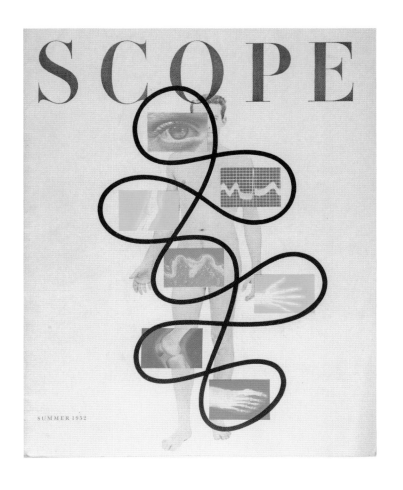

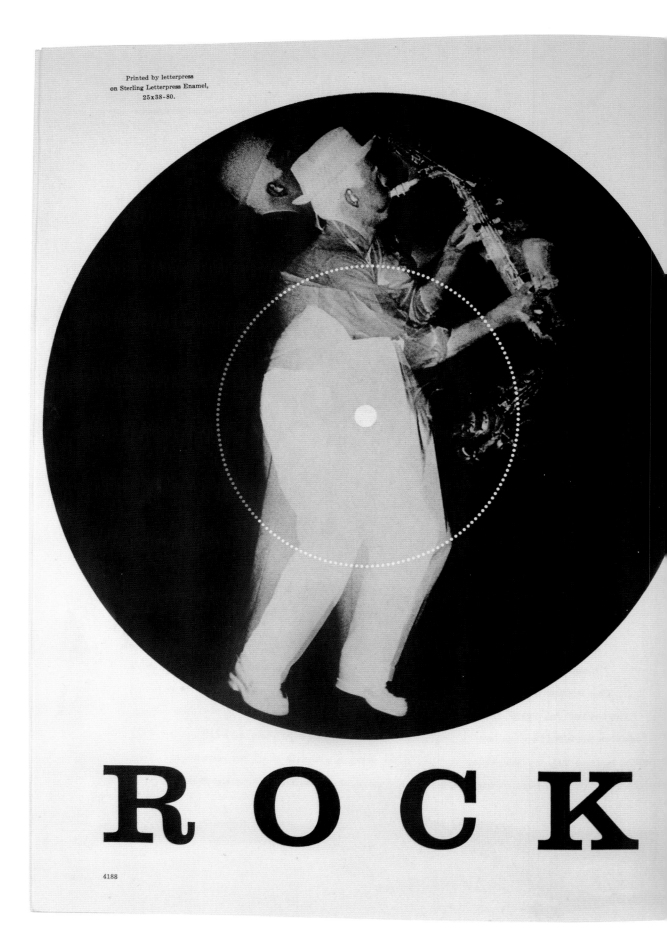

Printed by letterpress
on Sterling Letterpress Enamel,
25x38-80.

ROCK

4188

Westvaco Inspirations for Printers, no. 210, 1958, photograph by Rollie Guild, designed by Bradbury Thompson

Photograph: Rollie Guild.
Engraving: Halftone, 120 line screen,
printed in three colors of ink.

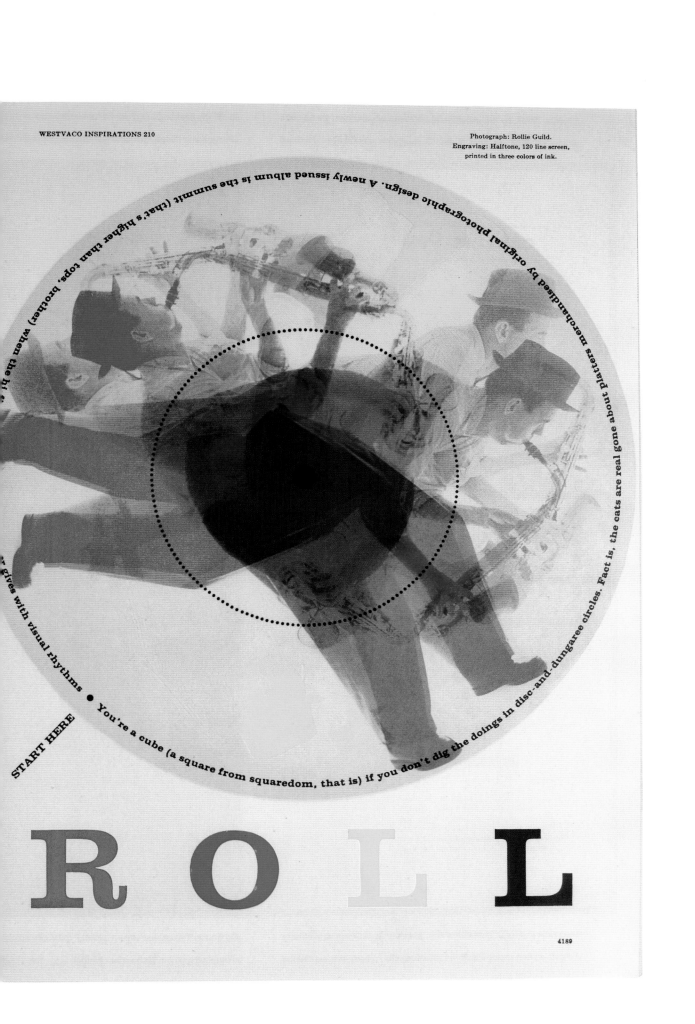

START HERE • You're a cube (a square from squaredom, that is) if you don't dig the doings in disc-and-dungaree circles. Fact is, the cats are real gone about platters merchandised by original photographic design. A newly issued album is the summit (that's higher than tops, brother) when the hit gives with visual rhythms

ROLL

4189

69

↑ Josef Breitenbach, *For Ever and Ever*, 1938, gelatin silver print with hand-coloring

→ Josef Breitenbach, *We New Yorkers*, 1942, gelatin silver print with collage

Cover of Alexey Brodovitch's book
Ballet, New York, 1945, with his
photographs and design

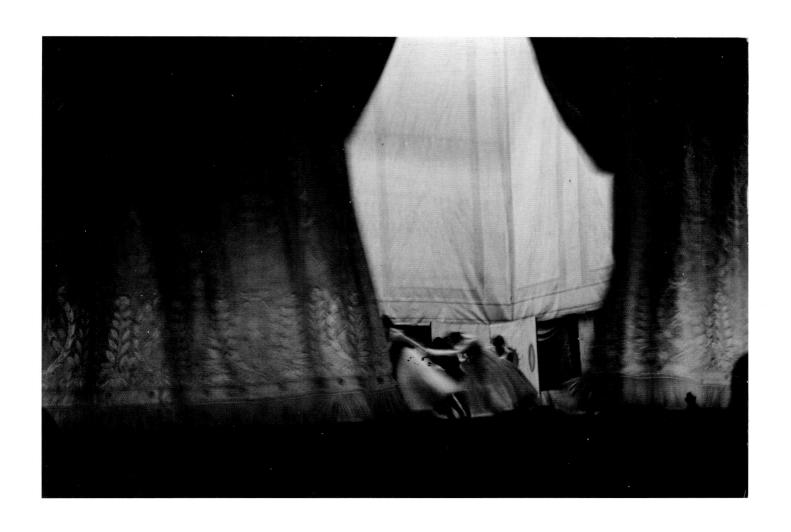

Alexey Brodovitch, *Cotillion*,
1935–37, from his book *Ballet*,
New York, 1945, page 138

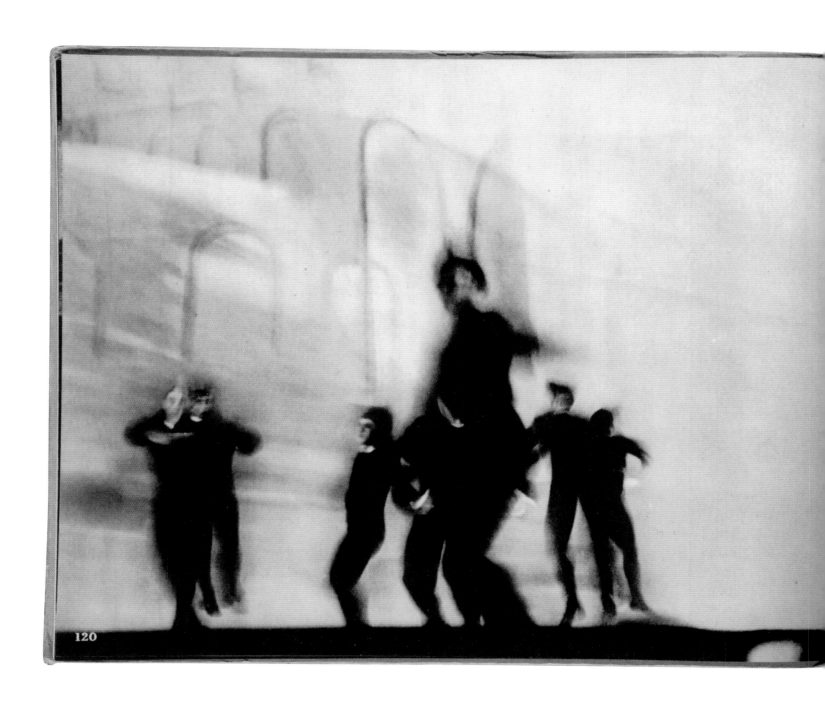

Alexey Brodovitch, *Choreartium*,
1935–37, from his book *Ballet*,
New York, 1945, pages 120–21

74

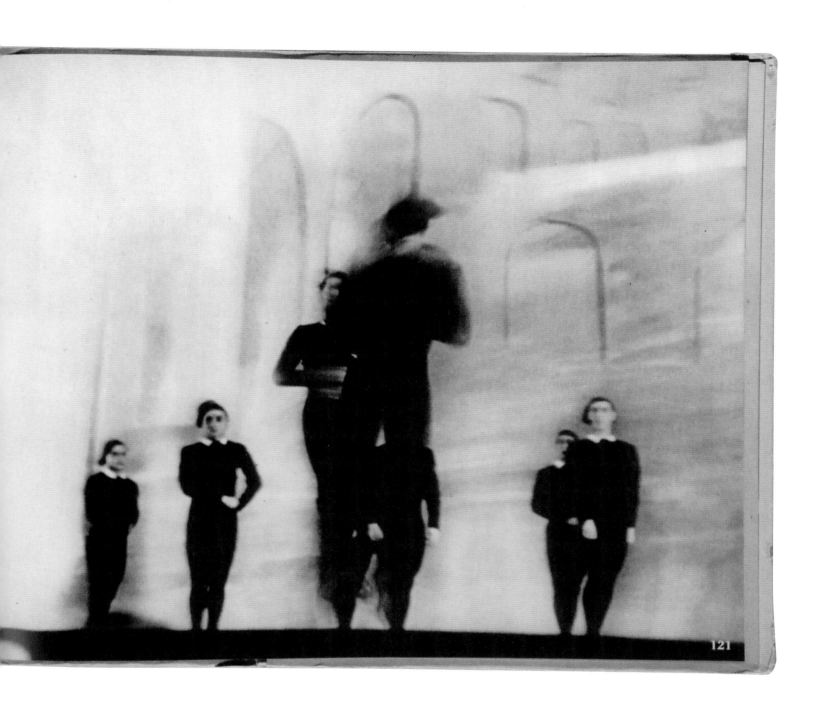

121

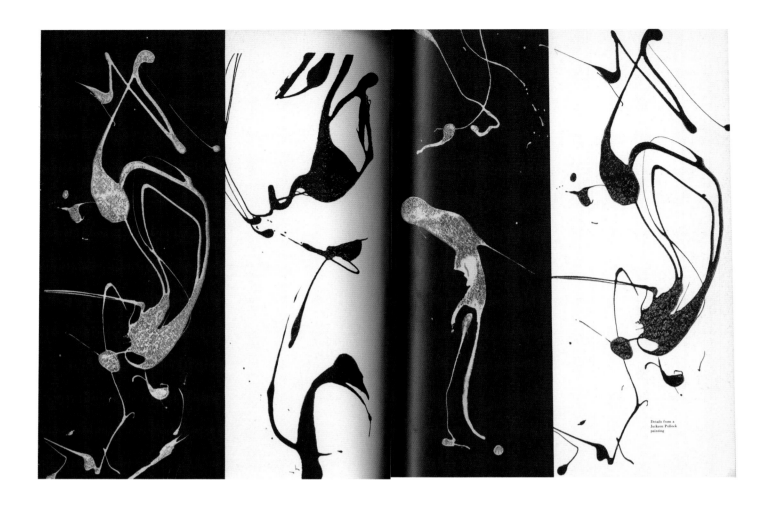

↑ Details of a drip painting by Jackson Pollock, from *Portfolio* 3, Spring 1951, designed by Alexey Brodovitch

→ Alexey Brodovitch's book *Observations*, New York, 1959, pages 118–19, text by Truman Capote, photographs by Richard Avedon, designed by Alexey Brodovitch

"Cattlebrands," *Portfolio* 2, Summer
1950, designed by Alexey Brodovitch

↑ Cover of *Vogue*, January 1950,
photograph by Erwin Blumenfeld,
art direction by Alexander Liberman

↗ Cover of *Vogue*, May 1949,
photograph by Erwin Blumenfeld,
art direction by Alexander Liberman

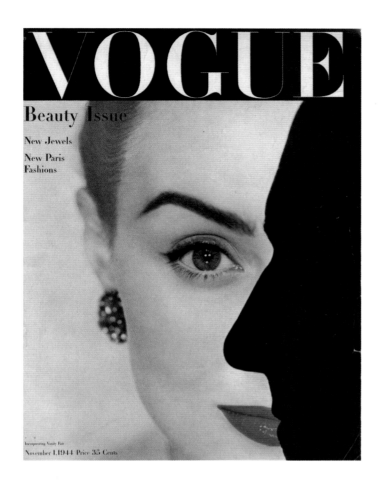

↑ Cover of *Vogue*, November
1944, photograph by Erwin
Blumenfeld, art direction by
Alexander Liberman

↗ Cover of *Vogue*, March 1945,
photograph by Erwin Blumenfeld,
art direction by Alexander Liberman

↖ Cover of *Vogue*, November 1949, photograph by Irving Penn, art direction by Alexander Liberman

← Cover of *Vogue*, June 1950, photograph by Irving Penn, art direction by Alexander Liberman

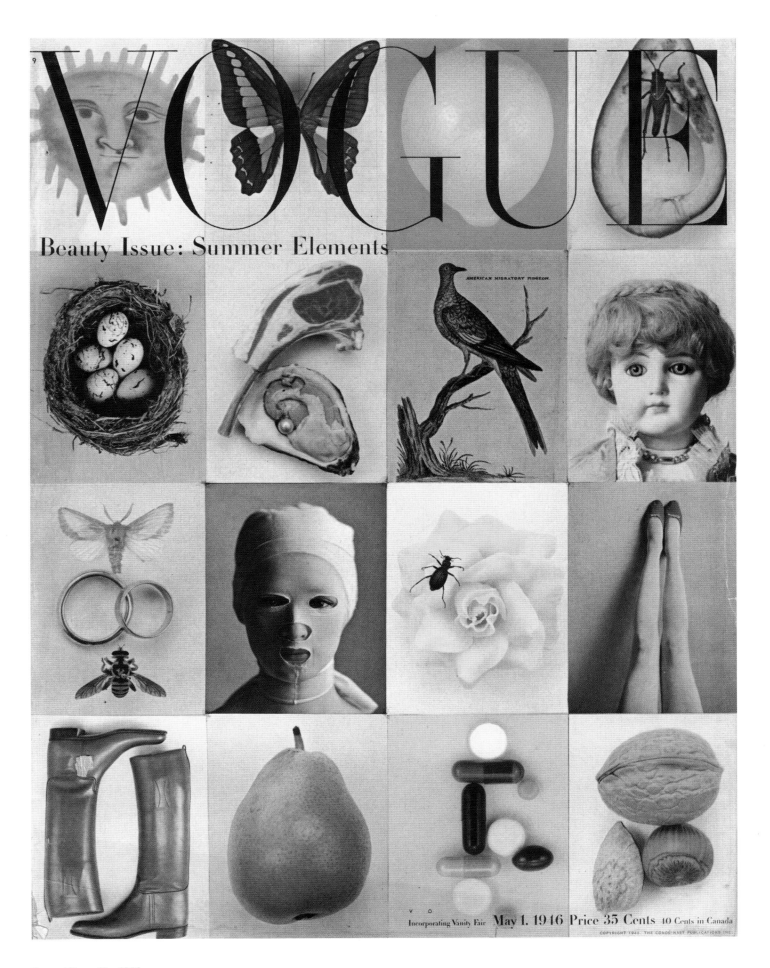

Cover of *Vogue*, May 1946,
photographs by Irving Penn,
art direction by Alexander Liberman

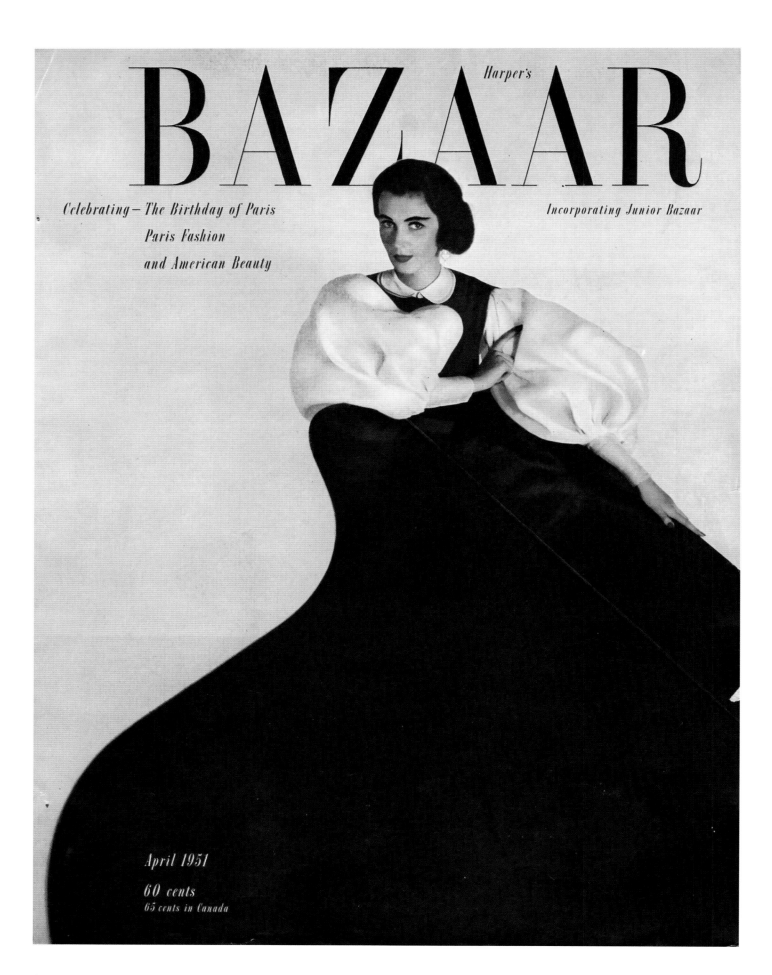

Cover of *Harper's Bazaar*, April 1951,
photograph by Richard Avedon,
art direction by Alexey Brodovitch

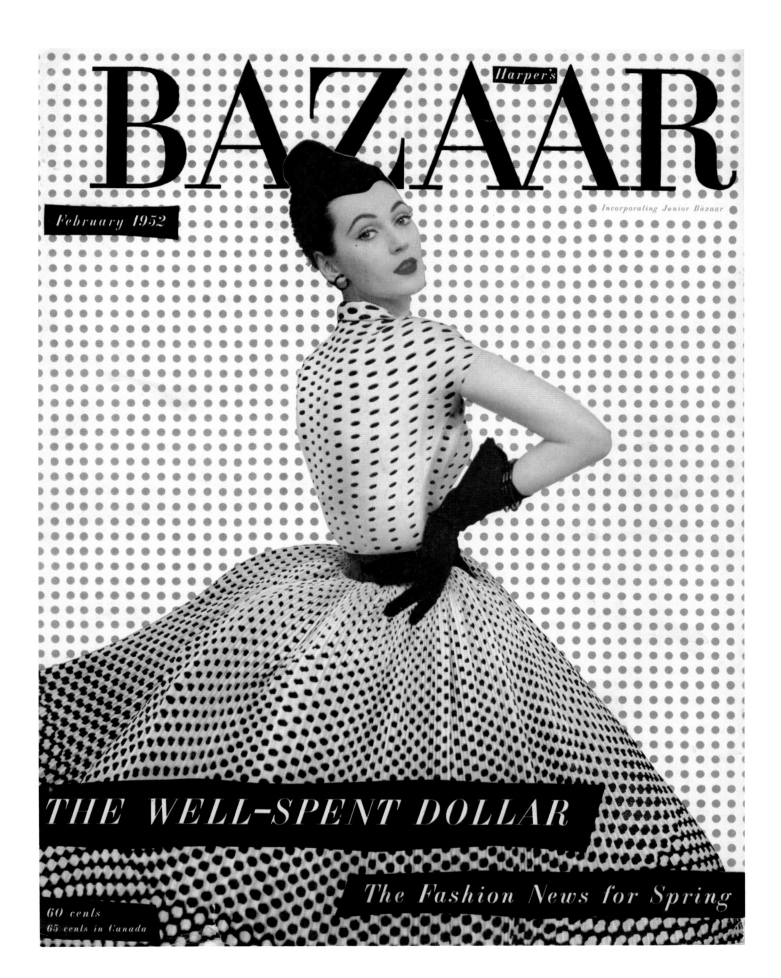

Cover of *Harper's Bazaar*, February
1952, photograph by Richard Avedon,
art direction by Alexey Brodovitch

83

Irving Penn, *Marlene Dietrich,*
December 23, 1948, gelatin
silver print

84

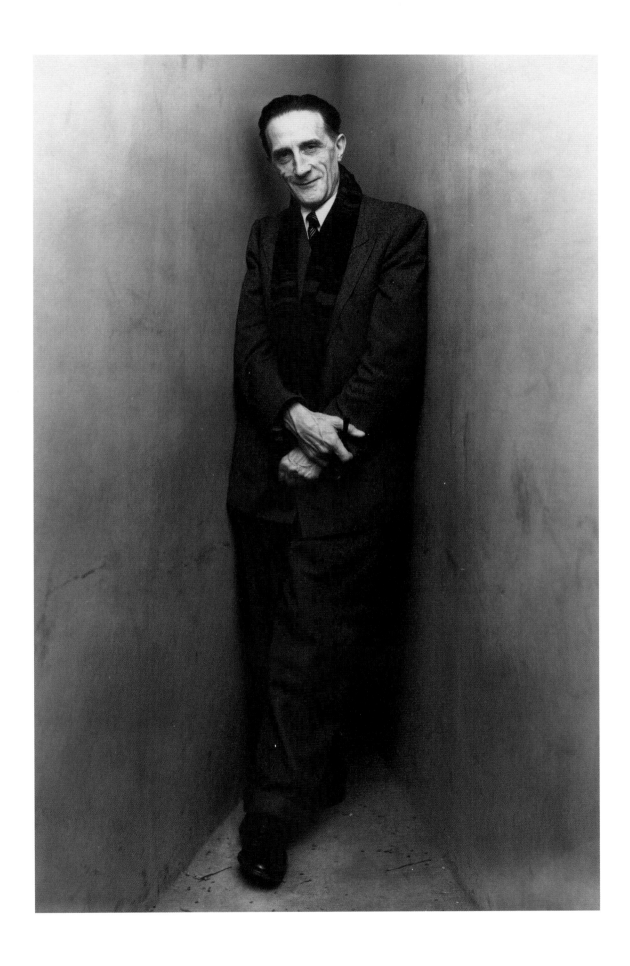

Irving Penn, *Marcel Duchamp,*
New York, 1948, gelatin silver print

"IN OUR LIVES WE WERE WHOLE"

Gordon Parks, Picture Magazines, and the Struggle for Identity

Maurice Berger

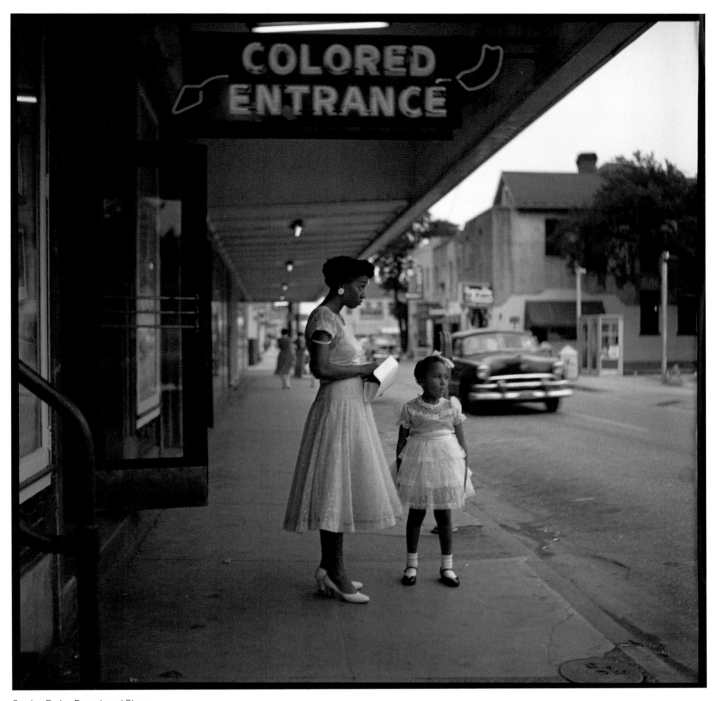

Gordon Parks, *Department Store*,
Mobile, Alabama, 1956, archival
pigment print

White America at the time did not know that we lived in a complete universe. In our private lives we were whole. We enjoyed a richness that the mainstream almost never showed, but that we took for granted just as white people did.
—Thulani Davis

People wanted to see themselves in photographs. White people wanted to see themselves in photographs, and Black people wanted to see themselves in photographs. We were dressing up for society balls, and we wanted to see that. We were going places we had never been before and doing things we'd never done before and wanted to see that. . . . The picture magazines of the 1940s did for the public what television did for audiences of the 1950s: they opened new windows in the mind and brought us face to face with the multicolored possibilities of man and woman.
—John H. Johnson

In 1947, on assignment for *Ebony* magazine, Gordon Parks documented a series of experiments designed by the psychologists Mamie and Kenneth Clark to determine the effects of racism and segregation on the psyches of children. Conducted in the Northside Testing and Consultation Center, a Harlem research institution founded by the Clarks, the tests were part of an initiative to help young people. "The Clarks know they cannot change the larger Jim Crow environment which twists young personalities," *Ebony* observed. "But they have shown that applied psychology can modify home and school environments, can unburden sick emotions, and guide children to new interests."[1]

In one photograph, Parks documented Northside's most influential experiment: the "Doll Test," intended to gauge the effects of internalized racism on children. A black child stares up at two dolls, one white, the other black, held in front of him by a psychologist, who asks him to choose the doll he prefers to play with. The study's sobering conclusions about racism's debilitating consequences— a majority of black children selected the white doll—served as persuasive evidence in *Brown v. Board of Education*, in which a unanimous Supreme Court declared unconstitutional racial segregation in public schools.

Parks's fraught image was also a metaphor for the existential struggle of many black Americans. While the child points to the white doll, he looks not at it but at the examiner, his eyes heavy with weariness, confusion, and pain. His sense of self, cultural affiliation, and security are at stake, and his anxious expression suggests his intuitive awareness of the dilemma he faces. He embodies the struggle to become whole in

defiance of a "hostility that bombards the individual from so many directions that he is often unable to identify with any specific object," as the writer Ralph Ellison described the toxic effects of racism on black Americans.[2]

Parks's understanding of black identity was commensurate with broader social and cultural trends in the twentieth century. He was influenced by pathbreaking black writers and intellectuals, who, in addition to Ellison, included W. E. B. Du Bois and Richard Wright.[3] Each endeavored to find ways to represent the struggle for self-realization, particularly of African Americans, in a chaotic, discriminatory, and fragmented modern world. But Parks was not content with the mere depiction of this struggle. He would also create complex, aesthetically adventurous, and hopeful photographs that represented its resolution, images

"In Our Lives We Were Whole"

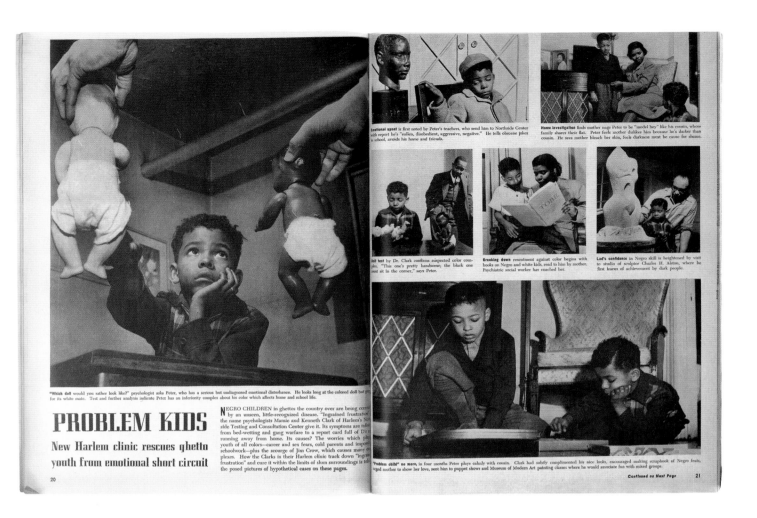

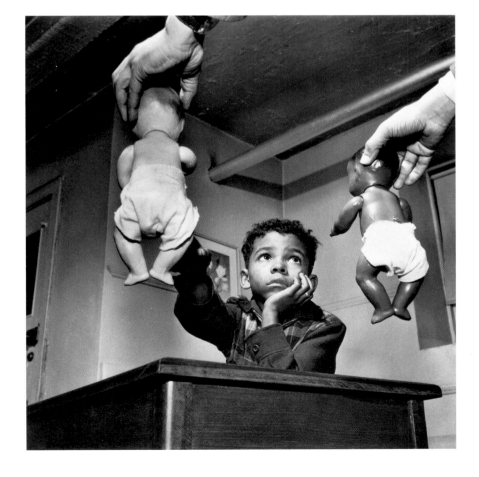

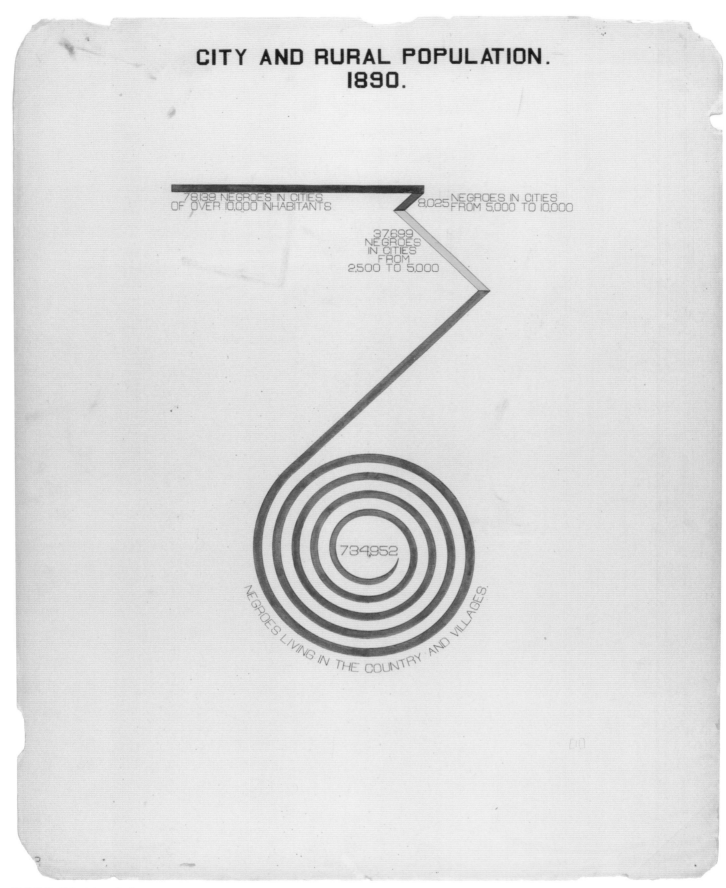

CITY AND RURAL POPULATION.
1890.

78,139 NEGROES IN CITIES OF OVER 10,000 INHABITANTS

8,025 NEGROES IN CITIES FROM 5,000 TO 10,000

37,699 NEGROES IN CITIES FROM 2,500 TO 5,000

734,952

NEGROES LIVING IN THE COUNTRY AND VILLAGES.

W. E. B. Du Bois, data portrait,
"City and Rural Population,
1890," from *The Georgia Negro:
A Social Study*, 1900

"In Our Lives We Were Whole"

in which people oppressed by discrimination and poverty emerge as whole and self-possessed.

Convinced of photography's authority to inform, motivate, and inspire, Parks created these images not in the rarefied context of the art gallery or museum but in widely accessible mass-media outlets. A brilliant polymath, Parks wrote best-selling novels and memoirs, directed television programs and Hollywood movies, and composed film scores. But, arguably, it was his photographs for a range of magazines—including *Ebony*, *Circuit's Smart Woman*, *Glamour*, *Vogue*, and *Life*—that made the greatest cultural impact. Their pages served for Parks as contested sites, where he resisted the conventions and biases of editors, and as conduits for self-realization, allowing the oppressed to see themselves in positive and empowering ways.

Parks's work for *Ebony* helped shape his understanding of the social possibilities of photography. Founded in 1945 by the Chicago business-man and publisher John H. Johnson, the magazine was based on *Life*. Johnson conceived of *Ebony* as an alternative to mainstream magazines that either rendered African Americans invisible or represented them in distorted ways. The magazine reflected the everyday realities of African American life, especially of its largely black, middle-class readers, a burgeoning and lucra-tive demographic long ignored by mainstream publications. Like *Life*, *Ebony* was photo driven, its pages filled with pictures of black celebrities, images of achievement and success, as well as reporting on segregation, racism, and protest.

In keeping with *Ebony*'s holistic approach to black life, Parks con-tributed pictures that revealed its fullness and complexity, from celeb-rity portraits and profiles of artists and working men and women to

stories about chorus girls in Harlem and black tourism in the Caribbean. Even before his work for the mag-azine, he had been committed to representing a more comprehensive view of the African American expe-rience. In 1942, in his successful application for a Julius Rosenwald fellowship, for example, he stated his intention to "spend one year portraying the Negro in his intel-lectual, professional, educational, social, farm and urban life," work that promised a breadth and nuance then almost nonexistent in the mainstream media.[4]

Parks's profile for *Ebony* of a hardworking railroad worker, twenty-six-year-old Curtis Smith, for example, was rich with detail.[5] Parks chronicled a typical day in Smith's life, from ordering provi-sions at 5:30 a.m. to preparing for bed at 10 p.m. His portrayal was measured, empathetic, and inclu-sive, a story he knew well, having worked as a waiter on the North Coast Limited in the 1930s. Neither skirting harsh realities, including Smith's encounters with discrim-ination, nor his exhausting and unrelenting labor, the photo-essay accentuated his resolve, self-possession, and aspirations: "When Smith tucks a volume on real estate (his future career) into his overnight bag, he is acting in the tradition of many colored professionals," *Ebony* wrote, acknowledging the ambition and optimism of many working-class black Americans.[6]

These positive depictions were of paramount importance for black readers, especially in the largely uninviting media world of the period. Mid-century pictorial magazines were a challenging place for anyone—not just people of color—to find self-realization. In the context of these publica-tions, individual photographs, no matter how affirmative, were part of a continuum of images, page after page of editorial content and

advertisements coalescing into a diffuse, sometimes contradictory whole. Beyond the popular press, a robust media culture—dispersed on the printed page, movie and television screens, and products and billboards—was cacophonous and decentering. As the artist and theorist Victor Burgin observes:

> From a Western world in which images were once limited in number, circum-scribed in meaning and contemplated at length, we have today arrived at a society inundated with images con-sumed "on the fly." . . . We are in turn bombarded by pictures not only of hopelessly unat-tainable images of idealized identities, but also images of past and present sufferings, images of destruction, of bodies quite literally in pieces. We are ourselves "torn" in the process, not only emotionally and morally but in the frag-mentary structure of the act of looking itself. In an image saturated environment . . . the very subject-object distinction begins to break down, and the subject comes apart in the space of his own making.[7]

If this morass of information was disorienting for white Americans, it was exponentially more confound-ing for black people. Engaging a media culture marked by destruc-tive stereotypes, distortions, and invisibility, they were tested by images that obliterated their humanity and undermined their ego. For Du Bois, the self-image of black Americans was inevitably riven, shaped by a "double conscious-ness," as he called it, the "peculiar sensation . . . of always looking at one's self through the eyes of others, of measuring one's soul by the tape of a world that looks on in amused contempt and pity. One ever feels his two-ness— an American, a Negro; two souls,

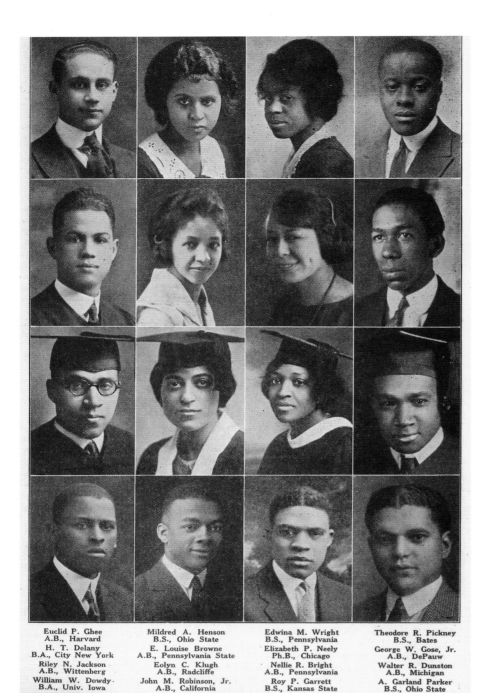

Euclid P. Ghee
A.B., Harvard
H. T. Delany
B.A., City New York
Riley N. Jackson
A.B., Wittenberg
William W. Dowdy
B.A., Univ. Iowa

Mildred A. Henson
B.S., Ohio State
E. Louise Browne
A.B., Pennsylvania State
Eolyn C. Klugh
A.B., Radcliffe
John M. Robinson, Jr.
A.B., California

Edwina M. Wright
B.S., Pennsylvania
Elizabeth P. Neely
Ph.B., Chicago
Nellie R. Bright
A.B., Pennsylvania
Roy P. Garrett
B.S., Kansas State

Theodore R. Pickney
B.S., Bates
George W. Gose, Jr.
A.B., DePauw
Walter R. Dunston
A.B., Michigan
A. Garland Parker
B.S., Ohio State

111

"Colored Students and Graduates
of 1923," *The Crisis*, July 1923,
page 111

two thoughts, two unreconciled strivings; two warring ideals in one black body, whose dogged sense alone keeps it from being torn asunder."[8]

Du Bois regarded visual culture as a powerful conduit for black self-realization. To this end, he employed three seemingly disparate but ultimately connected mediums: austere and modern graphics, the photographic portrait, and the mass-circulation pictorial magazine. In 1900, he contributed approximately sixty infographics to the *Exposition des Nègres d'Amérique*, a show organized by the lawyer and educator Thomas Junius Calloway for the Exposition Universelle in Paris. Part of a study about the status of black people in American society, the color-coded charts and graphs—a bold and groundbreaking sociological application of modern information graphics—were based on existing records and empirical data from Du Bois's laboratory in Atlanta. These "data portraits" enumerated an array of statistics, from the distribution of black Americans across the continent to the assessed value of their household and kitchen furniture.[9]

As the scholars Whitney Battle-Baptiste and Britt Rusert note, "The politics of visuality, and the very question of black invisibility, were central to Du Bois's thought, and his theory of double consciousness was expressed in a distinctly visual register."[10] Indeed, the data portraits serve as a visual analogy of this dual consciousness, offering a fragmented and contingent view of African American life seen from multiple perspectives. But to a great extent, their incongruity was countered by another, more holistic and humanist aspect of Du Bois's section of his exhibition: scores of photographic portraits.[11] A decade later, he would make portraiture a cornerstone of *The Crisis*, the pictorial

"In Our Lives We Were Whole"

magazine he cofounded and edited for the National Association for the Advancement of Colored People from 1910 to 1934, a publication through which he believed his readers "could form a collective memory about their legitimate past and their identity."[12] The portrait became for him a rallying point, serving as confirmation and paradigm of the richness of African American life.[13]

In the context of *The Crisis*, the portrait also served as a centering device, a counterpoint to the disturbing, sometimes jarring words and images that documented racial violence and the deleterious effects of segregation. Alternating between troubling and affirmative images, the magazine was able to represent the totality of the African American experience—from uncompromising reporting on segregation, racial terror, and lynching to images that inspired black pride, self-awareness, and confidence. The portraits served as icons of achievement and resilience onto which readers were invited to project their aspirations and hopes, an editorial device that served as the model for subsequent African American periodicals, including *Ebony*, *Jet*, and *Essence*.[14]

Parks was deeply invested in the idea of portraiture as an empowering force. From the outset of his career, he made numerous portraits of subjects, black and white. Taken for the Farm Security Administration (FSA), Office of War Information, Standard Oil Company, and numerous magazines, these pictures included children and families, workers, businessmen, policemen, and preachers, as well as prominent achievers and celebrities. Parks was so enamored of portraiture that he made it the focus of his second book: *Camera Portraits: The Techniques and Principles of Documentary Portraits* (1948).[15] Both technical primer and treatise on the discipline's cultural and social value, the book juxtaposed

Parks's photographs of eminent subjects with short biographies and essays about his sessions with them.[16] In the book's preface, he argued that a good portrait had to reach below surface appearance to reveal aspects of a subject's inner life. While no single image "embodies the whole man," as he wrote about Mathew Brady's epochal portraits of Abraham Lincoln, their greatness resided in their ability to look beyond the myths that distorted or concealed the president's humanity. Their depth, he continued, allowed future generations to "perceive the fearlessness, honesty, kindness, and resolution of which we read in biographies."[17]

In his searching portraits, Parks wanted to express "a more substantial picture of these personalities than mere words can do." When photographing famous people, for example, he avoided the trappings of wealth and success, the boilerplate of press releases, and the artificial situations set up by publicity agents. His introspective portrait of actor Henry Fonda—casually dressed, cigarette in hand—was taken between performances of the Broadway play *Mr. Roberts*, in an alley adjacent to the Alvin Theater. Parks writes of his struggle "to bridge psychological barriers" and make an emotional connection as he photographed Alexander Liberman, his editor at *Vogue*. A portrait of Roy Stryker, director of federal photography projects, including the historical section of the FSA, is penetrating and intimate. "This was the case of my knowing a person so well that to photograph him was relatively easy," Parks wrote of his former mentor at the agency.[18]

While few subjects in *Camera Portraits* were people of color, Parks often photographed black Americans, images that were essential in a media world that typically disregarded or stereotyped them.[19] His portraits for *Ebony*, for

example, which included a range of African American subjects both famous and not, were consistent with the magazine's mandate, which, in turn, reflected the influence of *The Crisis*. In creating the magazine, Johnson understood that black Americans—unlike their white counterparts awash in flattering media images of themselves—wanted to see the richness of their lives represented. "The picture magazines of the 1940s did for the public what television did for audiences of the 1950s: they opened new windows in the mind and brought us face to face with the multicolored possibilities of man and woman," Johnson later observed of *Ebony*'s role in enfranchising the image of black people.

In the 1941 portrait *Charles White, Chicago, Illinois*, made four years before he began working for *Ebony*, Parks allegorized the struggle at the root of this wide-reaching media project: that for wholeness and achievement in the face of destabilizing racism, segregation, and poverty (see page 100). Parks met White in Chicago when both were in residence at the South Side Community Art Center, where they spent hours discussing art and aesthetics. Parks depicts the painter in front of a mural commissioned by the Chicago Public Library, a project that was later canceled. The painting's swirling and frenzied composition "confronted the racial violence at the root of the black struggle," suggesting both "modern resistance through politics and protest, on the one hand, and the continuation of repression on the other."[20] In Parks's portrait, the stylishly dressed White, in contrast to the mural's depiction of chaos, appears placid and centered: brushes in hand, he epitomizes "the artist in control of his medium," as well as a man in charge of his destiny and the history he represents.[21]

Parks's understanding of the empowering nature of portraiture also informed his aesthetically adventurous fashion work. While most fashion photographers of the period shot in the studio, Parks was one of the first to prefer real-world settings. "He didn't necessarily focus on showcasing the clothes, but rather on giving a sense of the stories women could live out in them," writes the arts journalist Alexandra Alexa.[22] As he built his career in Chicago in the early 1940s, his "trademark soon became his photographs of the . . . fashionably dressed elite African American community," images that contributed to the sensibility of his fashion photographs.[23] These pictures—published in both the black and mainstream press, including the *Chicago Defender*, *Chicago Sunday Bee*, and the *Chicago Tribune*—underscored the extent to which self-presentation—and fashion itself—"has always been a means to question, resist, and mix together various markers of identity," as the art historian Horace D. Ballard writes.[24]

Parks's fashion photographs for the Chicago-based African American magazine *Circuit's Smart Woman*, where he was photo editor in the late 1940s, were remarkable in their complexity and social intent. As with his portraits and street photographs, these images were distinguished by their visual and emotional complexity, going "far beyond surface aspects [to] interpret dynamically and originally the essence of the subject," as one critic wrote at the time.[25] These pictures underscore the extent to which the black press provided African American women with models and icons of beauty that were virtually missing from the mainstream press (see page 101).

In the ensuing decades, Parks's fashion pictures for *Vogue*, *Glamour*, and *Life* continued to represent his

models as complex beings rather than as inscrutable mannequins. A dynamic photograph of his muse Bettina Graziani—"at work modeling fall college clothes," as its caption for *Vogue* reads—exemplifies this approach, representing his subject not as an empty signifier of style but as a working woman (see page 160). Commensurate with Parks's notion of the environmental portrait, in which the setting provides social or cultural context, the photograph is set across the street from Manhattan's Hunter College, an institution founded to educate and empower young women regardless of race, religion, or class. Significantly, the image is also a double-portrait: the photographer Frances McLaughlin-Gill faces the model as she looks down into the viewfinder of a Hasselblad camera. The startling effect creates a mirror image of the unseen action in front of both women, each rigorously practicing their profession, in which a female photographer serves as a proxy for Parks—a photograph, to quote the photo historian Deborah Willis, that serves as a "powerful mirror reflecting the achievements of individuals and the transformation of fashion history."[26]

In his broad range of work, from fashion pictures to street scenes, Parks's embrace of mass media was undoubtedly related to his understanding of photography's authority to change perceptions about race. If the camera was his "weapon of choice," as he called it, to fight oppression, the magazine page offered a wide-reaching platform on which to wage this battle. When Parks was appointed *Life*'s first African American staff photographer in 1949, he reached a significant milestone in his career, assuring broad distribution of his pictures and securing the kind of publicity that the sociologist Gunnar Myrdal then considered of the "highest strategic importance to the Negro people."[27] But Parks's

conception of the social and cultural importance of his project, as a motivator of change in a discriminatory world, was not entirely consistent with that of *Life*'s editors.

Unlike the thriving African American press of the period—which included scores of newspapers and magazines—*Life*'s coverage of people of color was at best sporadic. Focusing its reporting on the major and dramatic events of the civil rights movement, it told the story of black America largely through the lens of protest and conflagration. "By drawing attention to the plight of African Americans and the events surrounding the fight for civil rights," observes the journalist Michael DiBari, Jr., about *Life*, "less attention was given to covering African Americans as average or middle-class, such as in the promotion of the ideals of the American family. . . . [The magazine] did not show normal life for African Americans as it did so thoroughly with white Americans."[28]

Thus, *Life* was simultaneously an influential outlet and a profound challenge for a photographer committed to revealing the complexity and fullness of the African American experience. In his first photo-essay for the magazine, "Harlem Gang Leader," for example, Parks argued with his editors, who resisted his intention to represent not only the problems of his young subject but also his studiousness and the quiet domesticity of his family life.[29] In its published version—images were chosen for dramatic effect and some were aggressively cropped—the photo-essay similarly failed to portray the vitality and cultural richness of Harlem, representing it instead as foreboding and desolate.[30] A photo-essay for *Life* on Parks's hometown of Fort Scott, Kansas, went unpublished, his focus on dignified black subjects going about their lives apparently not in step with the expectations of his editors, who, like the magazine's

"In Our Lives We Were Whole"

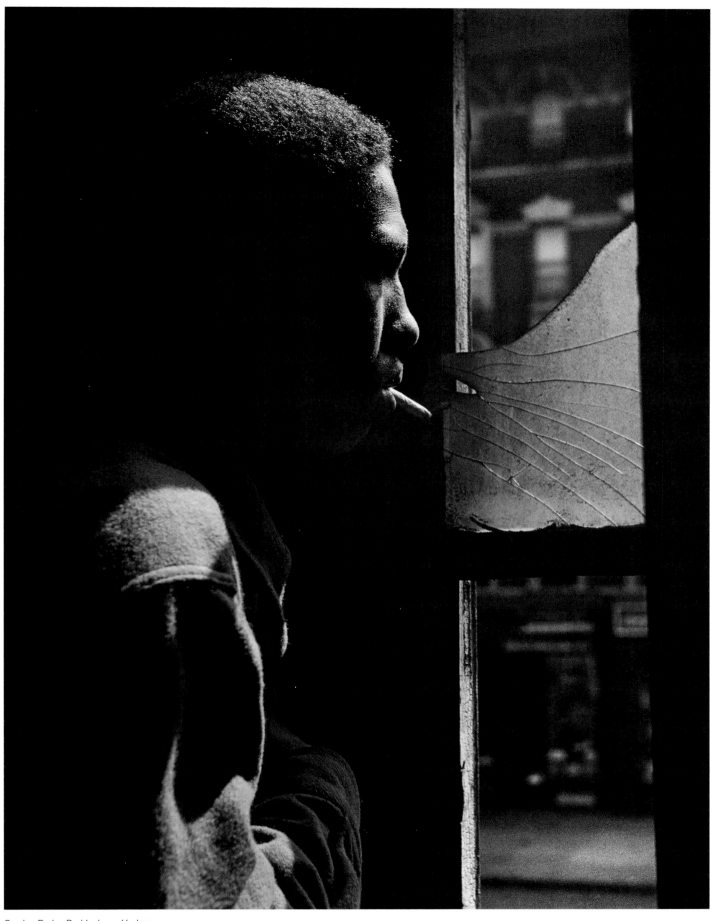

Gordon Parks, *Red Jackson, Harlem,*
New York, 1948, gelatin silver print

Berger

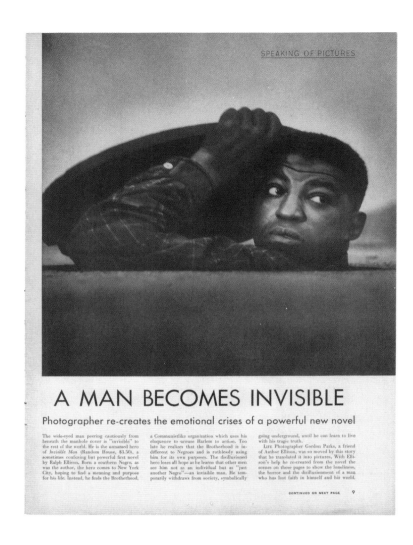

A MAN BECOMES INVISIBLE

Photographer re-creates the emotional crises of a powerful new novel

The wide-eyed man peering cautiously from beneath the manhole cover is "invisible" to the rest of the world. He is the unnamed hero of *Invisible Man* (Random House, $3.50), a sometimes confusing but powerful first novel by Ralph Ellison. Born a southern Negro, as was the author, the hero comes to New York City, hoping to find a meaning and purpose for his life. Instead, he finds the Brotherhood,

a Communistlike organization which uses his eloquence to arouse Harlem to action. Too late he realizes that the Brotherhood is indifferent to Negroes and is ruthlessly using him for its own purposes. The disillusioned hero loses all hope as he learns that other men see him not as an individual but as "just another Negro"—an invisible man. He temporarily withdraws from society, symbolically

going underground, until he can learn to live with his tragic truth.

LIFE Photographer Gordon Parks, a friend of Author Ellison, was so moved by this story that he translated it into pictures. With Ellison's help he re-created from the novel the scenes on these pages to show the loneliness, the horror and the disillusionment of a man who has lost faith in himself and his world.

CONTINUED ON NEXT PAGE 9

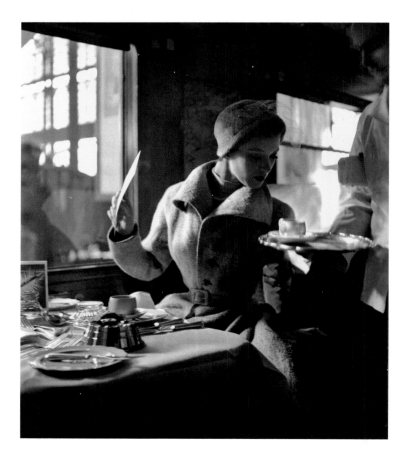

↑ "A Man Becomes Invisible," *Life*, August 25, 1952, photograph by Gordon Parks

→ Lillian Bassman, *Aboard the Flèche d'Or, Paris*, 1949, gelatin silver print

"In Our Lives We Were Whole"

predominantly white middle-class readers, understood African Americans principally through the filter of suffering, poverty, or protest.[31]

One project for *Life*, a collaboration with Ralph Ellison to promote his acclaimed novel *Invisible Man*, nevertheless reflected both men's understanding of black life in the face of racial injustice. They had teamed up a few years earlier on an illustrated essay, "Harlem Is Nowhere," for the short-lived *'48: The Magazine of the Year*, which went bankrupt before their project was scheduled to be published. Conceived while Ellison was at work on the novel, the photo-essay, which focused on the Lafargue Clinic in Harlem, which treated low-income African Americans with psychiatric problems, was a study of social and economic conditions in the neighborhood.[32] Their August 1952 article for *Life*, "A Man Becomes Invisible," re-created vignettes from *Invisible Man*. In the novel, a nameless black narrator looks back on his social invisibility and the search to find himself from the perspective of his present-day living situation, an underground room wired with hundreds of electric lights. He recounts the consequential events that affected his life, from participating in a humiliating battle royale, created for the pleasure of the white dignitaries of the southern town in which he was raised, to his troubled interaction with "the Brotherhood," a Harlem political group.

"A Man Becomes Invisible" loosely follows Ellison's narrative, refashioning scenes from it in photographs and extended captions that depict "the loneliness, the horror, and the disillusionment of a man who lost faith in himself and the world," as *Life* wrote. In one image, for example, Parks shows the narrator alone in his subterranean lair: "surrounded by lights, he plays records and eats ice cream and sloe gin as he broods over

his invisibility" (see page 102).[33] While the magazine published only four photographs, the project was considerably larger and more comprehensive. Ultimately, Parks and Ellison, in their representation of African American life, "were allied in their focus on black individuality, self-realization, and an insistence on making race a larger, universal issue."[34] Nevertheless, while a number of pictures for the photo-essay portrayed Ellison's Harlem through contemporary images of everyday life in the neighborhood, unsurprisingly, none was selected by *Life*'s editors for publication.[35]

One image published by *Life*, however, departed significantly from *Invisible Man*: that of the protagonist emerging out of a manhole, from an underground world of strife and self-discovery to a luminous street in Harlem (see page 103). As the curator Matthew S. Witkovsky observes, Ellison's narrator announces at the end of the novel, but never realizes, his intention to "end the 'hibernation' and 'come up for breath'; actual reemergence must take place after the story has finished." On one level, the photograph, much like Parks's image of a young child caught up in an existential struggle for identity, is fraught: "To appear in the world or disappear from it is nothing less than a momentous choice for all humanity to contemplate," as Witkovsky observes.[36] But in another sense, Parks shows the narrator definitively emerging into the conscious world, resolute and whole. He serves as a metaphor of the photographer's lifelong ambition to illuminate the humanity, complexity, and authority of the oppressed, despite the shadowy forces of prejudice that conspire to impede and hinder them.

Parks would be neither the first nor the last twentieth-century photographer to make visible the depth of our humanity in the face of corrosive cultural, social, or physical forces.

Lillian Bassman, in her elegant and groundbreaking fashion photographs, depicted her female models not as sexist mannequins but as multifaceted beings, reading on trains, driving cars, playing golf, or dining alone. Robert Frank, in his epochal photo book *The Americans*, first published in France in 1958, portrayed the grace, perseverance, and fortitude of a nation, despite the disunity that threatened to tear it apart. And Lisette Model, in her photographs of the blind, several published in *Harper's Bazaar*, brought into visible being the multidimensional and sentient men and women whose inability to see often defined their identity in the culture at large (see page 121).[37]

But there is something that sets Parks apart from many of his contemporaries: his own consequential search for unity and wholeness. In best-selling autobiographies— *A Choice of Weapons* (1966), *To Smile in Autumn* (1979), *Voices in the Mirror* (1990), and *A Hungry Heart* (2005)—he chronicled his personal triumph over segregation, discrimination, and poverty. These books echoed Ellison's insistence on charting the tentative path, as he wrote in his own unpublished memoir, on which one "groped toward manhood and true self-consciousness . . . toward yet some as yet unformulated form of integration, a sense of wholeness that was both personal and social."[38] Autobiography served for both men as a means for recording their dramatic evolution and demonstrating to their readers the possibility of finding one's identity in the face of adversity and prejudice.

Parks remained vulnerable throughout his early life, his very survival threatened by the bigotry of Fort Scott, the Jim Crow town where he was born and raised in abject poverty. His mother died when he was fourteen. Sent to live with his older sister in St. Paul, Minnesota,

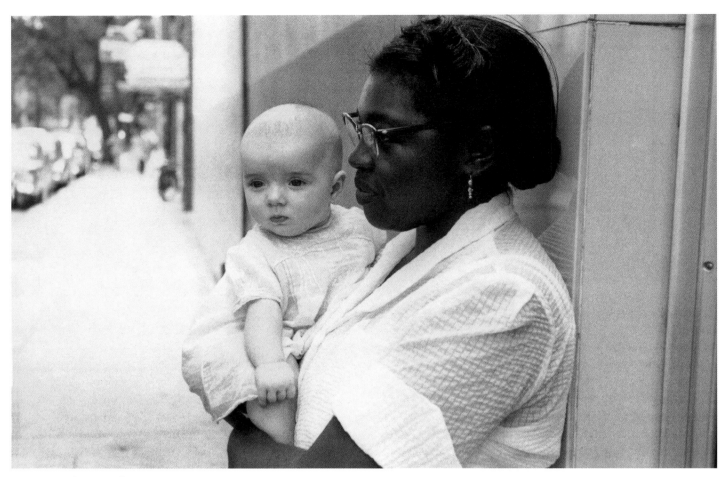

Robert Frank, *Charleston, South Carolina*, 1955, from his book *The Americans*, 1959, plate 13, gelatin silver print

he was soon kicked out by his brother-in-law. He dropped out of high school and took odd jobs to survive. At one point, desperate and hungry, he contemplated robbing a man at knifepoint. "I could have just as easily picked up a knife or a gun, like many of my childhood friends did . . . most of whom were murdered or put in prison . . . but I chose not to go that way," Parks wrote about his search for self-realization. "I felt that I could somehow subdue these evils by doing something beautiful that people recognize me by, and thus make a whole different life for myself, which has proved to be so."[39] As Parks cycled through a range of occupations, he found the instrument that assured his future and helped him to become whole: the camera.

Through his work in mass media, Parks continually made visible the fruits of this struggle: he did so at the outset of his career in his FSA photographs of Ella Watson, a Washington, D.C., charwoman who lived her life with quiet dignity and self-possession; he did so in a 1956 photo-essay for *Life* on segregation in the Jim Crow South, his vivid color photographs celebrating the prosaic activities and extraordinary fortitude of an extended family in Alabama; he did so in his semi-autobiographical Hollywood film *The Learning Tree* (1969), its young protagonist overcoming the indignities of Jim Crow segregation in rural Kansas; and he did so, more abstractly, in his conception of empathy as an antidote to prejudice, an idea that paralleled Ellison's contention that art should help us to look beyond a polarized and tribal world to the "essential unity of experience."[40]

In the end, Parks did so aware that for people of color, the poor, and the oppressed, popular culture was a minefield of stereotypes and biases powerful enough to undermine the ego and damage the soul. Armed with astonishing talent, a perceptive eye, and a limitless capacity for empathy, he employed his camera as his weapon of choice to fight injustice. He remained focused on his mission, standing up to prejudice, divisiveness, and hate. In so doing, he represented on the pages of the American magazine both the withering effects of bigotry and poverty, and the fortitude that allowed even the most vulnerable among us to emerge from the modern condition self-possessed, beautiful, and whole.

"In Our Lives We Were Whole"

Notes

I would like to thank Peter W. Kunhardt, Jr., executive director of the Gordon Parks Foundation, and Philip Brookman, consulting curator, Department of Photography, National Gallery of Art, Washington, DC, for their assistance with research for this essay.

Epigraphs. Thulani Davis as quoted in Maurice Berger, *For All the World to See: Visual Culture and the Struggle for Civil Rights* (New Haven: Yale University Press, 2010), 164. John H. Johnson, *Succeeding Against the Odds: The Inspiring Autobiography of One of America's Wealthiest Entrepreneurs* (New York: Warner, 1989), 156.

1
"Problem Kids," *Ebony* 2, no. 9 (July 1947): 22.

2
Ralph Ellison, "Harlem Is Nowhere," in *Shadow and Act* (New York: Random House, 1964), 300. For more on the photograph, see Jesús Costantino, "Harlem in Furs: Race and Fashion in the Photography of Gordon Parks," *Modernism/Modernity* 23, no. 4 (November 2016): 802–4; and Maia Silber, "Racial Innocence in Postwar America," https://aperture.org/blog/racial-innocence-postwar-america/.

3
For more on the influence of Du Bois and Wright on Parks, see Maurice Berger, "The Crucible of Race: Gordon Parks and an Emerging Civil Rights Movement," in *Gordon Parks: The New Tide, Early Work, 1940–1950*, ed. Philip Brookman (Göttingen: Steidl, 2018), 278–80. For more on Parks's working relationship with Ellison, see Michal Raz-Russo, *Invisible Man: Gordon Parks and Ralph Ellison in Harlem* (Göttingen: Steidl, 2016).

4
For a facsimile of the application, see Brookman, *Gordon Parks: New Tide*, 296.

5
"Around the Clock with a Freshman Waiter," *Ebony* 2, no. 8 (June 1947): 14–19.

6
Ibid., 16.

7
Victor Burgin, "Paranoiac Space," in *Visualizing Theory: Selected Essays from V. A. R., 1990–1994*, ed. Lucien Tayler (London: Routledge, 1994), 232.

8
W. E. B. Du Bois, *The Souls of Black Folk: Essays and Sketches* (Chicago: A. G. McClurg, 1903), 3.

9
Whitney Battle-Baptiste and Britt Rusert, eds., *W. E. B. Du Bois's Data Portraits: Visualizing Black America* (Amherst and New York: W. E. B. Du Bois Center at the University of Massachusetts Amherst and Princeton Architectural Press, 2018).

10
Ibid., 15.

11
For more on Du Bois's contributions to the *Exposition des Nègres d'Amérique*, see David Levering Lewis and Deborah Willis, *A Small Nation of People: W. E. B. Du Bois and African American Portraits of Progress* (New York: Amistad, 2003).

12
Amy Helene Kirschke, *Art in Crisis: W. E. B. Du Bois and the Struggle for African American Memory and Identity* (Bloomington: Indiana University Press, 2007), 15.

13
For more on Du Bois's view of portraiture and agency, see W. E. B. Du Bois, *Dusk of Dawn: An Essay Towards an Autobiography of a Race Concept* (1940; reprint ed., New Brunswick, NJ: Transaction, 1984), 271.

14
For more on Du Bois's visual strategies in *The Crisis*, see Anne Elizabeth Carroll, *Word, Image, and the New Negro: Representation and Identity in the Harlem Renaissance* (Bloomington: Indiana University Press, 2005), 20–54.

15
Gordon Parks, *Camera Portraits: The Techniques and Principles of Documentary Portraiture* (New York: Franklin Watts, 1948).

16
Among Parks's subjects were the artists Ben Shahn and Jo Davidson; photographers Edward Steichen and Margaret Bourke-White; publisher Bennett Cerf; lyricist Cynthia Norwood; radio host Alma Dettinger; symphonic conductor Dean Dixon; U.S. congressman Adam Clayton Powell, Jr.; and writers Ralph Ellison, Leo Lerman, and Theodore H. White.

17
Parks, *Camera Portraits*, 5.

18
Ibid., quotes at 5, 28, and 50.

19
Over the first decade of his career, Parks's black subjects included the cartoonist E. Simms Campbell; visual artist Aaron Douglas; jazz musician Phil Moore; actors Eartha Kitt, Canada Lee, and Paul Robeson; opera singer Todd Duncan; conductor Dean Dixon; philosopher and educator Alain Locke; writers Ralph Ellison and Langston Hughes; and civil rights pioneers Mary McLeod Bethune, Walter White, and Roy Wilkins.

20
Sarah Kelly Oehler, "Yesterday, Today, Tomorrow: Charles White's Murals and History as Art," in *Charles White: A Retrospective*, ed. Oehler and Esther Adler (Chicago: Art Institute of Chicago, 2018), 30–31.

21
Deborah Willis, "Gordon Parks: Haute Couture and the Everyday," in Brookman, *Gordon Parks: New Tide*, 268.

22
Alexandra Alexa, "The Role of Fashion Photography in Gordon Parks's Singular Career," *Artsy* (October 23, 2015).

23
Willis, "Haute Couture," 268.

24
Horace D. Ballard in *Artist/Rebel/Dandy: Men of Fashion*, ed. Kate Irvin and Laurie Anne Brewer (New Haven: Yale University Press, 2013); as quoted in ibid.

25
David P. Ross, Jr., foreword, "An Exhibition of Creative Photography by Gordon Rogers Parks," brochure, South Side Community Art Center, Chicago, November 1941; as quoted in Willis, "Haute Couture," 269.

26
Willis, "Haute Couture," 275. For more on the social and political underpinnings of Parks's fashion photographs, see ibid., 267–75, and Costantino, "Harlem in Furs," 789–811.

27
Gunnar Myrdal, *An American Dilemma: The Negro Problem and Modern Democracy*, vol. 1 (1944; reprint ed., New Brunswick, NJ: Transaction, 2009), 48.

28
Michael DiBari, Jr., *Advancing the Civil Rights Movement: Race and Geography of Life Magazine's Visual Representations, 1954–1965* (New York: Lexington, 2017), 109. For more on this subject, see Wendy Kozol, "Gazing at Race in the Pages of *Life*: Picturing Segregation Through Theory and History," in *Looking at Life Magazine*, ed. Erika Lee Doss (Washington, DC: Smithsonian Institution Press, 2001), 159–75.

29
"Harlem Gang Leader," *Life* 25, no. 18 (November 1, 1948): 96–106.

30
For more on Parks's original conception of the photo-essay, see Russell Lord, *Gordon Parks: The Making of an Argument* (Göttingen: Steidl, 2013).

31
For more on *Life*'s rejection of the photo-essay, see Karen Haas, *Gordon Parks: Back to Fort Scott* (Göttingen: Steidl, 2015).

32
For more on "Harlem Is Nowhere," see Jean-Christophe Cloutier, "Harlem Is Now Here," in Raz-Russo, *Invisible Man*, 29–40.

33
"Harlem Is Nowhere," *Life* 33, no. 8 (August 25, 1952): 9, 10.

34
Michael Raz-Russo, "Visible Men," in Raz-Russo, *Invisible Man*, 27.

35
For an excellent accounting and analysis of the project, see ibid., 13–28.

36
Matthew S. Witkovsky, "Introduction," in ibid., 10.

37
For a discussion of these photographers, see Mason Klein's essay in this volume.

38
Ralph Ellison, "Leaving the Territory," unpublished manuscript, as quoted in Marc C. Conner, "Leaving the Territory: Ralph Ellison's Backward Glance," in *Modernism and Autobiography*, ed. Maria DiBattista and Emily O. Wittman (New York: Cambridge University Press, 2014), 116.

39
Parks as quoted in "Gordon Parks," *PDN Legends Online*, http://pdngallery.com/legends/parks/intro.shtml.

40
Ralph Ellison in Richard Kostelanetz, "An Interview with Ralph Ellison" (1965), in *Conversations with Ralph Ellison*, ed. Maryemma Graham and Amritjit Singh (Jackson: University of Mississippi Press, 1995), 87.

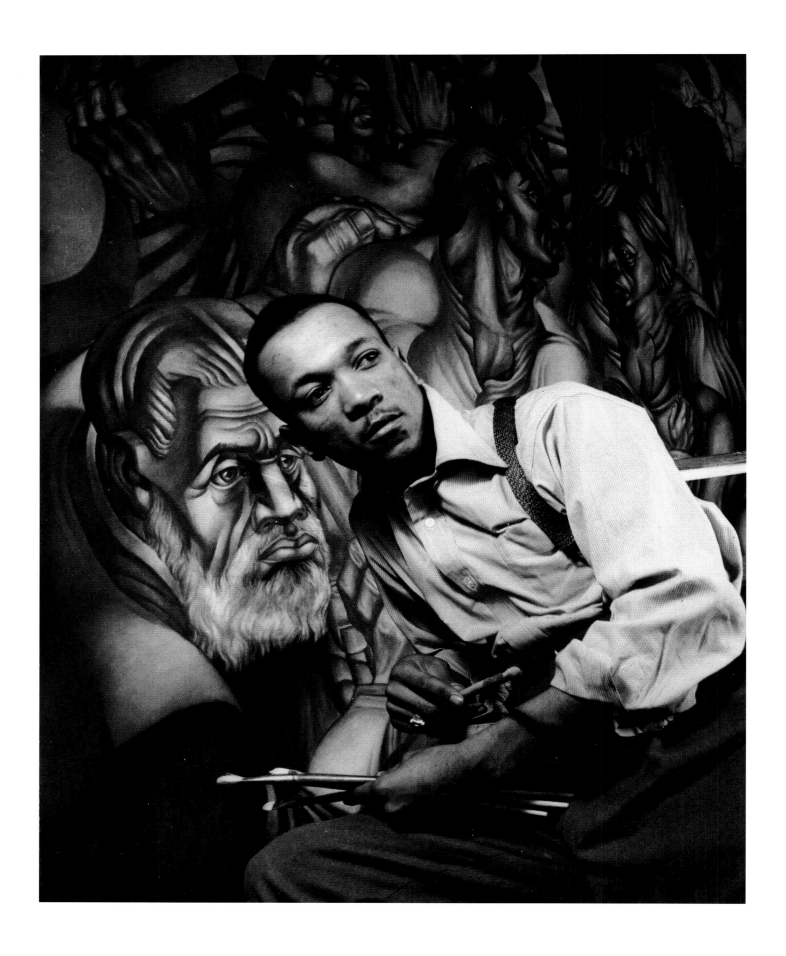

Gordon Parks, *Charles White, Chicago, Illinois*, 1941, gelatin silver print

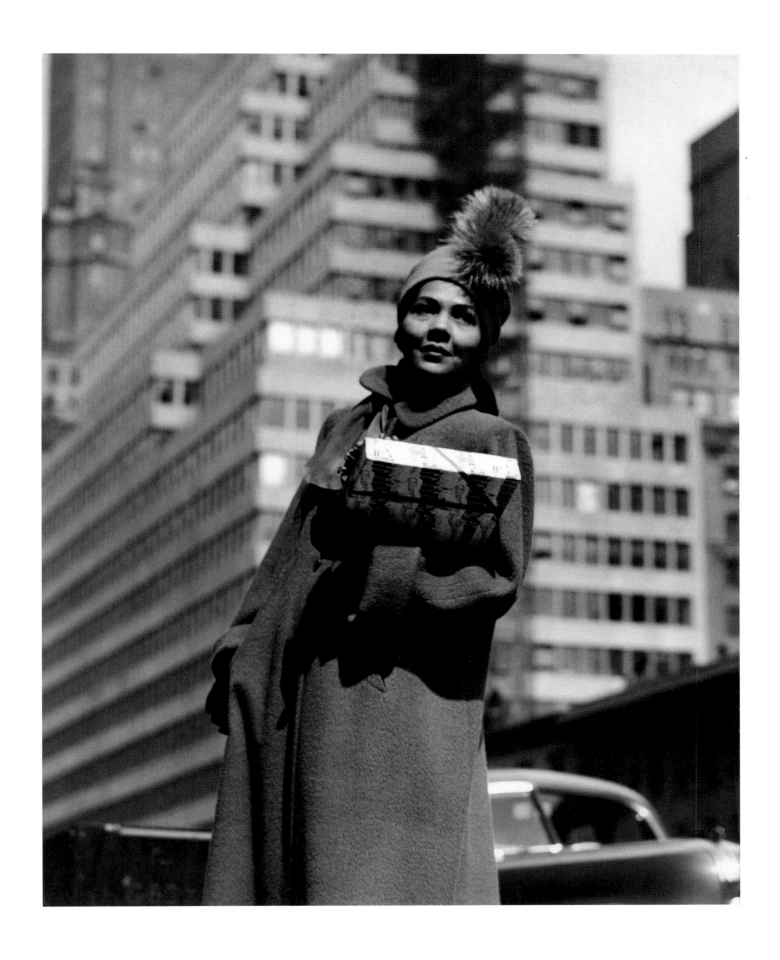

Gordon Parks, *Sally Alvis*
Parks for "Circuit's Smart Woman,"
1947, gelatin silver print

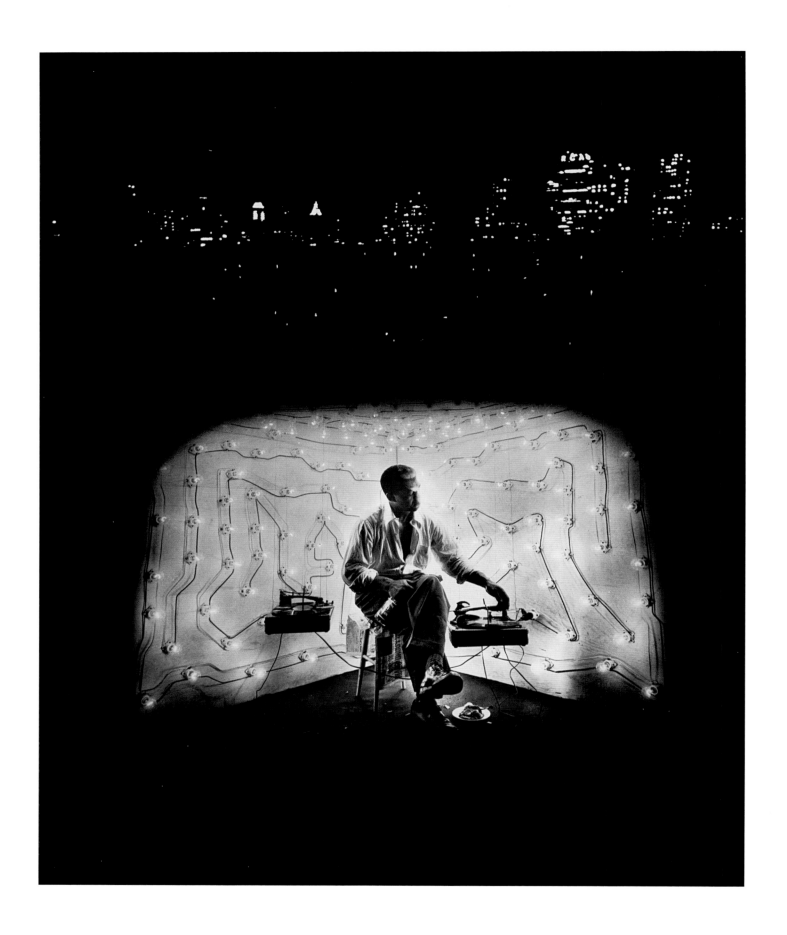

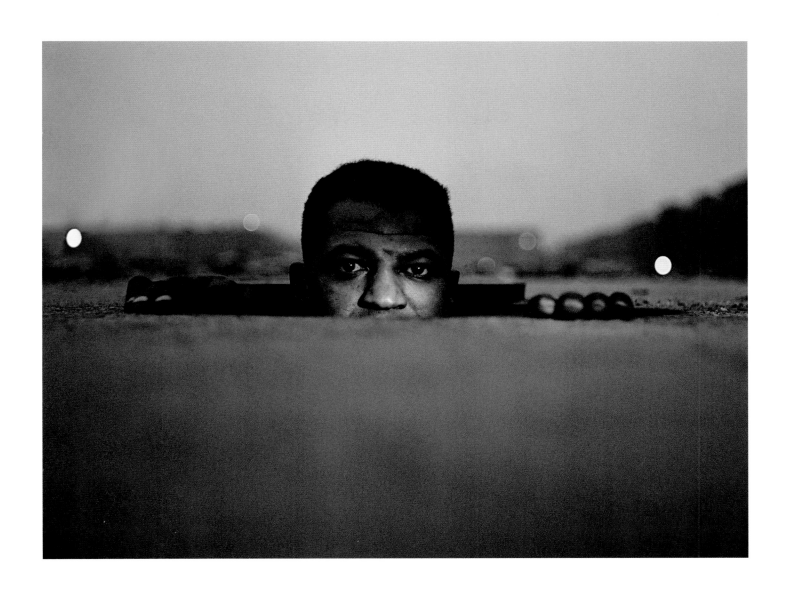

← Gordon Parks, *Invisible Man Retreat, Harlem, New York*, 1952, gelatin silver print

↑ Gordon Parks, *Emerging Man, Harlem, New York*, 1952, gelatin silver print

Robert Frank, *40 Fotos,
page 5*, and *40 Fotos,
page 6*, 1946, gelatin
silver prints

Louis Faurer, *New York, N.Y.* [Four women and poster of Barbara Stanwyck], 1949, gelatin silver print

William Klein, *Hamburger 40 cents, New York*, 1955, gelatin silver print

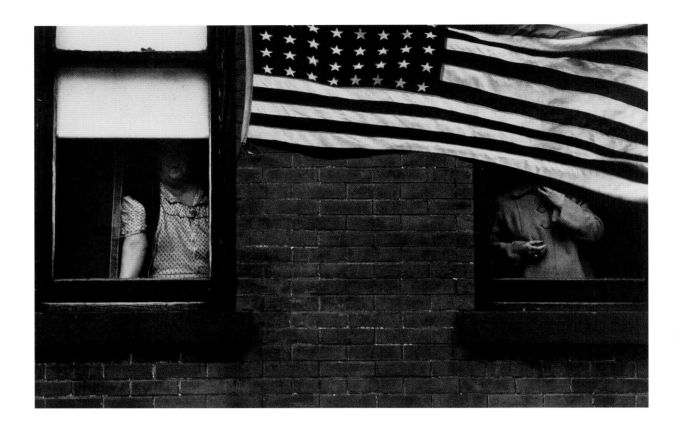

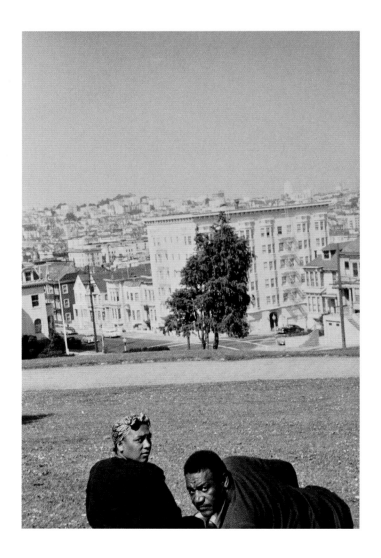

↖ Robert Frank, *Parade—Hoboken, New Jersey*, 1955, from his book *The Americans*, 1959, plate 1, gelatin silver print

← Robert Frank, *San Francisco*, 1956, from his book *The Americans*, 1959, plate 72, gelatin silver print

→ Robert Frank, *From the Bus, New York*, 1958, gelatin silver print

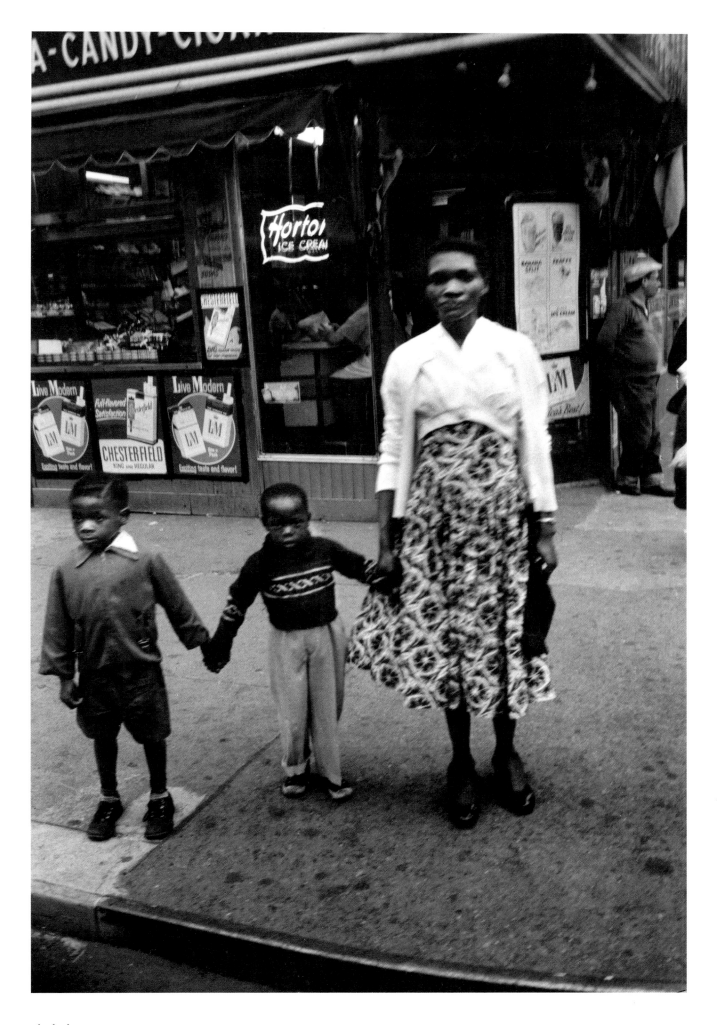

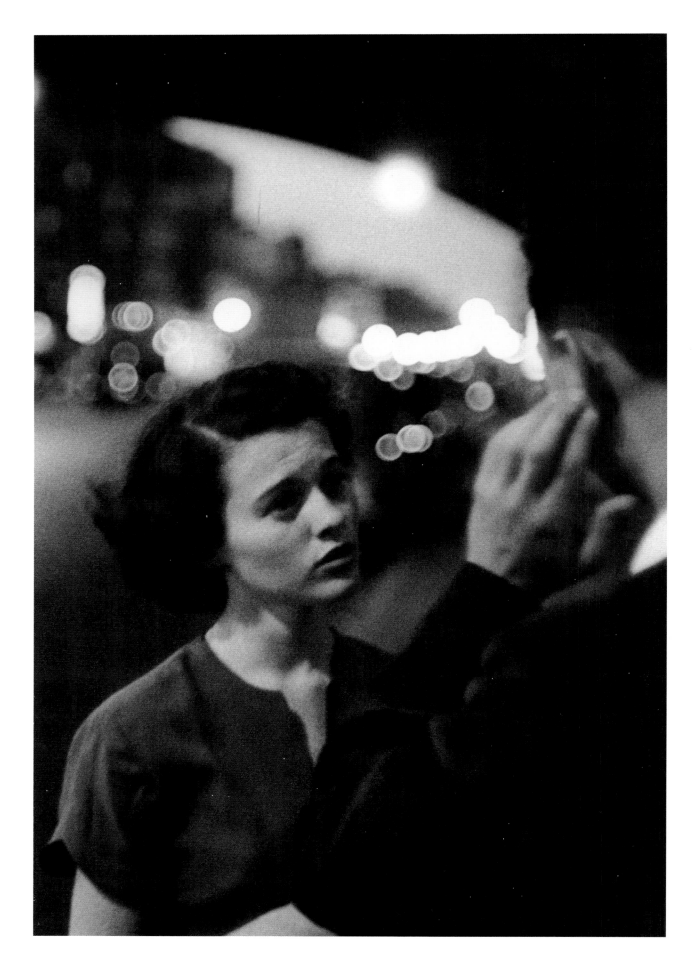

Louis Faurer, *Deaf Mute, New York,*
N.Y., 1950, gelatin silver print

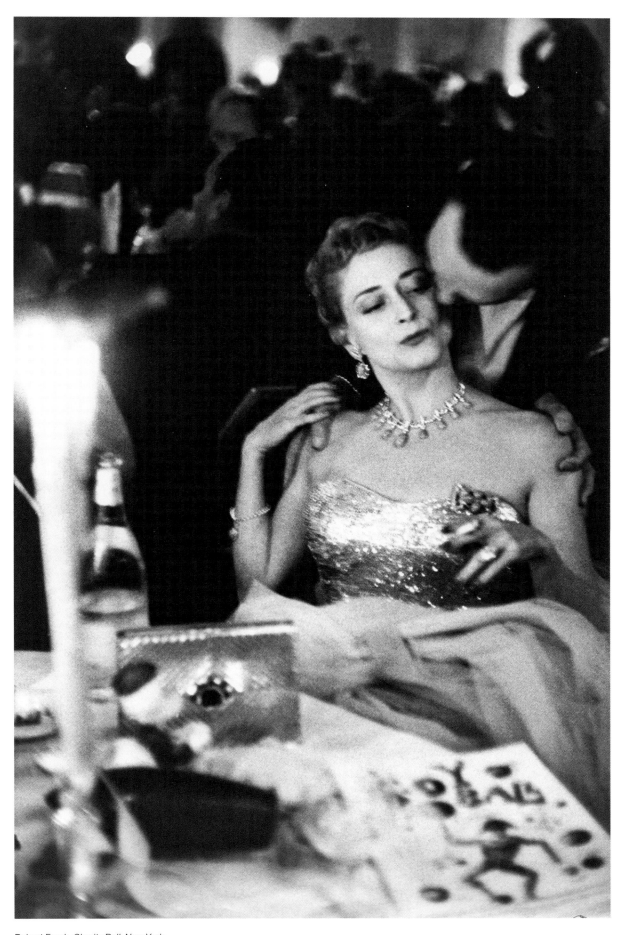

Robert Frank, *Charity Ball, New York
City*, 1955, from his book
The Americans, 1955–56, plate 67,
gelatin silver print

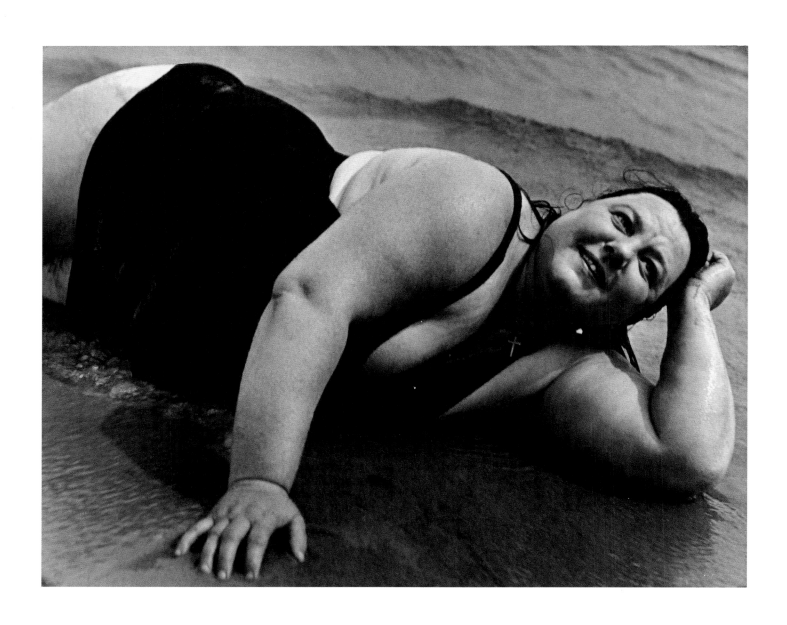

Lisette Model, *Coney Island
Bather, New York*, 1939–41,
gelatin silver print

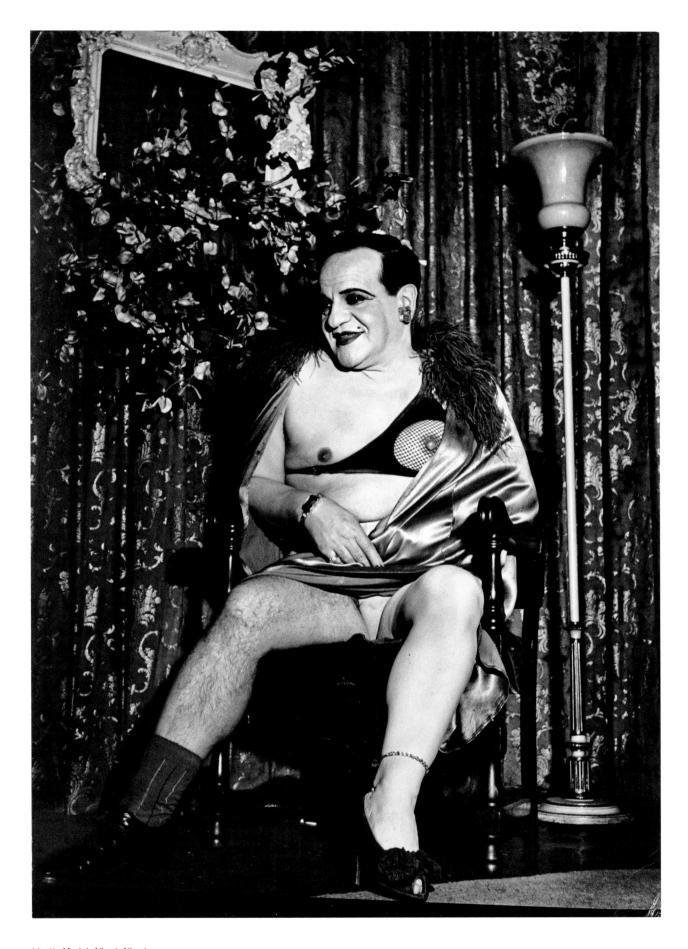

Lisette Model, *Albert-Alberta,
Hubert's Forty-Second Street Flea
Circus, New York*, c. 1945, gelatin
silver print

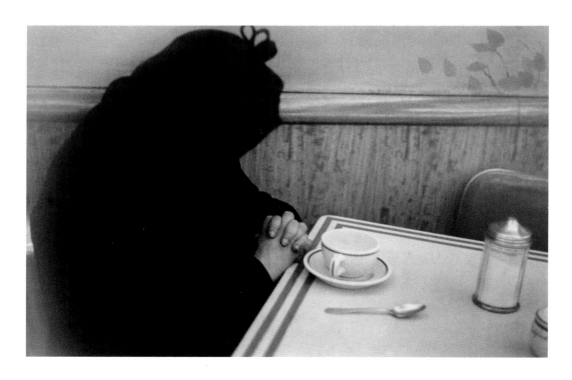

↑ "The Eight Million," *Flair*, September 1950, pages 30–31, photographs by Louis Faurer

← Louis Faurer, *Cafeteria, Lexington Avenue, near 51st Street, New York*, 1947, gelatin silver print

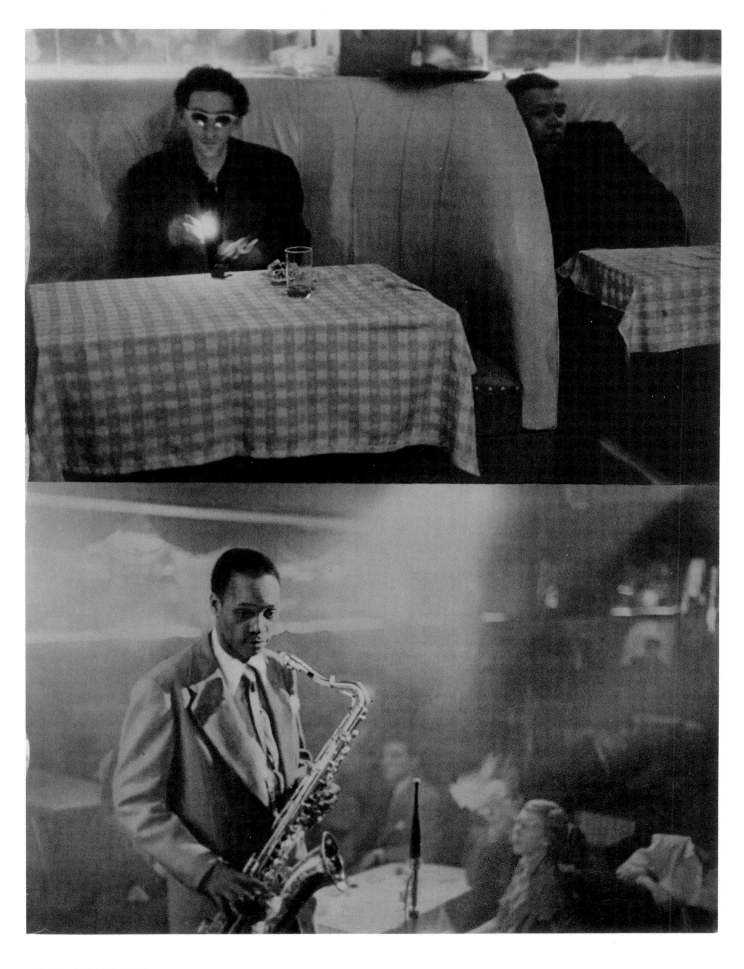

"Coolness," *Flair*, May 1950, page
29, photographs by Louis Faurer

← Robert Frank, *NYC for A.B.*, 1947, gelatin silver print

↗ William Klein, *Candy Store, Amsterdam Avenue*, c. 1955, gelatin silver print

→ William Klein, *Kid + Homeless, New York*, c. 1955, gelatin silver print

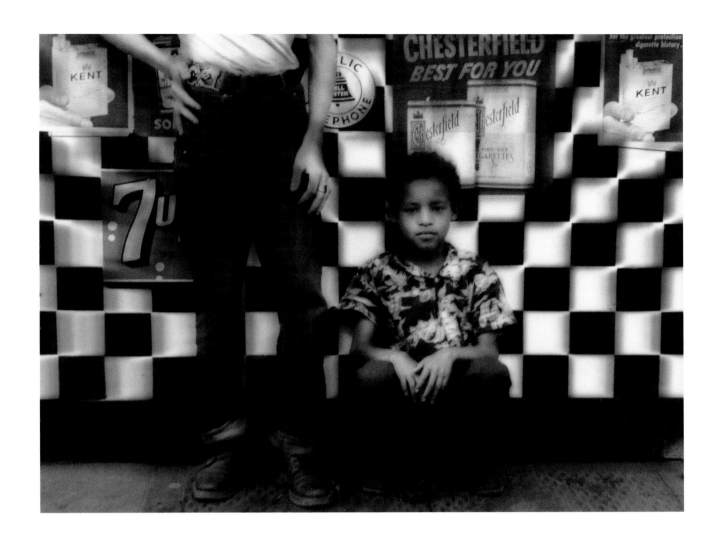

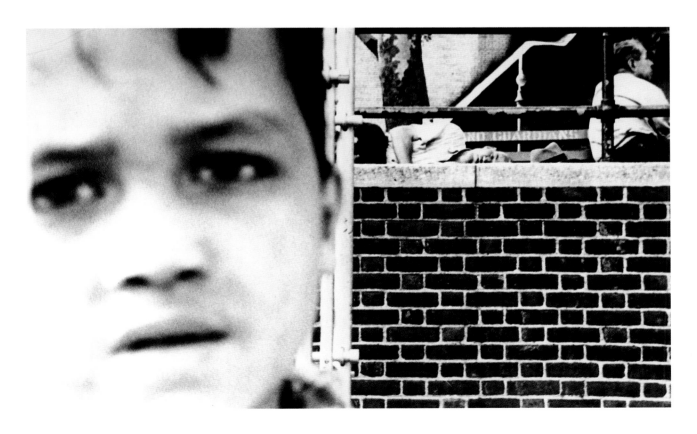

119

Saul Leiter, *Three Feet*, c. 1950,
gelatin silver print

Lisette Model, *Lighthouse,
Blind Workshop, New York*, 1944,
gelatin silver print

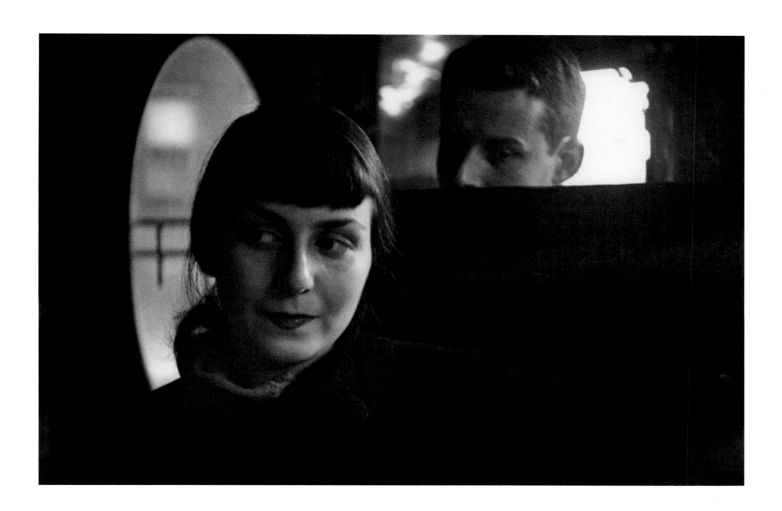

← Saul Leiter, *Canopy*, c. 1958,
chromogenic print

↑ Saul Leiter, *Dick and Adele*,
c. 1947, gelatin silver print

123

PROPRIETY AND PROVOCATION

Women, Émigrés, and Outliers in American Magazines at Mid-Century

Leslie Camhi

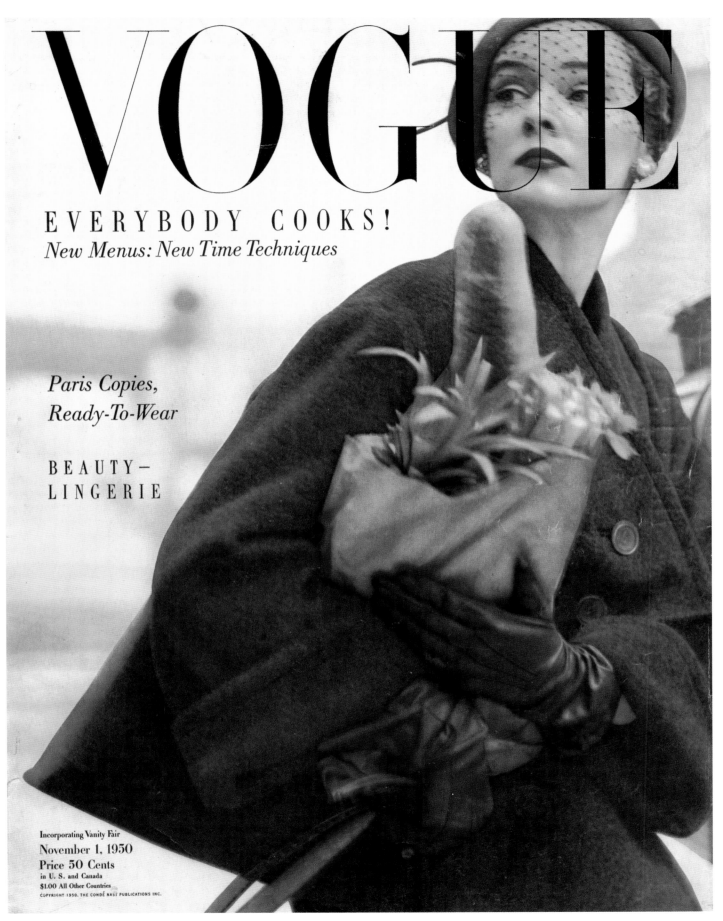

Cover of *Vogue*, November 1950,
photograph by Norman Parkinson,
art direction by Alexander Liberman

First cover of *Life*, November 23, 1936, photograph, *Fort Peck Dam, Montana*, by Margaret Bourke-White

promoted it also played a role—subtle at times, overt at others—in advancing ideals of independence and social engagement for women during the decades surrounding World War II. Belying the cliché (often borne out in real life) of the junior society editor—whose low salary was subsidized by family money, and whose employment would cease upon her marriage (preferably to a socially "advantageous" match)—many of the women who worked as art directors, editors, and photographers in the illustrated magazines of the 1930s, 1940s, and 1950s embodied these ideals. Many were also immigrants, and the avant-gardism they championed in their work, situated, like the experiments of the Bauhaus, at the border between art and commerce, was also reflected in the lives they led.

Carmel Snow (née White), perhaps the best known of these figures, emigrated from Ireland as a child and learned about clothes from the inside out in her widowed Irish mother's high-society dressmaking shops in Chicago and New York.[2] Hired at *Vogue* in 1921, she rose through the ranks, becoming fashion editor five years later and developing a working relationship of mutual devotion with the photographer Edward Steichen, who had made the (still controversial) leap from art to fashion.

Vogue, founded in 1892 as a weekly about fashion and society, still had a fusty look, with eighteenth-century typefaces and decorative borders framing illustrations. But by the mid-1920s, its owner, Condé Nast, was seeking to update the magazine. In 1928 he went shopping for talent in Europe and persuaded the multilingual, cosmopolitan graphic designer Mehemed Fehmy Agha, born to Turkish parents in the Ukraine, to join *Vogue* as art director. Agha set about modernizing the look of all Nast's publications,

In 1941 a U.S. government report listed "lipstick" as among the necessities whose production should be prioritized in wartime.[1] Far from mere frivolities, cosmetics were an important component of feminine armor, as women—laboring in factories, employed in relief work, leading government agencies, and heading families—would be increasingly called upon to meet the challenges of men's near-absence on the domestic front. A made-up face may have been associated, in times past, with the artifice of the theater's "painted women" or with prostitutes, but now it suggested an independent woman's strength and confidence.

The fashion world, with its emphasis on appearances, cultivation of luxury, and prescriptions for chic (parodied, most notoriously, in the "Think Pink!" musical number from the 1957 movie *Funny Face*) might be the last place one would be inclined to look for nascent feminist impulses among American women at mid-century. Yet fashion and the American magazines that

Propriety and Provocation

simplifying and systematizing the typography, and prioritizing photography over illustration.[3] Snow learned a great deal from him, but she still chafed under *Vogue*'s restrictions, wanting to move fashion photography beyond the stilted confines of the studio. According to Snow biographer Penelope Rowlands, "she once bought [*sic*] a photo of women on a balcony by the photo-journalist Margaret Bourke-White to a meeting at *Vogue*, only to have it be dismissed by the rest of the staff as 'just a snapshot.'"[4]

The young Bourke-White, meanwhile, paid great attention to style when she was just starting out on her storied career—sewing custom cloths, for example, to use with her heavy 4-by-5 camera in colors that matched her hats, gloves, and dresses.[5] In 1927, channeling the spirit of the new Machine Age in her first major professional coup, she photographed the blast furnaces of Cleveland's Otis Steel Company. "You weren't exactly dressed for the occasion," her mentor, Alfred Hall Bemis, recalled to her years later. "You had on some kind of a flimsy skirt and high-heeled slippers. And there you were, dancing on the edge of the fiery crater in your velvet slippers, taking pictures like blazes and singing for joy."[6] By 1936 her photograph of the WPA's Fort Peck Dam in Montana, its monumental supports towering like the pyramids at Giza, would land on the very first cover of *Life* magazine.[7]

It was in jumping ship to *Vogue*'s arch-rival, *Harper's Bazaar* (owned by newspaper magnate William Randolph Hearst), in October 1932 that Snow finally came into her own as an editor. She had married at thirty-nine (giving birth to the first of three daughters at forty), and the magazine would remain her primary passion. Her peculiar mixture of propriety (the pearls she wore even in her sleep during Paris couture week) and provocation (the early

morning Paris business meetings conducted from bed and punctuated by "vitamin" shots delivered by a uniformed nurse), and her combination of imperious taste and openness to new ideas, gave *Harper's Bazaar* a bracing jolt.

Even before she hired Alexey Brodovitch, the Russian-born art director who would revolutionize the magazine's look, Snow had made her first "discovery." At *Vogue* she'd heard of Martin Munkacsi, a Hungarian Jew then living in Berlin, whose sports photographs and reportage for German photo weeklies were imbued with modern speed and dynamism. Agha and Steichen had been interested in his work. But it was Snow who first employed him to shoot fashion. In October 1933, learning that Munkacsi was in New York for two days, Snow hired him to reshoot a swimwear feature that had been photographed against a studio's painted backdrop. Wanting an outdoor location, she chose the beach attached to the Long Island country club to which her blue-blooded American husband, George Palen Snow, belonged. Munkacsi spoke no English, so Munkacsi's friend and fellow Hungarian, the illustrator Frederic Varady, came along to translate.

The weather was cold and dull, but "the day I took those two Hungarians to the Piping Rock Beach is a day I will never forget," Snow wrote in her memoir.[8] In her description, it is as much an ethnic as an aesthetic breach—an infusion of immigrant energy and motion into staid and chilly Protestant environs. (Despite the sheen of Snow's high-society marriage, she was Irish Catholic, an immigrant, and her mother had been "in trade.")

After much hand waving and shouting into the wind, Snow and the society model Lucile Brokaw, the latter shivering in her bathing

suit, finally understood what the photographer wanted. The picture that resulted—of taut-limbed Brokaw running by the seaside, her bathing cape billowing out behind her—broke with the conventions of fashion photography in its frank athleticism and sheer vibrancy (see page 142). Far from a vision of marmoreal elegance, the model's legs had evident muscles. Fashion, photography, magazines, and the women who made and shaped them were suddenly on the move.

Ilse Bing was another photographer Snow commissioned, one whose radical work bridged the gap between the artistic and social ferment of Weimar Germany and the magazine world of New York. Born in 1899 to a bourgeois Jewish family in Frankfurt, Bing, who studied architectural history, first turned to photography to document buildings for her dissertation. By 1929 she had bought her first Leica, the revolutionary point-and-shoot 35mm camera whose light weight and small size made the act of photography feel like an extension of sight itself.[9] In fact, many professional photographers, accustomed to heavy, large-format view cameras and the highly detailed negatives they produced, initially dismissed the Leica as the plaything of amateurs, a toy of well-off young women in particular. But the camera's portability matched the increasing social mobility of young women in Weimar Germany with the rise of the edgy, sexually liberated *Neue Frau* (New Woman), a modern social type akin to the American flapper.

Bing joined the growing ranks of German intellectual photojournalists, contributing both single images to art publications and photo-essays to an illustrated supplement of *Die Frankfurter Zeitung*, Germany's leading liberal newspaper. She had a gift for capturing performers in motion—from the choreographer Rudolf Laban's modernist troupe to

a swirl of cancan dancers. But with rising economic instability and the ascension of the Nazi Party in the legislative elections of September 1930, the market for her photographs dried up; two months later, she immigrated to Paris.

The City of Light was quickly displacing Germany as the international center of avant-garde photography. The American Man Ray (born Emmanuel Radnitzky), the German-born Germaine Krull (the radical modernist photojournalist and photo-essayist), and the German American Florence Henri (the latter a role model for Bing) were all active there, as were a passel of Hungarians, including Brassaï and André Kertész. Women were prominent among émigré photographers in Paris in the 1930s: Gisèle Freund and Gerda Taro, who arrived as refugees from Germany; the Americans Berenice Abbott and former fashion model Lee Miller, who would shoot for both *Vogue* and *Harper's Bazaar*; and former Austro-Hungarians, including Rogi André and Lisette Model.[10] (Snow and Brodovitch would publish Model regularly in the 1940s after she and her husband immigrated to New York, including one of the photographer's signature images, the astonishing—and anti-fashion— *Coney Island Bather* (see page 114).

Photography's relatively low threshold for entry in terms of finances and training, and limited (if growing) prestige, helped to keep the field open for women. The camera's portability was particularly appealing to émigré photographers, many of whom were Jewish (Bing, of course, but also Freund, Taro, Kertész, and Ray), or half Jewish and married to Jews (Model), and eyeing developments in Nazi Germany warily.

In Paris, Bing moved between different milieus but found regular work in the fashion world.

She was introduced to *Harper's Bazaar* through Daisy Fellowes, an American-born socialite and leading figure of fashion who embodied the "hard chic" of the 1930s associated with designer Elsa Schiaparelli, and who had become the magazine's Paris editor. (During the August collections, Fellowes, one observer noted, was "a revolution herself, with her bare feet in sandals and her dress of white cotton piqué"—cotton, which Snow also promoted in the pages of her magazine, was considered a lowly, plebeian fabric, as opposed to crepe de chine.[11]) Bing's first photographs for the magazine were a series focusing on Fellowes's accessories, such as a gray felt hat by designer Caroline Reboux— a men's-style fedora that Fellowes wore rakishly pulled down over one eye, its androgynous appeal and abstract forms emphasized by Bing's close-cropped picture.

Though the 35mm camera was primarily associated with candid street photography, Bing's fashion photographs for *Bazaar* were all shot in studios and with artificial lighting. It was in the context of her work for *Harper's Bazaar* that the photographer said she learned to "model with light."[12] Her pictures of cast-off white gloves, or of a pair of gold lamé evening slippers, disembodied and glowing in the Paris night beneath the hem of a pleated chiffon gown, were imbued with surreal intensity. "Bing was among the first to focus, not so much on displaying the outfit, but on the essence of it, the sizzle, rather than the design underpinnings of it," says Sarah Morthland, an appraiser specializing in photography.[13] As such, she was an influence on photographers such as Lillian Bassman, who with Brodovitch art-directed *Junior Bazaar*, a six-page feature introduced in 1943 and aimed at the emerging youth market.[14]

Junior Bazaar was often used as a testing ground for new talent,

including, in 1944, an ambitious, twenty-two-year-old photographer, recently discharged from the U.S. Merchant Marines, named Richard Avedon. Photographs by Louise Dahl-Wolfe, a San Francisco native trained as a painter, dominated the fashion pages of "Big Bazaar" for more than twenty years (see pages 142, 144, 158–59). Her exquisite and witty color images often used contemporary painting and sculpture as both backdrops and sly commentary on the distinction between fine and applied art. But she was notoriously territorial. So *Junior Bazaar*, lower in prestige and more open, gave space to other photographers, many of them women who were pushing the boundaries of both style and society. Dahl-Wolfe had managed to keep Toni Frissell's war reportage out of "Big Bazaar," but in 1947 *Junior Bazaar* published her picture of the first American bikini, shot from high above the recumbent bather, almost like aerial reconnaissance photography. *Junior Bazaar* also printed Genevieve Naylor's bathing suit spread, "in which a black man could be glimpsed swimming in the same body of water as a group of frolicking models."[15] There was considerable protest in the offices at Hearst, but Snow prevailed.

Junior Bazaar was also the first to publish Bassman's fashion photography. Using innovative darkroom techniques, including bleaching and diffusing light with tissue paper or cigarette smoke, she created impossibly elegant, almost abstract silhouettes of models in lingerie and mid-century haute couture, their identities often obscured.

Bing, Naylor, and Bassman were unconventional and independent, free-thinking Bohemians. (Bassman, who had moved in with her future husband, the photographer Paul Himmel, at age fifteen, recalled Snow once slapping her across the face when the young art director

Propriety and Provocation

"ventured the opinion that marriage was overrated."[16]) But could one call Bing's and Bassman's work, in particular, with its anonymity and abstraction, feminist? Only, perhaps, in the sense that through it *Harper's Bazaar* was no longer providing, as *Vogue* had in its inception, a how-to manual, a template for leading a fashionable life. Instead, these very feminine images of glamour, intimate and sensual, produced by women for women, were invitations not to consume, but to dream—to inhabit, at least psychologically, a more beautiful world.

"To be a refugee is also a great opportunity for those who are determined to experiment," the German film critic and philosopher Siegfried Kracauer, then in exile in the United States, wrote in a letter to a friend.[17] Such was the case for a cadre of art directors—Brodovitch at *Harper's Bazaar*; Alexander Liberman at *Vogue*; and their contemporaries, Cipe Pineles and Miki Denhof, each of whom broke new ground in magazine design. But the price of exile, in personal terms, could also be steep.

Pineles joined *Vogue* as assistant art director in 1932. Born in Vienna in 1908, she immigrated as a teenager with her family to New York, finishing high school in Bay Ridge, Brooklyn, and studying art at Pratt Institute. She worked under Agha at *Vogue*, learning about typeface and layout, and designing experimental covers, like one from December 1939 that spelled out the magazine's name in jewelry. She moved to *Glamour*, another Condé Nast title, in 1939, becoming art director there three years later. It was at *Glamour*, a less prestigious title than *Vogue*, aimed at working women, that she began commissioning work from dozens of artists and photographers whom she would use throughout her career, including Kertész, Frissell, and Jacob Lawrence.[18]

Despite her remarkable professional growth, the immediate postwar years were troubling for Pineles. During the war, her first husband, the designer William Golden, had been drafted. In 1945, Pineles was able to take a leave of absence and join him for a few months in Paris, helping him design U.S. military publications. But something about her return to civilian life proved difficult.

Her biographer, Martha Scotford, remains circumspect about the possible reasons for Pineles's attempted suicide in 1946. One might turn to memories of another Viennese refugee, the distinguished mid-century magazine designer (and Liberman protégé) Denhof, for indications of the curious mixture of discipline and deep wounds that marked the experience of this group of exiles. Denhof, the daughter of a doctor who was a high-ranking Jewish official in the Austrian army, studied art as a teenager in Berlin between the wars and escaped Vienna with her family at almost the last moment, in 1938. Leslie Gill, whose mother, photographer Frances McLaughlin-Gill, worked with Denhof at *Glamour*, recalled going through the older woman's papers after her death and seeing a picture of Denhof's extended family on vacation before the war. "There were X's through perhaps thirty of the faces," she said, indicating those murdered in the Shoah.[19] Hired by Liberman as promotion art director at *Vogue* in 1945, this elegant woman with an understated personal style and an infallible eye would go on to become a key mentor of photographers such as David Bailey and Saul Leiter, and a bridge between the world of fine art, design, and fashion as art director at *Glamour* in the 1960s and later at *House and Garden*.

Yet the memory of the world she had left behind could come surging back unexpectedly. Amy Greene, wife of the photographer Milton

Greene, who as beauty editor at *Glamour* worked closely with Denhof, remembered walking back to the office with her from a business lunch with cosmetics industry executive Charles Revson at La Grenouille in the early 1960s. "All of the sudden, a couple of cops said, 'Step back, step back, the president, LBJ, is coming,'" Greene recalled. "Miki started trembling. I asked, 'What's the matter?' And she said, 'It reminds me of when the Nazis came to Vienna.'"[20]

Nevertheless, in the immediate postwar years, Pineles soldiered on. Joining *Seventeen* as art director in 1947, she was able to shape a magazine more fully to her vision. *Seventeen* appealed to a newly defined demographic: thoughtful, socially engaged high-school girls. To illustrate fiction, Pineles commissioned work by the leading artists of the day, including Lawrence, Yasuo Kuniyoshi, Reginald Marsh, Ben Shahn, and the brothers Raphael and Moses Soyer. She also contributed her own illustrations, such as one for February 1948, on the humble subject of potatoes. Tubers, peels, and kitchen instruments dance around the page, at once giddily animated and tightly controlled (see page 132). Pineles won numerous awards for her work, but it took the intervention of Golden, then working for CBS (where he would go on to design the network's famous "eye" logo), to gain his wife's admittance, in 1948, to the prestigious Art Director's Club. It was the first for a woman in the club's fifty-five-year history.[21]

Charm, which Pineles joined at its launch in 1950, was a fashion magazine aimed at a slightly older demographic—"the magazine for women who work" was its subtitle. "*Charm* was really the first feminist magazine," Pineles said in 1976. "There would have been no room for *Ms.* magazine if *Charm* had not been dropped."[22] Whether Pineles and

Camhi

When a magazine acquires a new editor, its readers have a right to know her plans. So, after a warm hello, come have a look at our ideas for CHARM . . . and for you. It has long seemed to me that we women who work (whether we be teachers or typists, nurses or saleswomen or editors) have needed a magazine. We have found good fashions in one, good beauty advice in another, good

"We Work Too," *Charm*, first issue, August 1950, photograph by Robert Frank, art direction by Cipe Pineles

her collaborators, the editor Helen Valentine and promotion editor Estelle Ellis, identified as feminists at the time is beside the point. Theirs was a stylish service magazine for women with two jobs—one in the obvious workplace and the other at home. In the postwar era, when women across America were being nudged into suburban complacency, the magazine was a quietly subversive force.

Pineles's dynamic layouts—for a spread juxtaposing stylish clothing for work with office machines or with the car culture of Detroit—emphasized the integration of fashion and everyday life. As Pineles described it, "We try to make the prosaic attractive without using the tired clichés of false glamour. You might say we are trying to convey the

attractiveness of reality, as opposed to the glitter of a never-never land."[23] How surprising to find, in a commercial magazine in mid-century, amid the insularity and complacency of Eisenhower's America, the flowering of Bauhaus ideals.

On a summer day in New York City in 1950s, the model Bettina, wearing a dark, belted dress with a bow collar, a hat, veil, and gloves, posed outside of Hunter College for two photographers who captured both her and each other in their viewfinders as, standing on either side of her, they faced one another across a narrow alley (see pages 160–61). Gordon Parks and Frances McLaughlin were both members of Vogue Studios, which Liberman had set up in the 1940s on one floor of the Graybar Building in Midtown. There, ten staff

photographers, including Horst P. Horst, Irving Penn, and Norman Parkinson, labored in-house for Condé Nast. At the time McLaughlin was the only woman, and Parks the only African American, employed there.[24] Both photographers were deeply invested in the realities that lay beyond the traditional frame of fashion's tightly prescribed world of elegance and artifice. So it is not surprising that they would take each other as subjects.

Parks's photograph is almost an essay on the changing roles of women at this pivotal moment in mid-century. The model's pose—rounded shoulders, arched back, and hips jutting forward—is drawn from the gestural vocabulary of haute couture. McLaughlin's stance, in contrast, is remarkably

straightforward. Shod in ballerina flats and with her legs spread wide, perfectly symmetrical, she is like a human tripod ensuring the stability of the camera that she grips with both hands as she peers into its viewfinder. Behind and above her, an inspirational quote (presumably from one of Hunter's founders), graven in stone, is not entirely legible—"We Are of Differ . . . ," it proclaims. With humor and humanism, Parks is posing the question: Caught between archaic elegance and the energy and exigencies of the modern Machine Age, whither women today?

Such a neat and tidy reading can't be ascribed to the photograph McLaughlin made of Parks that day. She shows him with his Rolleiflex mounted on a tripod, in a contemplative pause between shots. There are no inspirational quotes graven in stone behind him. The model stands impassively before him; off to one side and in the background are two more models, in high heels, hats, and suits with tightly nipped waists, awaiting, perhaps impatiently, their turn before his camera. With the empathy of a fellow outsider, McLaughlin portrays Parks surrounded but somehow apart from them all.

Born in Brooklyn and raised in Connecticut, McLaughlin (she added the hyphenated "Gill" after her husband's death) and her twin sister, Kathryn (later photographer Kathryn Abbe), studied applied art at Pratt Institute, where they received training in photography. In 1941 the sisters were both finalists in the Prix de Paris contest, a *Vogue*-sponsored search for new talent. Upon graduating, Frances worked briefly as a stylist for Montgomery Ward and as a photographer's assistant, while Kathryn landed a job assisting *Vogue* photographer Frissell. Two years later, Frissell introduced Frances to *Vogue*'s new art director, Liberman, whose background in photo-reportage informed his aim to cover fashion while injecting "the grit of life into this artificial world."[25]

At twenty-four, McLaughlin was young and stylish, but also socially aware, thanks in part to her early studies at the Art Students League of New York with the painters Marsh and Kuniyoshi.[26] The influence of Marsh's social realist style and gritty urban subject matter became evident

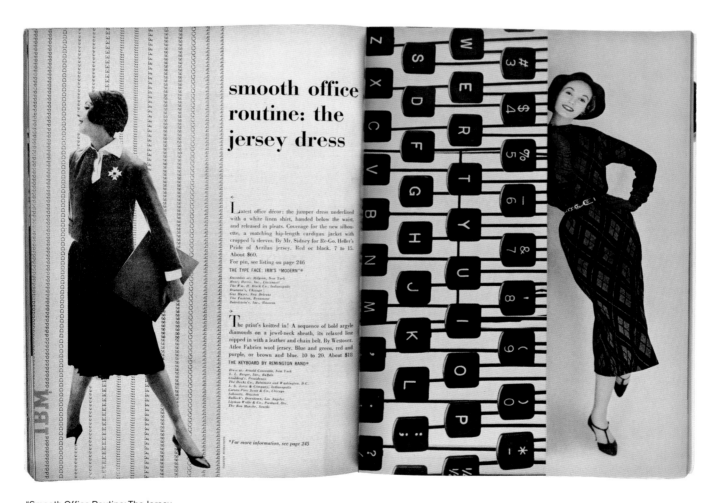

"Smooth Office Routine: The Jersey Dress," *Charm*, September 1957, photographs by Carmen Schiavone, art direction by Cipe Pineles

131

"Pick Your Potato," *Seventeen*,
February 1948, pages 90–91,
illustration and art direction
by Cipe Pineles

in her work for *Vogue* and *Glamour*. By 1952, she had "graduated" to photographing the haute couture collections in Paris, but before then she depicted models, sometimes wearing junior fashions that appear strikingly avant-garde today, walking along the derelict Bowery, posing in abandoned buildings or in the shadow of the Second Avenue El.

For Liberman, the work of his young protégée "bordered on a kind of improvisational theater."[27] McLaughlin preferred to cast models who could act and improvise in any given set of circumstances. She stressed the performative and narrative aspect of her work. "The theatre can be compared to photography in that it presents an illusion of reality by artificial contrivance, producing for the viewer the image of true life," she wrote.[28]

An incongruously elegant young woman in a windowpane-checked suit and fur muff strides down Third Avenue, one white-gloved hand gesturing enigmatically. Graffiti on the brick wall behind her depicts a comically stolid baseball player. Where is she headed?

A matron wearing what looks like chinchilla walks a dachshund amid a flock of pigeons in Venice's St. Mark's Square. She, too, is on her way somewhere.

The actress Nan Martin stands facing away from the camera, wearing a black cloche and a houndstooth jacket with buttons all down the back, her black-gloved hands holding open the newspaper she is avidly reading (see page 143). The brand-new United Nations headquarters (in 1949, still under construction) rises in the background— a beacon of hope in a world just barely recovering from disaster.

All these women are players in fashion's theater of modernity.

Notes

1
See Linda M. Scott, *Fresh Lipstick: Redressing Fashion and Feminism* (New York: Palgrave Macmillan, 2005), 222.
2
Penelope Rowlands, *Carmel Snow: A Dash of Daring* (New York: Atria, 2005), 17.
3
Martha Scotford, *Cipe Pineles: A Life of Design* (New York: W. W. Norton, 1999), 33.
4
Rowlands, *Carmel Snow*, 89.
5
Vicki Goldberg, *Margaret Bourke-White: A Biography* (New York: Harper and Row, 1986), 67.
6
Margaret Bourke-White, *Portrait of Myself* (New York: Simon and Schuster, 1963), 50.
7
Life, November 23, 1936.
8
Carmel Snow with Mary Louise Aswell, *The World of Carmel Snow* (New York: McGraw-Hill, 1962), 88.
9
See Larisa Dryansky, with photographs edited by Edwynn Houk, *Ilse Bing: Photography Through the Looking Glass* (New York: Abrams, 2006), 9ff.
10
See Dryansky, *Ilse Bing*, 27.
11
Frances McFadden, *Louise Dahl-Wolfe: A Photographer's Scrapbook* (New York: St. Martin's, 1984), xii.
12
Dryansky, *Ilse Bing*, 35. Carmel Snow also helped Bing and her husband, pianist and musicologist Konrad Wolff, acquire visas to come to the United States, after they were interned as enemy aliens soon after war broke out between France and Germany, thus narrowly escaping deportation as Jews. Ibid., 52–53.
13
Author interview, March 2019.
14
In November 1945 *Junior Bazaar* began life as a separate publication before being folded back into "Big Bazaar" three years later.
15
Rowlands, *Carmel Snow*, 349.
16
Ibid., 204.
17
Letter from Siegfried Kracauer to Daniel Halévy, January 8, 1947, quoted in *Siegfried Kracauer's American Writings: Essays on Film and Popular Culture*, ed. J. von Moltke and K. Rawson (Berkeley: University of California Press, 2012), 3.
18
Scotford, *Cipe Pineles*, 43.
19
Author interview, March 2019.
20
Ibid. "When the limo with LBJ came by, he waved to us," Greene continued. "Miki smiled, she was thrilled to have seen the President of the United States."
21
Debbie Millman, "On Brand," in *Leave Me Alone with the Recipes: The Life, Art, and Cookbook of Cipe Pineles*, ed. Sarah Rich and Wendy MacNaughton, with Maria Popova and Debbie Millman (New York: Bloomsbury, 2017), 21.
22
Quoted in Scotford, *Cipe Pineles*, 80.
23
Ibid., 93.
24
Author interview with architect Leslie Gill, daughter of photographers Leslie Gill and Frances McLaughlin-Gill, New York, March 18, 2019.
25
Martin Harrison, "Fashion: Classic Camera," *Independent*, April 2, 1995.
26
Author interview with Gill, March 18, 2019.
27
Harrison, "Fashion: Classic Camera."
28
In Alexander Liberman, *The Art and Technique of Color Photography: A Treasury of Color Photographs by the Staff Photographers of Vogue, House & Garden, and Glamour* (New York: Simon and Schuster, 1951).

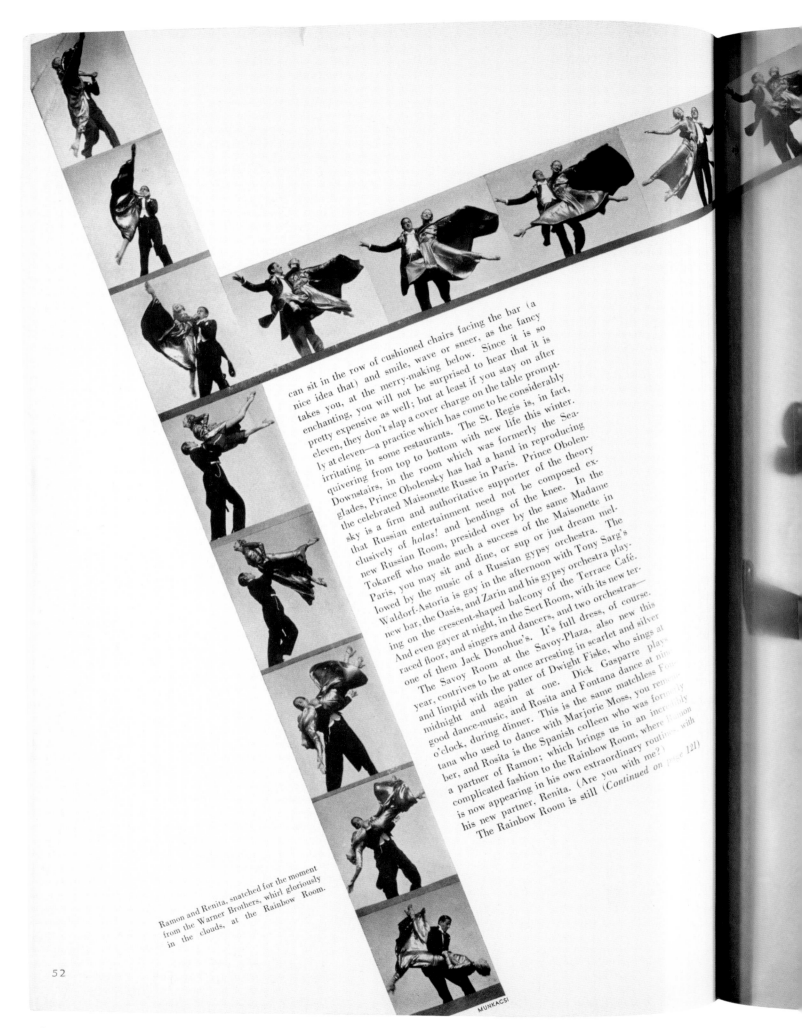

can sit in the row of cushioned chairs facing the bar (a nice idea that) and smile, wave or sneer, as the fancy takes you, at the merry-making below. Since it is so enchanting, you will not be surprised to hear that it is pretty expensive as well; but at least if you stay on after eleven, they don't slap a cover charge on the table promptly at eleven—a practice which has come to be considerably irritating in some restaurants. The St. Regis is, in fact, quivering from top to bottom with new life this winter. Downstairs, in the room which was formerly the Seaglades, Prince Obolensky has had a hand in reproducing the celebrated Maisonette Russe in Paris. Prince Obolensky is a firm and authoritative supporter of the theory that Russian entertainment need not be composed exclusively of *holas!* and bendings of the knee. In the new Russian Room, presided over by the same Madame Tokareff who made such a success of the Maisonette in Paris, you may sit and dine, or sup or just dream mellowed by the music of a Russian gypsy orchestra. The Waldorf-Astoria is gay in the afternoon with Tony Sarg's new bar, the Oasis, and Zarin and his gypsy orchestra playing on the crescent-shaped balcony of the Terrace Café. And even gayer at night, in the Sert Room, with its new terraced floor, and singers and dancers, and two orchestras—one of them Jack Donohue's. It's full dress, of course.

The Savoy Room at the Savoy-Plaza, also new this year, contrives to be at once arresting in scarlet and silver and limpid with the patter of Dwight Fiske, who sings at midnight and again at one. Dick Gasparre plays good dance-music, and Rosita and Fontana dance at nine o'clock, during dinner. This is the same matchless Fontana who used to dance with Marjorie Moss, you remember, and Rosita is the Spanish colleen who was formerly a partner of Ramon; which brings us in an incredibly complicated fashion to the Rainbow Room, where Ramon is now appearing in his own extraordinary routine, with his new partner, Renita. (Are you with me?) The Rainbow Room is still (*Continued on page 121*)

Ramon and Renita, snatched for the moment from the Warner Brothers, whirl gloriously in the clouds, at the Rainbow Room.

52

MUNKACSI

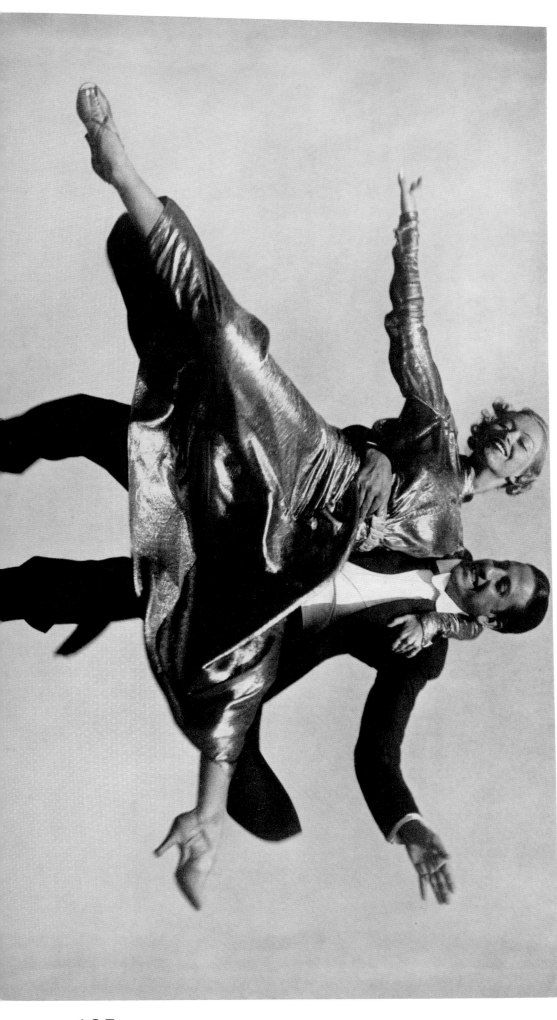

"A Week in New York," text by Margaret Case Harriman, "Ramon and Renita, snatched for the moment from the Warner Brothers, whirl gloriously in the clouds at the Rainbow Room," *Harper's Bazaar*, November 1935, pages 52–53, photographs by Martin Munkacsi, art direction by Alexey Brodovitch

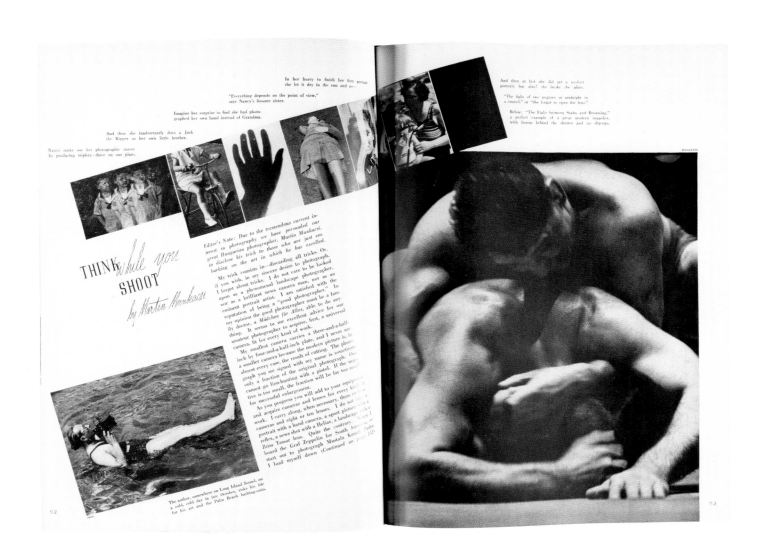

In her hurry to finish her fine portrait she let it dry in the sun and so—

"Everything depends on the point of view," says Nancy's lissome sister.

Imagine her surprise to find she had photographed her own hand instead of Grandma.

And then she inadvertently does a Jack the Ripper on her own little brother.

Nancy starts out her photographic career by producing triplets—three on one plate.

And then at last she did get a perfect portrait, but alas! she broke the plate.

"The fight of two negroes at midnight in a tunnel," or "She forgot to open the lens."

Below: "The Fight between Stabs and Browning," a perfect example of a great modern snapshot, with brains behind the shutter and no slip-ups.

THINK *while you* SHOOT *by Martin Munkacsi*

Editor's Note: Due to the tremendous current interest in photography we have persuaded our great Hungarian photographer, Martin Munkacsi, to disclose his trick to those who are just embarking on the art in which he has excelled.

My trick consists in—discarding all tricks. Or, if you wish, in my sincere desire to photograph. I forget about tricks. I do not care to be looked upon as a phenomenal landscape photographer, nor as an eminent portrait artist. I am satisfied with the reputation of being a "good photographer." In my opinion the good photographer must be a family doctor, a *Mädchen für Alles*, able to do anything. It seems to me excellent advice for our amateur photographer to acquire, first, a universal camera, fit for every kind of work.

My smallest camera carries a three-and-a-half-inch by four-and-a-half-inch plate, and I never use a smaller camera because the modern picture is, in almost every case, the result of cutting. The photograph you see signed with my name is sometimes only a fraction of the original photograph. The negative cannot go lion-hunting with a pistol. If the negative is too small, the fraction will be far too small for successful enlargement.

As you progress you will add to your equipment and acquire cameras and lenses for every kind of work. I carry along, when necessary, three or four cameras and eight or ten lenses. I do not do a portrait with a hand camera, a sport picture with a reflex, a news shot with a Heliar, a landscape with a Zeiss Tessar lens. Quite the contrary. When I board the Graf Zeppelin for South America to photograph Mustafa Kemal Pasha, I start out to photograph Mustafa Kemal Pasha. I load myself down (Continued on page 128)

The author, somewhere on Long Island Sound, on a cold, cold day in late October, risks his life for his art and the Palm Beach bathing-suits.

"Think While You Shoot," *Harper's Bazaar*, November 1935, pages 92–93, photographs and text by Martin Munkacsi

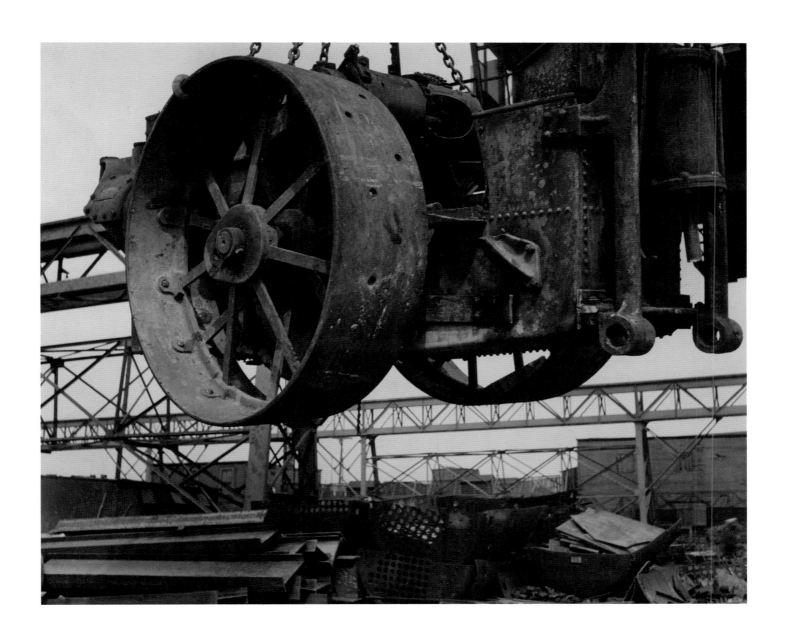

Josef Breitenbach, *"What About
Steel?" New Jersey*, 1942,
toned gelatin silver print with
hand-applied color

↑ Martin Munkacsi, *Nude with Parasol*, 1935, gelatin silver print

→ Martin Munkacsi, *Woman on Electrical Productions Building, New York World's Fair*, 1938, gelatin silver print

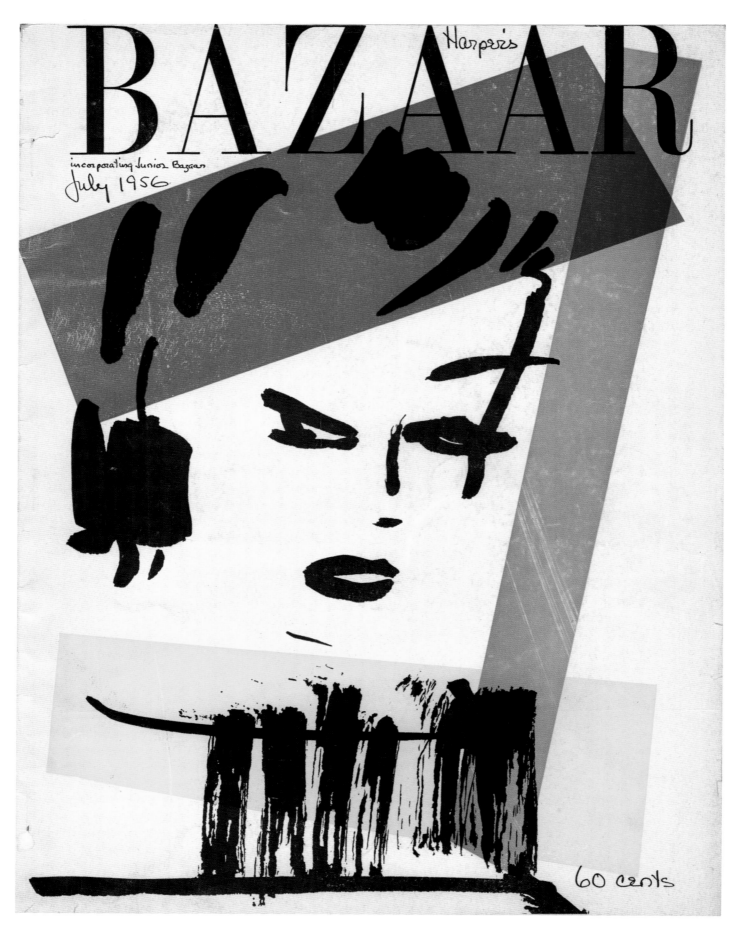

↑ Cover of *Harper's Bazaar*, July
1956, illustration by Sara Johns,
art direction by Alexey Brodovitch
and Lillian Bassman

→ "It Looks Like Spring," *Junior
Bazaar*, March 1946, photographs
by Leslie Gill, art direction by Alexey
Brodovitch and Lillian Bassman

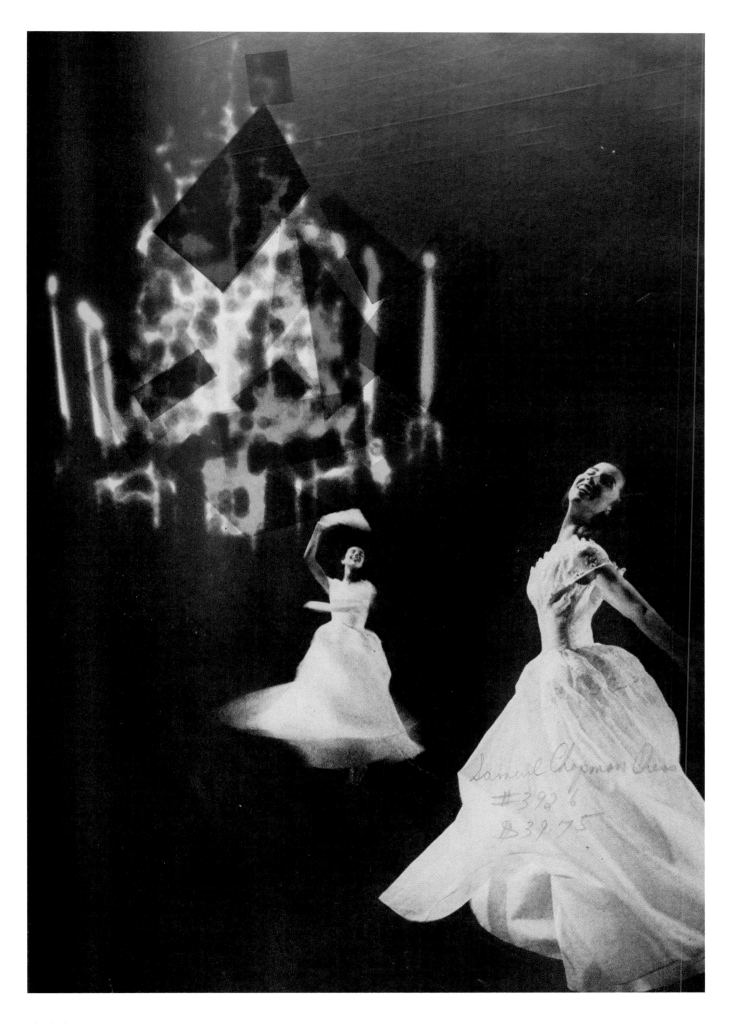

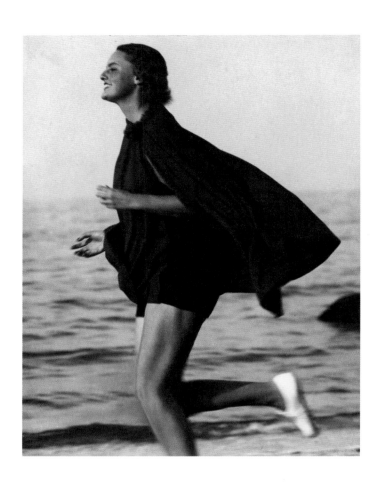

↖ Martin Munkacsi, Lucile Brokaw, *Harper's Bazaar*, December 1933, gelatin silver print

← Cover of *Harper's Bazaar*, March 1943, photograph by Louise Dahl-Wolfe, art direction by Alexey Brodovitch

→ Frances McLaughlin, *Nan Martin, Street Scene, First Avenue*, 1949, gelatin silver print

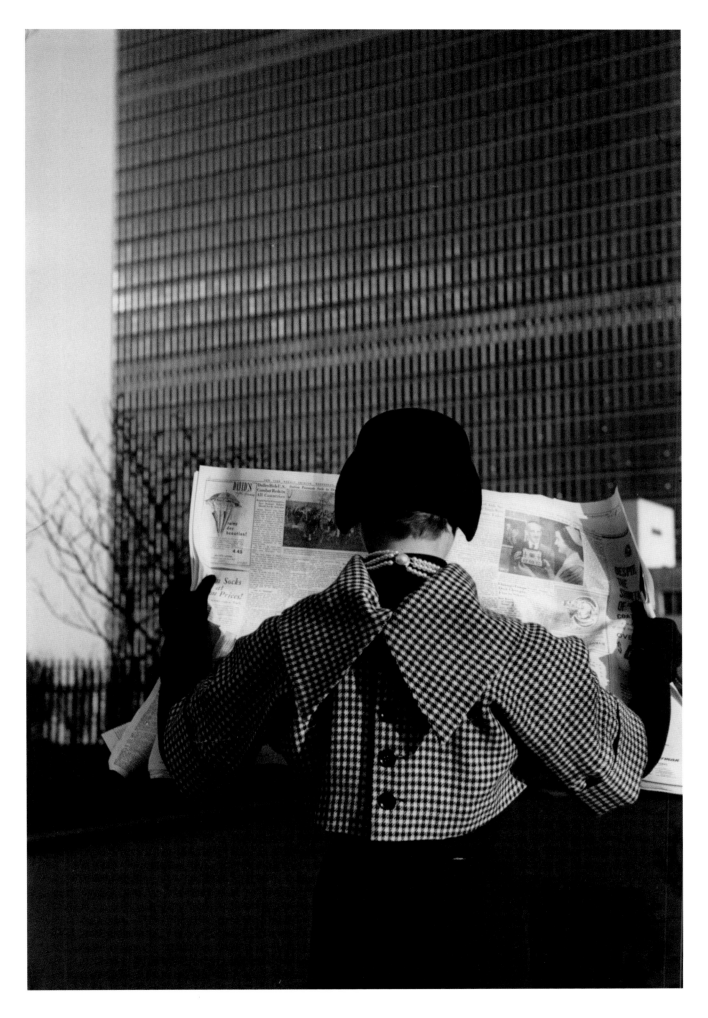

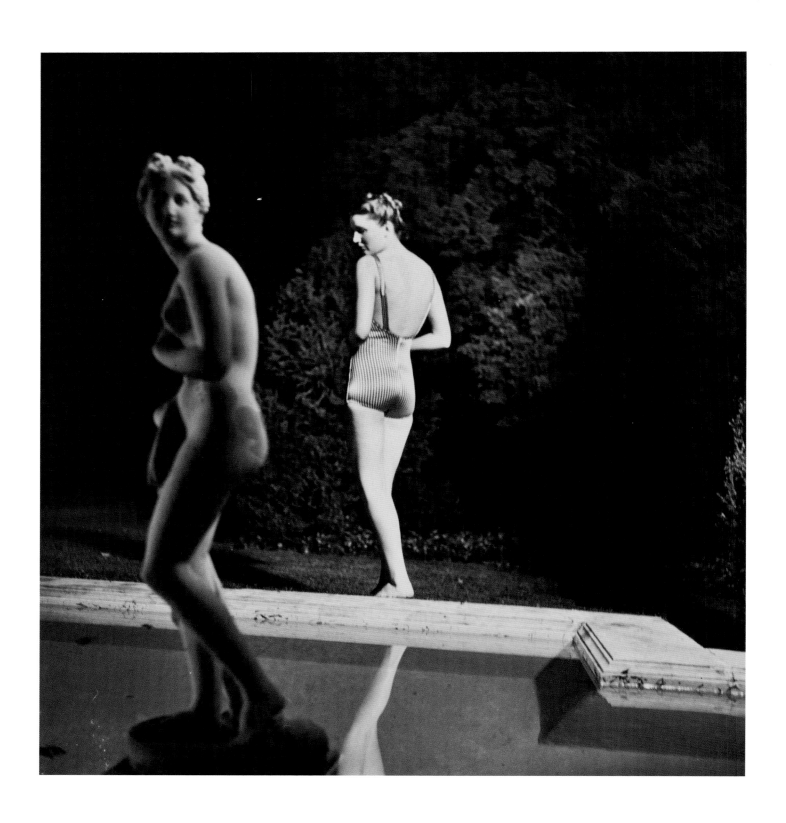

Louise Dahl-Wolfe, *Night Bathing*,
1939, gelatin silver print

144

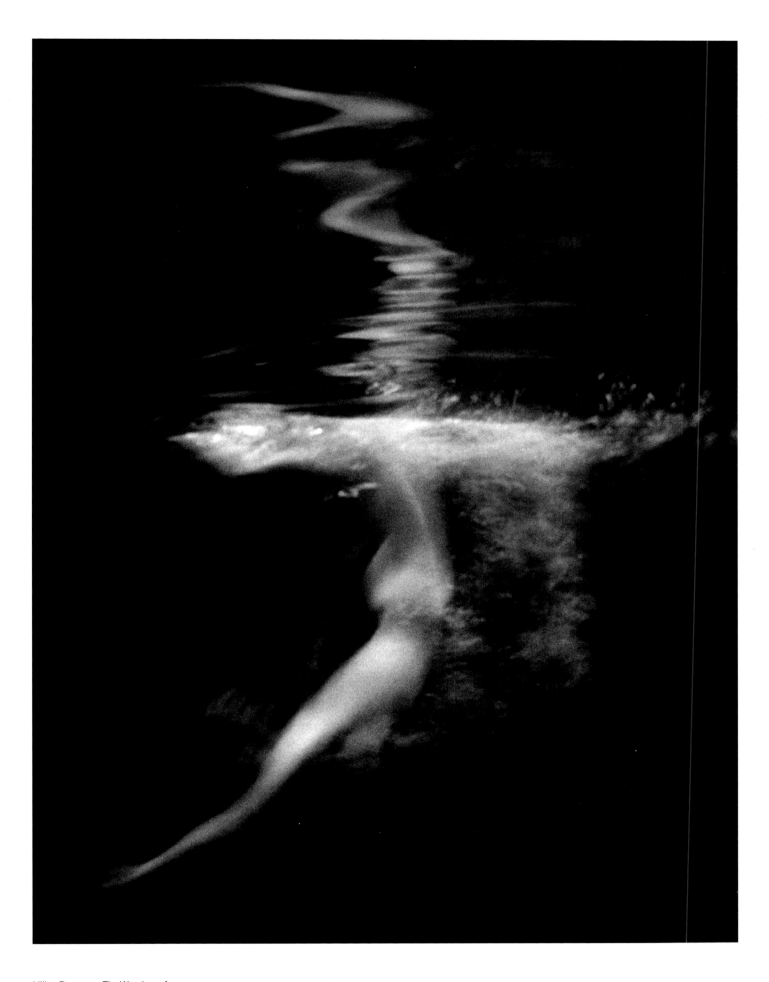

Lillian Bassman, *The Wonders of Water*, 1959, gelatin silver print

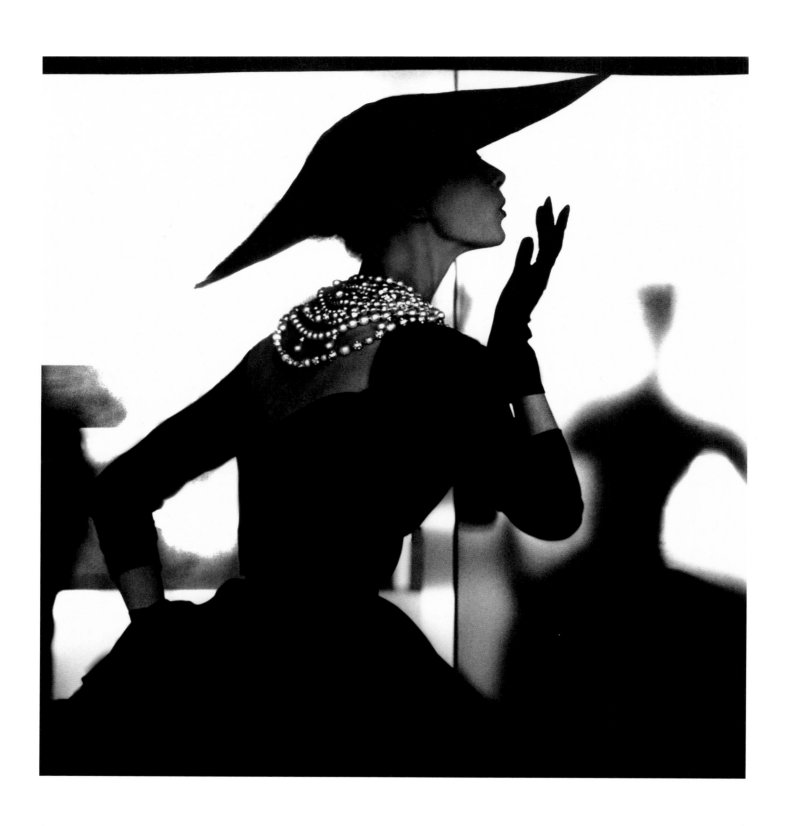

Lillian Bassman, *Barbara
Mullen Blowing Kiss*, 1950,
gelatin silver print

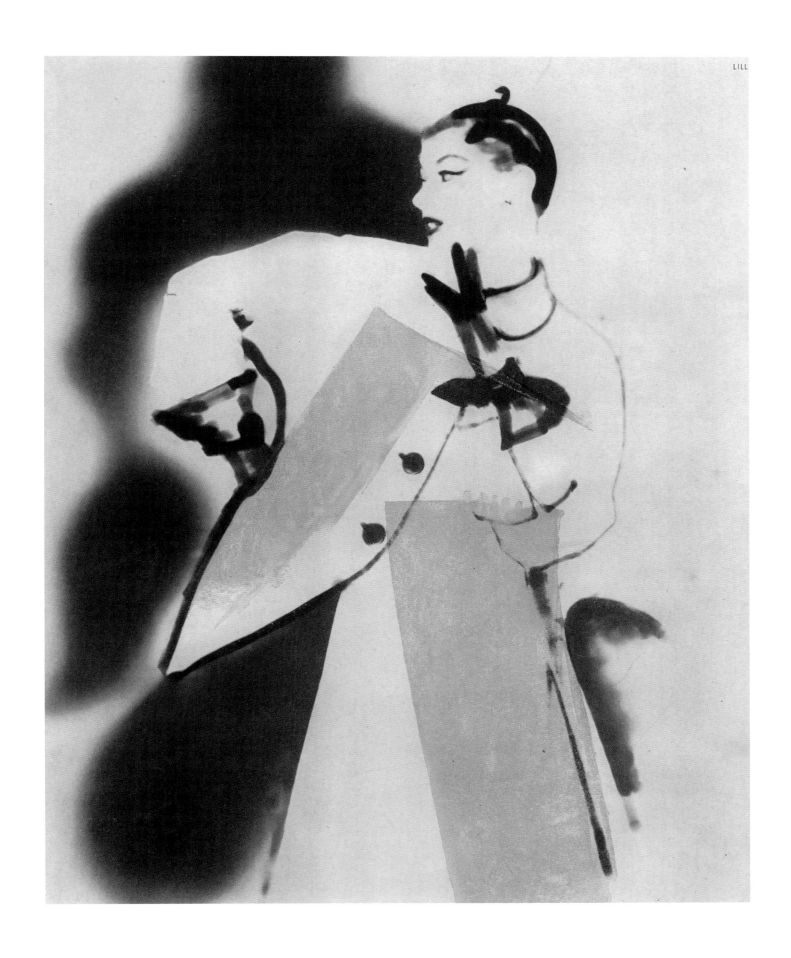

Lillian Bassman, *Mink Royal
Pastel and Midnight Blue, Barbara
Mullen, New York*, 1950, tearsheet

147

Louis Faurer, *Nude*, c. 1947,
gelatin silver print

Louis Faurer, *Freudian Handclasp,
New York, N.Y.*, c. 1947, gelatin
silver print

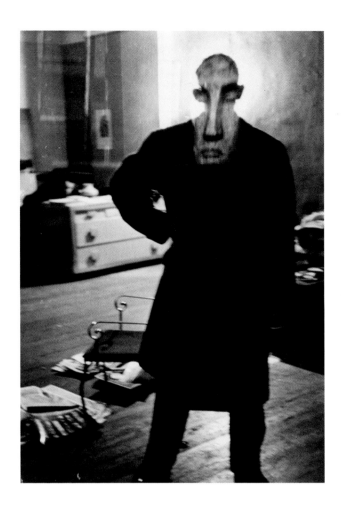

← Louis Faurer, *Robert and Mary Frank, San Gennaro Festival, New York*, 1950, gelatin silver print

↑ Louis Faurer, *George Barrows in Robert Frank's Loft, New York*, 1947–49, gelatin silver print

→ Louis Faurer, *Staten Island Ferry*, 1946, gelatin silver print

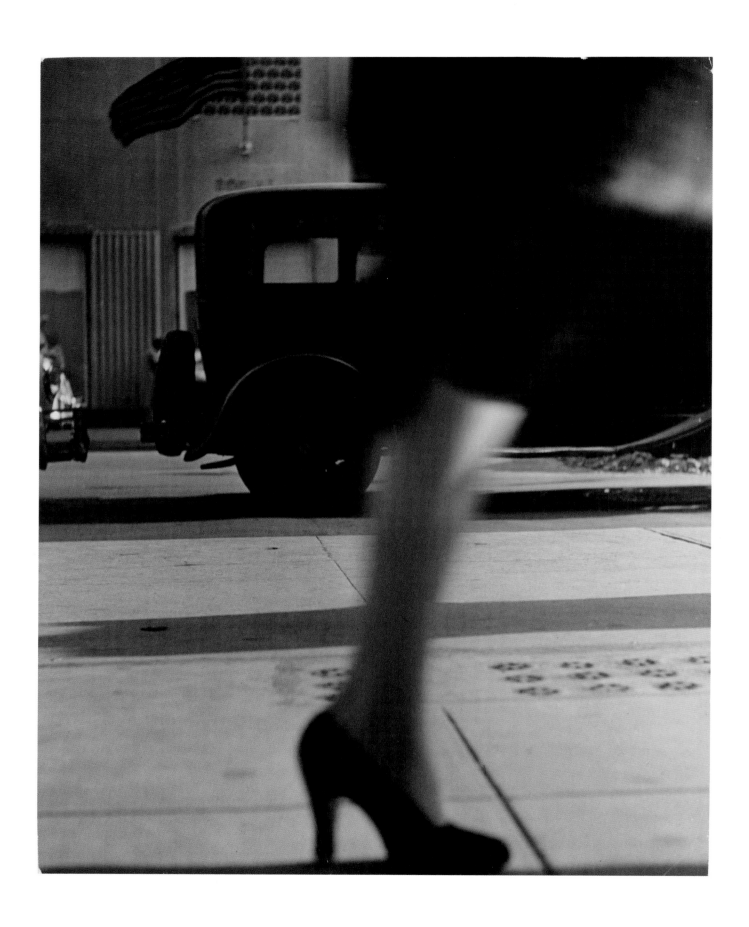

Lisette Model, *Running Legs, New York City*, c. 1941, gelatin silver print

Lisette Model, *Reflections, New York*,
1940, gelatin silver print

Bill Manville's book
*Saloon Society: The Diary
of a Year Beyond Aspirin,
New York*, 1960, interior
spread, photographs by
David Attie, designed by
Alexey Brodovitch

155

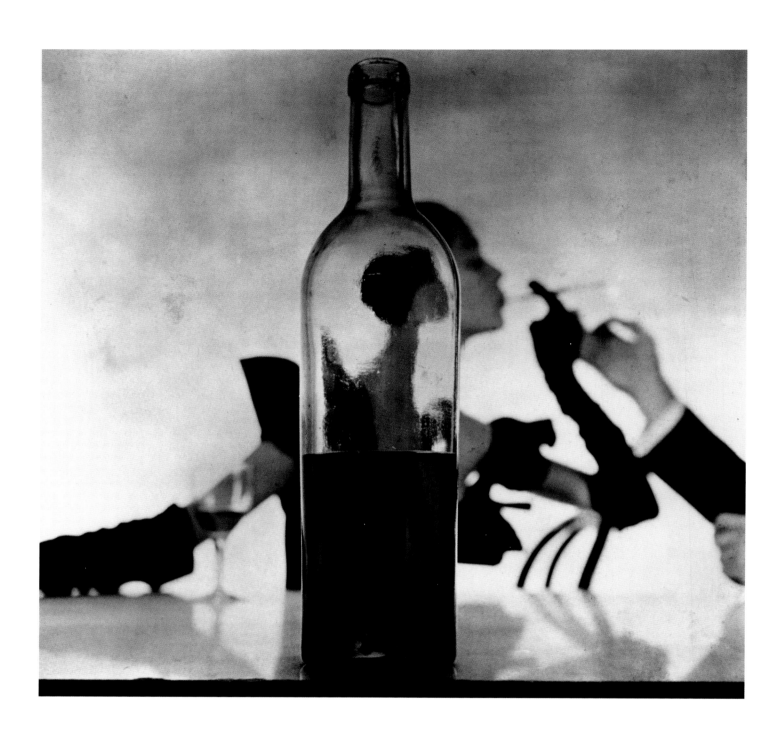

Irving Penn, *Man Lighting Girl's
Cigarette (Jean Patchett),
New York*, 1949, gelatin silver print

Irving Penn, *After-Dinner Games*,
New York, 1947, dye transfer print

157

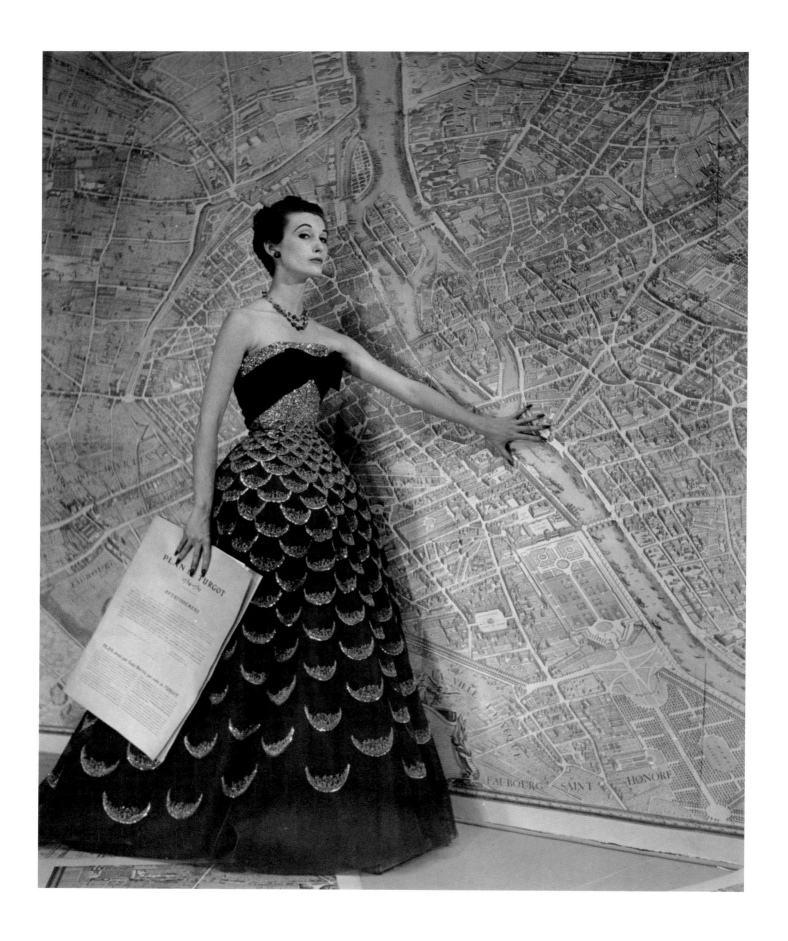

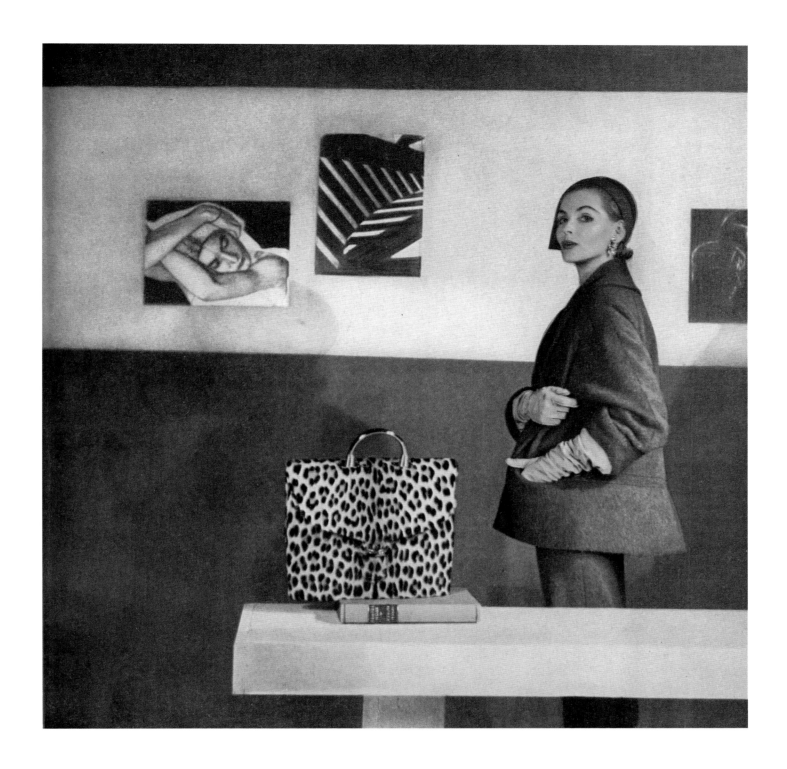

← Louise Dahl-Wolfe, *Plan de Paris, Mary Jane Russell in a Dior Dress*, 1951, gelatin silver print

↑ "Georgia Hamilton wearing a hat by Hattie Carnegie and suit by Tom Brigance, photographed at the Museum of Modern Art, New York, with photographs by Man Ray and Paul Strand in the background," *Harper's Bazaar*, September 1952, photograph by Louise Dahl-Wolfe

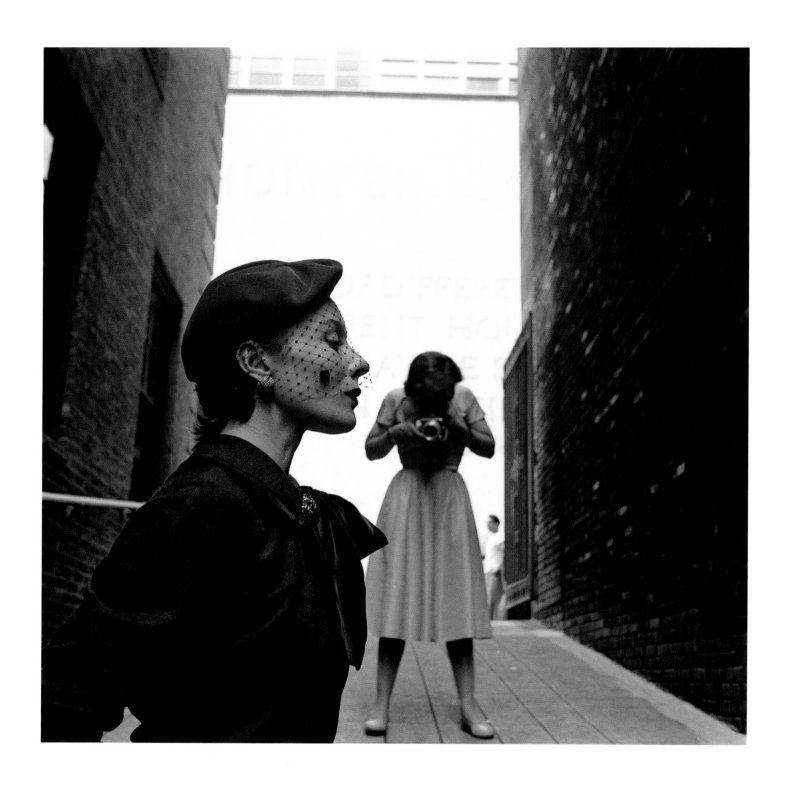

Gordon Parks, *Untitled, New York,*
New York [Frances McLaughlin-Gill
and Bettina Graziani Outside Hunter
College], 1950, gelatin silver print

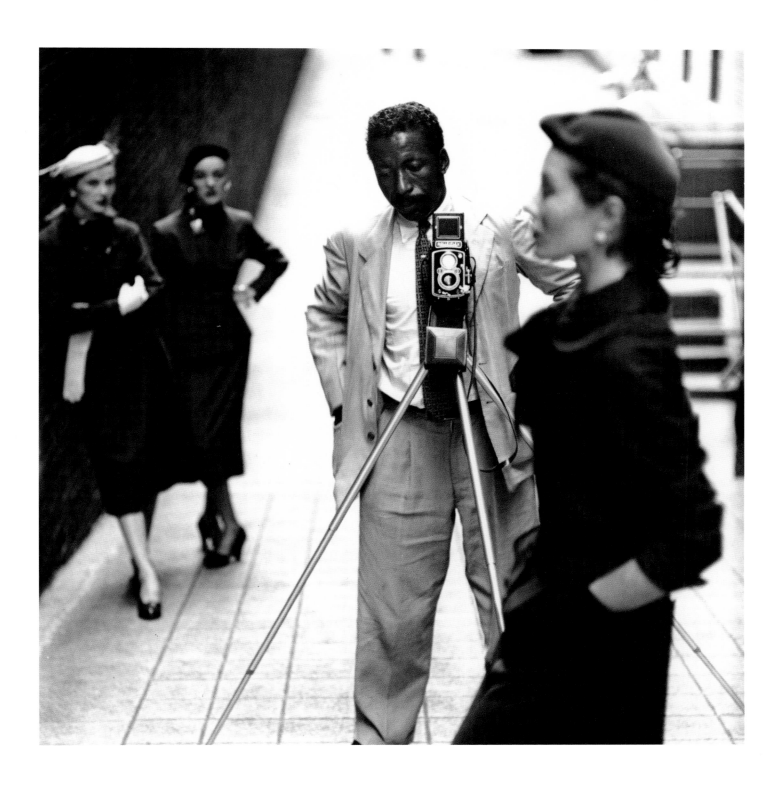

Frances McLaughlin, *Gordon Parks
and Bettina Graziani Outside Hunter
College, NYC*, 1950, photograph

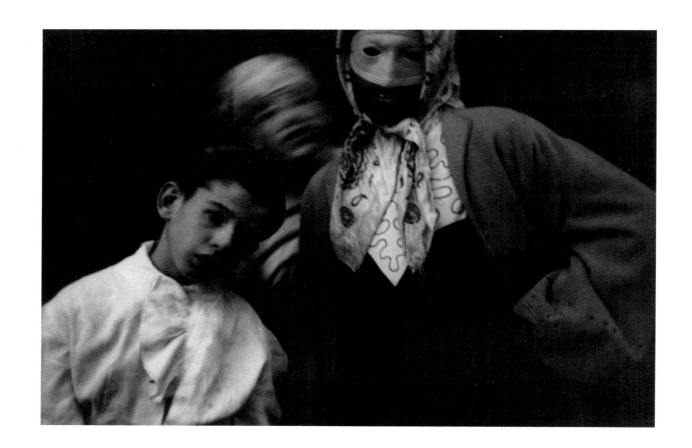

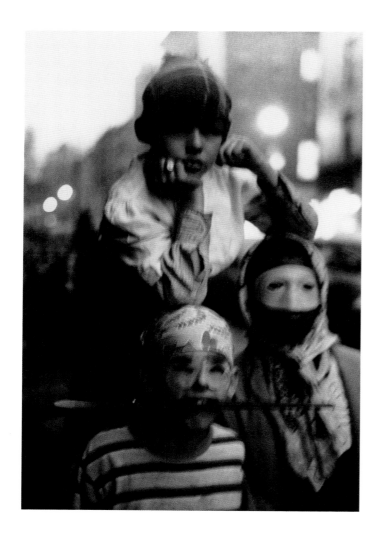

↑ Saul Leiter, *Halloween*, c. 1952,
gelatin silver print

← Saul Leiter, *Halloween*, c. 1952,
gelatin silver print

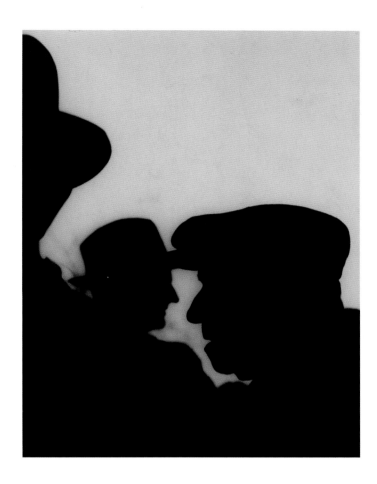

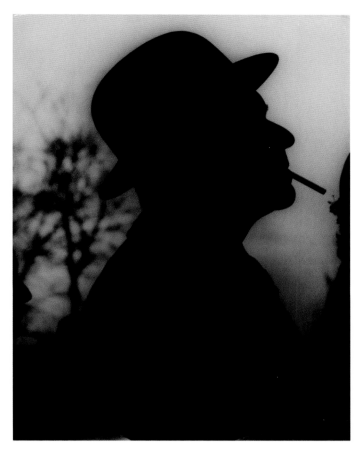

↑ ↗ ↓ ↘ Saul Leiter, four images
from *Wedding as a Funeral* series,
c. 1951, gelatin silver prints

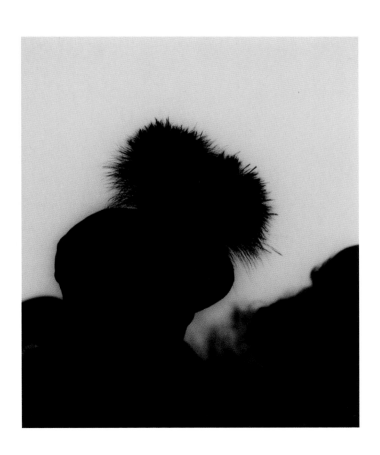

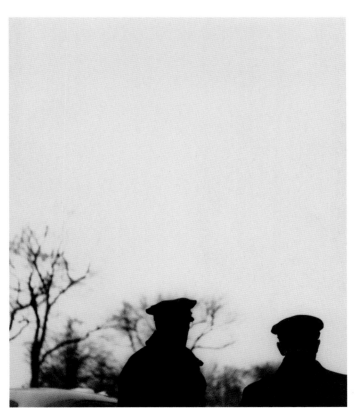

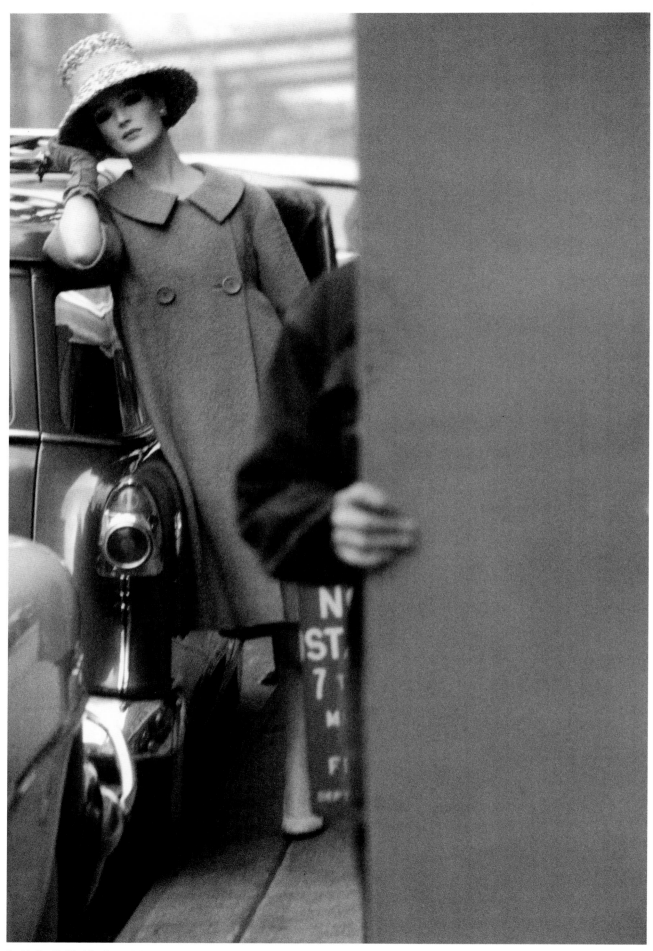

Saul Leiter, *Untitled*, for *Harper's Bazaar*,
February 1959, Cibachrome print

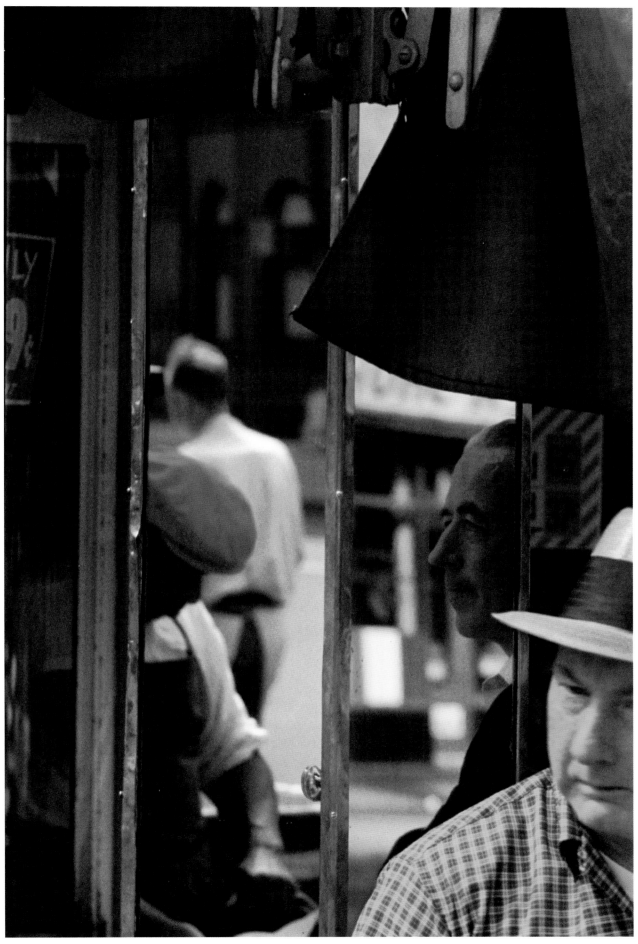

Saul Leiter, *Reflections*, 1958,
chromogenic print

ASTONISH ME!

Photography, Graphic Design, and Mid-Century Visual Culture

Marvin Heiferman

166

"Newsstand," *Look*, 1947,
photograph attributed to either
Jim Chappelle or Stanley Kubrick

Heiferman

It was in Paris, in the years leading up to the First World War, that a terse provocation—*Étonnez-moi!* (astonish me)—first voiced by Sergei Diaghilev, the impresario of the Ballets Russes and a ringmaster of avant-garde collaborators—became a challenge that would rouse artists in all media and enliven culture for decades to come.[1] In *Make It New*, Ezra Pound's 1934 collection of essays, the American poet also argued for cultural churn and the need for artists to refresh the ideas and tools of the past in order to usher in more contemporary and relevant modes of expression.[2] Historically, echoes of those exhortations—*Astonish Me! Make It New!*—have goaded risk-taking creatives of all sorts, as well as the venues that present their works. And so, when innovators in photography, graphic design, and American magazine production began working together in the period between the Great Depression and the Cold War, the result was a transformation not only in publishing but in visual culture at large.

Diaghilev's demand for wonderment was appropriated by the art director Alexey Brodovitch, a former Ballets Russes set decorator, who at *Harper's Bazaar* and *Portfolio* "invented a new way of designing the page, in which the photograph and page itself are interactive and synergetic."[3] In addition to his magazine work, Brodovitch taught classes in which he mentored a generation of graphic designers and photographers, urging them to devise visual strategies that would kindle astonishment and viewer engagement: "We must provoke the interest of the audience," he wrote. "Everybody is not creative in the way of thinking. . . . The most important thing in communication is how to provoke this. How to present. How to shock."[4]

The aesthetic, informational, and business imperatives to surprise readers and keep visuals lively were all driving forces in New York's frenetic mid-century media environment. Throughout the 1930s, nine daily newspapers competed for readers and advertisers by publishing multiple editions throughout the day and evening.[5] In magazines, the dynamic relationship linking photography and graphic design was made palpable in the dazzling displays of covers that dotted newsstands and filled the pages of periodicals with eye-catching mixes of editorial and advertising content.

Photography, when introduced a century earlier, had quickly established itself as an attention-getting medium that, while valued primarily for its objectivity, could also be exploited for the novel optical and narrative perspectives it could just as efficiently deliver. By the 1920s, visual provocateurs in a range of pioneering modern art circles were eagerly pushing photography in yet another direction by systematically investigating the medium's conceptual, visual, and social potential. In both his photographic works and publications, for instance, the Hungarian-born László Moholy-Nagy emerged as a passionate spokesperson for what became known as New Vision, an approach to image making that, rather than fixating on photography's representational strengths, vigorously explored the more abstract and disruptive qualities of photographic vision: "the view from above, from below, the oblique view, which today often disconcert people."[6] Like other inventive European image makers and shapers of the period—including Herbert Bayer, Will Burtin, György Kepes, Alexander Liberman, and Herbert Matter, who all immigrated to and found employment opportunities in America—Moholy-Nagy understood how it was "only in recent years that the course of [photography's] development has allowed us to see beyond the specific instance and recognize the creative consequence."[7]

Given the displaced avant-gardists' firsthand experiences with Constructivism, Surrealism, Futurism, and Bauhaus philosophy, the challenge they faced—once they arrived in what the merchant John Wanamaker called the "land of desire"—was to adapt their European mindsets to America's hyperactive and photographically driven consumer culture and mass-media markets.[8] "Photographs have the kind of authority over imagination to-day, which the printed word had yesterday, and the spoken word before that," wrote Walter Lippmann in his pioneering 1922 book, *Public Opinion*, about the ways Americans relied on photography to communicate with each other. Photographs, he said, "seem utterly real. They come, we imagine, directly to us without human meddling, and they are the most effortless food for the mind imaginable."[9] But in practice, the ways that powerful mass-media pictures were conceived of and reached large audiences were neither direct nor simple, but calculated. Both genesis and delivery of pictures that informed and, at times, astounded the public—photographs that documented what people, things, and events actually looked like, or, with some hands-on finessing, suggested what they could or should look like—were end products of collaborations in which photographers, publishers, art directors, photo editors, and advertisers had varying degrees of input.

In the world of picture magazines at that time, it was *Vu* (1928–40)—the French pictorial weekly created by Lucien Vogel, art-directed for a while by Alexander Liberman and featuring images by photographers including Brassaï, Henri Cartier-Bresson, Robert Capa, André Kertész, and Man Ray—that set a high global standard for

publications and their ambitious creative teams (see page 32). *Vu*'s double-page layouts were renowned for presenting picture stories "full of sharp angles and wild proportions—vigorous, effusive, dizzying, almost violent."[10] The groundbreaking magazine so consistently rejected staid graphic design that its issues came to serve "as textbooks for the next generation of designers."[11] *Vu* was even the inspiration for later and far more conservative magazines like *Life*, whose founding publisher, Henry Luce, was said to have admitted "that without the example of *Vu*, *Life* would never have existed."[12]

It was photography's ability to astonish that would become *Life*'s unique perspective and strength. In a confidential prospectus that circulated around Time, Incorporated's office in 1936, Luce defined his vision for a new magazine whose impressive weekly deployment of photography would open the eyes and minds of readers, enabling them

> to see life; to see the world; to eyewitness great events; to watch the faces of the poor and the gestures of the proud; to see strange things— machines, armies, multitudes, shadows in the jungle and on the moon; to see man's work—his paintings, towers and discoveries; to see things thousands of miles away, things hidden behind walls and within rooms, things dangerous to come to; the women that men love and many children; to see and take pleasure in seeing; to see and be amazed; to see and be instructed.[13]

Luce understood photography to be a "new language, difficult, as yet unmastered, but incredibly powerful."[14] And so at *Life*, photography became the publication's motivation, message, and messenger.

Ironically, in an era when brilliant designers at special-interest magazines were experimenting with fanciful or aggressive graphic solutions to bolster the impact of the printed page, Luce chose to focus on the pictures. In its straightforward presentation of carefully shot and shrewdly edited photographic images, *Life* underscored what the German cultural critic Walter Benjamin had realized a few years earlier: photography had, on its own, become "more and more modern, and the result is that it is now incapable of photographing a tenement or a rubbish-heap without transfiguring it. Not to mention a river dam or an electric cable factory: in front of these, photography can now only say 'How beautiful.'"[15]

Interestingly, the visual template for *Life* was not devised by a creative art director but by Paul Hollister, an advertising executive at Macy's who, after sending a blistering critique of the magazine's first mock-up to Luce, was hired to overhaul its look. Hollister's strategy was to make *Life*'s pages conform to "a total 'basic format' character: to 'sell' each page for itself . . . to clean up margins and gutters; to eliminate sloppy disturbances and tricks from the page."[16] His disdain for stylish art direction was articulated in his suggestions for how designers should be housebroken to conform to *Life*'s style:

> On a table at his left put your basic format dummy for reference. On a table at his right feed him batches of photographs, with a note saying you want one, two, four or eight . . . and any suggestions you have for playing up any particular angles of the picture story. So he makes layouts from the pictures. If they are right, you pat him on the head. If they have strayed from the mood of the basic format, you take a small hammer, which you have

chained to the wall for the purpose, rap him smartly over the skull, point severely to the basic format dummy—cry "no, no, no! Naughty!" He then repents and makes the layout right, or you get yourself a new art director.[17]

Life's punchy images and accessible design delighted the public and took media-business insiders by surprise. Luce initially projected that the magazine might sell 500,000 copies and break even in two or three years. But the entire run of *Life*'s first issue, all 250,000 copies, sold out within hours on the day of its release, creating what one Los Angeles news vendor said was the "heaviest demand . . . of any publication ever known."[18] Within a year, 1.5 million copies of each issue of the large-format, photo-filled, and formidable weekly—printed on bulky stock and weighing in at about a pound—were regularly being sold.[19] By the late 1940s, *Life* had 5.2 million subscribers, and it hit its peak circulation of 8.5 million in 1969, three years before it dramatically stopped regular publication, a casualty of changing media preferences and markets.[20] "Before television," the design historians Steven Heller and Karen Pomeroy wrote, "no other medium reached as many individuals at once, and for decades no magazine stamped the collective consciousness with as many indelible images."[21]

One explanation for *Life*'s runaway success was that by emphasizing photographs over text, it upended one of print media's most entrenched graphic relationships, that a picture's function was to illustrate text. In *Life*, the opposite was the case. Photographs did the heavy lifting in the presentation of news, cultural, and human-interest narratives, and text was marginalized, serving more introductory or anecdotal functions. This reversal of convention in printed matter was,

Heiferman

American family reading *Life*
magazine in 1958

however, not quite as startling as it was a logical step and smart business decision. Back in 1920, when the *Daily News* declared itself to be "New York's Picture Newspaper," the daily reiteration of that slogan and brash presentation of photographic images (which often triggered astonishment with their sensational content) were credited with boosting the tabloid into profitability.[22] About the same time, a far more nuanced understanding of the partnership of photography and graphic design was also evolving. In the seminal 1928 publication *The New Typography*, Dutch designer Jan Tschichold pinpointed the transformation taking place in print communication: "The picture-hunger of modern man is satisfied today chiefly by photo-illustrated

newspapers and magazines; and advertising, especially in the USA," wrote Tschichold. "As a consequence of the purity of its appearance and of the mechanical production process, photography is becoming the obvious means of visual representation in our time."[23]

Recognizing that paradigm shift and advocating for an approach to graphic design that recalibrated the relationship of text and image for the twentieth century, Tschichold argued for an amalgam of the two. Acknowledging that words and photographs worked differently when presented separately, Tschichold explained that if graphic designers conceived of text and images working together, a new unity would be created, one where "harmony

lies in the contrast of form and colour" and "both have two things in common: their objectivity and their impersonal form, which mark them as suiting our age."[24] Seen in less hierarchical juxtaposition with each other, photography, text, and illustration could combine to define something distinctively modern and visually challenging. On any given page, representation and abstraction, and photography's depiction of three-dimensional space, seen in juxtaposition with flat planes of typography, blocks of color, and white space, would interact and establish a new graphic look and logic. And once they did, "the verbal and visual elements of modern communication," as George Lois, one of the late twentieth century's most provocative art directors, would later

Astonish Me!

Alexey Brodovitch, art director
of *Harper's Bazaar*, working on
a Paris fashion layout, 1937,
photograph by George Karger

describe it, became "as indivisible as lyric and music in a song."[25]

From the 1930s through the 1950s, a number of influential émigré art directors—many of them photographers themselves and all well versed in the "new European Style of layouts"—rose to prominence as their "departure from the static, stilted look of all American magazines at the time" injected excitement into American graphic design.[26] When Mehemed Fehmy Agha arrived in New York to become the art director of *Vogue*'s U.S. edition, he "immediately broke through the restrictive antiquarian ideas of page layout, photography and illustration."[27] Agha spearheaded the transformation of the fashion magazine, with the help of his

associate, Cipe Pineles, at *Vogue*, as well as makeovers of other Condé Nast titles, including *Vanity Fair*.

As the art director of the Hearst Corporation's rival fashion magazine, *Harper's Bazaar*, from 1934 to 1958, Brodovitch exerted an industrywide influence as the "tireless advocate of photography's powers of communication."[28] Brodovitch would go on to play an unprecedented role in the shaping of American design, publishing, and photographic work for the next four decades. At *Harper's Bazaar* and the short-lived *Portfolio* magazine (1949–51), Brodovitch created work that was characterized by its audacity, intelligence, and wit. He was known and widely admired for his cinematic use and idiosyncratic cropping of

photographs (see page 134).[29] Frank Zachary, *Portfolio*'s editor, recalled of Brodovitch's work process: "He used the photostat machine like a note pad. He would get stats of every photo, often different sizes of the same piece, in tiny increments that might vary from a quarter inch to an inch, or from an inch to two inches, and so on. You would see him surrounded by all these stats. But as he put them down, my God, all of a sudden, a spread materialized beautifully proportioned, everything in scale, with just the right amount of white space, type and picture mass."[30] "His need for visual excitement was tremendous. He was always waiting for that one step forward that would juice him up a bit," is the way Lillian Bassman described the man who, apart from

his corporate job, and in the popular Design Laboratory workshops he conducted, mentored students, many of whom became important mid-century American art directors and astonishing image makers in their own right: Diane Arbus, Eve Arnold, Richard Avedon, Marvin Israel, Lisette Model, Irving Penn, Garry Winogrand, and Bassman, as well.[31]

When Alexander Liberman, who had done graphic design at *Vu* in the early 1930s, arrived in America and became *Vogue*'s art director in 1943, he, too, devoted himself to rethinking how image and text worked together. "I had always resented the fussy, feminine condescending approach to women by women's magazines," he later explained. "I thought it was important to shake up this rather somnolent society."[32] Liberman, partial to restraint in his layout preferences, felt that graphic design that called attention to itself was meaningless.[33] And during World War II and the years that followed, it was the vigor of mid-century photojournalism "in general and the emergence of a daring paparazzi" that led Liberman to rethink his priorities and steer *Vogue* toward a broader cultural approach and topical look.[34] "It seemed to me that Brodovitch was serving the same purpose as Agha had served," Liberman said, "which was to make the magazine attractive to women—not interesting to women. . . . So I defended a more journalistic approach—rougher lettering, no white space, crowded pages, messier layouts."[35]

Recalibrating the relationship of photography and text on the printed page was not solely confined to creatives modernizing the visual identity of American fashion magazines. On the pages of numerous travel, architecture, engineering, and even science magazines, a new self-assurance in art direction was signaling changing times,

technologies, and lifestyles.[36] Will Burtin—who, with his Jewish wife, fled Germany in the late 1930s when Joseph Goebbels courted him to become the Nazi Propaganda Ministry's design director—signed on as art director of *Fortune* in 1945, the same year Walker Evans became one of its staff photographers. At *Fortune*, Burtin worked with Ezra Stoller, one of America's most innovative architectural photographers, who appreciated Burtin's photo-centric methodology: "He would never suggest pictures for his story before he sent me out on assignment. . . . And when he laid out a story, you could read that story from his pictures and you didn't need a word of type. . . . He needed type for texture on the page. He used to send down to the writers and ask, could he have more text for this page? And they knew he meant texture, and they hated him for that. . . . He was strictly a visual man."[37]

In 1949 Burtin became the art director of *Scope*, a periodical for scientists, doctors, and medical workers, sponsored by Upjohn Company, a major U.S. pharmaceutical manufacturer. *Scope*'s upbeat modernist style—previously shaped by Lester Beall, yet another trailblazing mid-century graphic designer—is widely credited with turning what was a niche journal into an unexpectedly appealing publication.

"The desire to meet the challenge of a new period in our economic and social history was reflected by the search for forms that were strong, direct, and exciting," Beall would later explain.[38] And by the 1950s, it was not only magazines but book and record covers, product packaging, advertising, and the identity campaigns of major corporations that were reflecting the energetic and crisp look of American modernist graphic design. As the cultural observer Daniel Boorstin noted in a remarkable 1961 treatise, *The*

Image: A Guide to Pseudo-Events in America: "A corporation which decides to rebuild its image has decided less on a change of heart than on a change of face. The face-lifting operation can usually be done for hire, by the new professions of plastic surgeons and cosmetic experts. . . . Once the image was constructed, the object was to make the corporation, its products, and, hopefully, its customers, all fit neatly into the picture."[39]

As part of that process, photography came to play an ever more pivotal role in the branding of American corporations and the shaping of consumer lifestyles. Thoughtful photographs—and, as important, photographs thoughtfully deployed—were counted upon to pique public interest and stimulate spending, whether the economy was booming or depressed. And while professional graphic designers were frequently and correctly credited with pioneering new ways to present imagery and capture attention, the general public's more personal interactions with images and text on the page were numerous, too. Snapshot photography, heavily marketed by Kodak in the late nineteenth and early twentieth centuries, had become even more affordable and widespread. So was the practice of creating photo albums, in which amateurs experienced, firsthand, the challenges of combining images, captions, and texts to create a desired effect. "As author, editor, photographer, curator, and inevitable protagonist," the graphic designer and historian Jessica Helfand points out, "the scrapbook maker engaged in what seems today, in retrospect, a comparatively crude exercise in graphic design."[40] Like the art directors of the popular magazines they paged through, and influenced by the image treatments in the newspapers and ads they perused daily, people crafting photo albums could "arrange photographs symmetrically or asymmetrically,

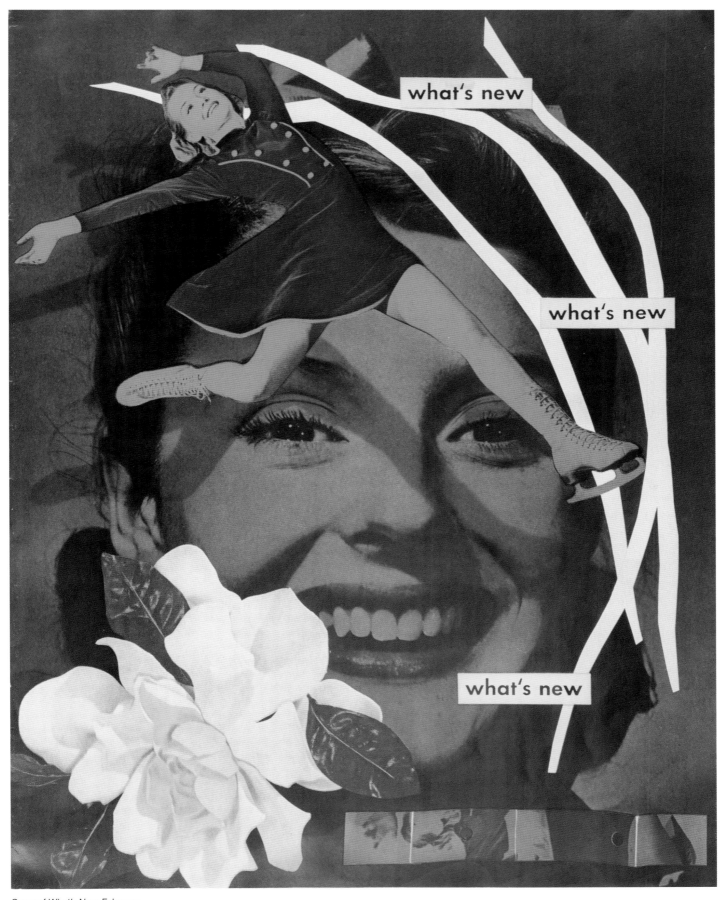

Cover of *What's New*, February
1941, art direction by Lester Beall

Heiferman

could overlap photographs, could place photographs at any angle, could cut the photographs into any shape desired."[41]

Creative treatments of photographs were regularly encountered on the page and, increasingly, off it as well. It was common for viewers of editorial and advertising spreads in magazines to find photographs tipped on their axes, radically cropped, silhouetted, and aggressively collaged or juxtaposed to generate visual friction and excitement. The bravado that fueled pages designed by Brodovitch, Liberman, and others, in turn, gave photographers—in their personal as well as professional work—the license to make more adventurous and subjective images, and to experiment with focus, contrast, blurs, multiple exposures, and abstraction. Art directors who had been or were practicing photographers themselves, working with photographers as intrigued with the medium's expressive possibilities as its reportorial accuracy, changed the content and choreography of the printed page.

Simultaneously, venues in which to explore the shifting dynamics of imagery were spreading from the flat plane of the printed page into three-dimensional space. In the 1930s and 1940s, visitors to the National Broadcasting Company Studios in Rockefeller Center entered through a 67-foot-wide rotunda featuring an enormous mural composed of Margaret Bourke-White photographs—depicting vertiginous radio towers and high-tech broadcasting equipment of the period—and strolled past what was, in essence, a larger-than-life picture magazine story. Immersive photographic environments were also a popular feature of exhibits at the New York World's Fair of 1939–40. At the Finnish Pavilion, architect Alvar Aalto created an imposing space in which "an undulating wood-slatted wall, inset with three rows of giant photos" depicting Finland's people and places, dominated a five-story-tall atrium whose function was to funnel visitors toward a shop offering Finnish products.[42] Astonishment was the goal of the Kodak pavilion, touted as "the greatest photographic show on earth," where the company's new Kodachrome products were introduced in a "Cavalcade of Color," an awe-inspiring, multimedia, twelve-minute-long spectacle in which synchronized projectors flashed more than two thousand saturated color images above and around visitors on a wraparound screen that was 22 feet tall and 188 feet wide.[43]

The influence of art directors' exuberant image treatments on magazine pages also influenced exhibition practices and shook up viewer expectations at cultural institutions such as the Museum of Modern Art. There, the striking installations for photography exhibitions curated by Edward Steichen in the 1940s and 1950s were the work of some of the mid-century's most accomplished, influential, and provocative design practitioners. Visitors to *Road to Victory*, a wartime exhibition presented in 1942, followed a winding path through a dynamic display of free-hanging, oversized images and texts, all designed by the graphic and environmental designer Herbert Bayer (see page 176). The unprecedented popularity and cultural impact of Steichen's curatorial blockbuster *The Family of Man* (1955) was as much a consequence of the immersive installation that the architect Paul Rudolph created for it—featuring images of varying sizes, suspended by wires, hoisted on poles, cantilevered off walls, and hung in thematic vignettes—as it was a manifestation of Steichen's picture-editing skills and curatorial showmanship.[44]

Elsewhere in America, of course, were equally extraordinary mid-century designers—such as Los Angeles–based Ray Eames, who produced innovative covers for *Arts & Architecture* magazine in the 1940s—who were helping to define the distinctive mid-century modern look of cultural products and programming. It was in New York's dense and image-dominated public spaces—such as Times Square, crammed with signage, or Grand Central Terminal, where hundreds of thousands of commuters strode past Kodak's huge backlit Colorama advertisements daily—that three-dimensional encounters with spectacularly produced imagery and text became a defining feature of urban life. But elsewhere, too, on the page and in shared space, viewer engagement with carefully crafted and art-directed messages increased with "the rising American standard of living, the rising level of expectations, and the growing ingenuity" of those charged with producing and presenting those images, as Boorstin observed. Print readers, in particular, he noted, "enjoy the sense of being courted, they luxuriate in the knowledge that so much money, time, effort, and art have gone into making all these pseudo-events especially for them."[45]

"Every period has its own optical focus," Moholy-Nagy noted in the 1920s, an observation that would be borne out again as the visual strategies that are now so closely associated with mid-century American graphic style became widespread, and even the patterns on wallpaper, fabrics, kitchenware, and Formica countertops reverberated with the shapes and blithe elegance that had evolved on the pages of magazines. But by the 1960s and 1970s, contentious political, racial, and cultural issues began churning in and redefining America—from opposition to the Vietnam War to struggles over civil rights to demands for gender equality. In this climate a new generation of creatives arose, one less concerned with upbeat expressions

The Finnish Pavilion at the New York
World's Fair, 1939, designed by
Alvar Aalto

Installation view of *The Road to Victory* exhibition, designed by Herbert Bayer, at the Museum of Modern Art, New York, 1942, photograph by Albert Fenn

of style and that valued authenticity above all else. Looking back at the 1950s, widely considered a golden age of art direction, Lois, the art director of *Esquire* magazine's controversial and overtly political covers from 1962 to 1972, made his distaste for the aesthetics of the era absolutely clear. "In those days," he said, "the buzzword was 'tasteful.' Taste, schmaste, my ass! . . . I thought of myself as a modern-day Hieronymus Bosch, vulgar at times, but conceptually and viscerally dead-on."[46] Soon enough, the aesthetic traditions and the literal work practice of twentieth-century graphic design would be challenged when, in the mid-1980s, desktop publishing and layout software turned art direction into a less hands-on, artisanal pursuit.

For more than a hundred years, the adventurously designed photo magazine proved a resilient print format, bringing information, entertainment, and visual delight to buyers and readers. And even today, long after the impact of daily television news hastened the demise of weeklies like *Life*, and as the rapid rise of the internet's digital delivery system challenges the materiality and profitability of magazines themselves, the format lingers. But with content now being viewed, most often, on the small screens of phones, tablets, and laptops, what becomes clear is how, as magazines switch to digital platforms, the functions of art direction and photography have had to evolve. The creative flourishes and tactility that defined the look and feel of mid-century magazines become extraneous when the navigational ease of websites and apps is as crucial a determinant of page content and style as aesthetics. Today, images that remain vivid and readable at a reduced scale are the ones that fare best and go viral more often. Something to consider—while paging through this book and as you next scroll, rather than flip, through a magazine online—is what the prescient media theorist Marshall McLuhan said more than a half-century ago, when the magazine industry was peaking: "In a culture like ours . . . it is sometimes a bit of a shock to be reminded that, in operational and practical fact, the medium is the message."[47]

176

Astonish Me!

Notes

1
Ernst Hans Gombrich, *Reflections on the History of Art: Views and Reviews*, ed. Richard Woodfield (Berkeley: University of California Press, 1987), 211.

2
Eric Matthew Bledsoe, "Make It New," in *Routledge Encyclopedia of Modernism*, January 10, 2016, https://rem.routledge.com /articles/make-it-new.

3
Andy Grundberg, *Brodovitch* (New York: Abrams, 1989), 84.

4
Ibid., 140.

5
Christopher Bonano, *Flash: The Making of Weegee the Famous* (New York: Henry Holt, 2018), 49.

6
László Moholy-Nagy, *Painting, Photography, Film*, trans. Janet Seligman (1925; trans. ed., London: Lund Humphries, 1969), 28.

7
Ibid., 7.

8
William Leach, *Land of Desire: Merchants, Power, and the Rise of a New American Culture* (New York: Pantheon, 1993), xiv.

9
Walter Lippmann, *Public Opinion* (1922; reprint ed., New York: Free Press, 1965), 61.

10
Josh Clark, "*Vu* Magazine: Photos, Robots, and Cutting-Edge Design," *Big Medium,* February 19, 2007, https://bigmedium .com/ideas/vu-magazine.html.

11
R. Roger Remington, *American Modernism: Graphic Design, 1920–1960* (New Haven: Yale University Press, 2003), 75.

12
Grundberg, *Brodovitch*, 116–17.

13
Life (magazine), Beinecke Rare Book & Manuscript Library, Yale University Library, New Haven, https://brbl-dl.library.yale.edu /vufind/Author?author=Life +magazine&type=Author&page =2.

14
Steven Heller and Karen Pomeroy, *Design Literacy: Understanding Graphic Design* (New York: Allworth, 1997), 53.

15
Walter Benjamin, "The Author as Producer" (1934), in *Thinking Photography*, ed. Victor Burgin (London: Macmillan, 1982), 15–31.

16
Heller and Pomeroy, *Design Literacy*, 54.

17
Ibid.

18
David E. Sumner, *The Magazine Century: American Magazines Since 1900* (New York: Peter Lang, 2010), 89.

19
Ibid.

20
Ibid., 90.

21
Heller and Pomeroy, *Design Literacy*, 53.

22
Kenneth Aaron, "New York Daily News," in *The Encyclopedia of New York State*, ed. Peter R. Eisenstadt (Syracuse, NY: Syracuse University Press, 2005), 1086.

23
Jan Tschichold, *The New Typography: A Handbook for Modern Designers*, trans. Ruari McLean, with an introduction by Robin Kinross (Berkeley: University of California Press, 1995), 87–88.

24
Ibid., 92.

25
George Lois quoted in Alan Fletcher, *The Art of Looking Sideways* (London: Phaidon, 2001), 443.

26
Grundberg, *Brodovitch*, 67.

27
Margaret MacDonald, "Dr. Mehemed Fehmy Agha," in *History of Graphic Design*, 2018, http:// historygraphicdesign.com /index.php/the-modernist-era /the-genesis-of-twentieth -century-design/165-margaret -macdonald.

28
Grundberg, *Brodovitch*, 18.

29
Brodovitch, http://iconofgraphics .com/alexey-brodovitch/.

30
Heller and Pomeroy, *Design Literacy*, 42.

31
Grundberg, *Brodovitch*, 20.

32
Heller and Pomeroy, *Design Literacy*, 48.

33
Ibid.

34
Ibid., 49.

35
Dodie Kazanjian and Calvin Tomkins, *Alex: The Life of Alexander Liberman* (New York: Knopf, 1995), 146.

36
The exuberant design at magazines such as *Holiday*, *Industrial Design*, and *Arts & Architecture* all reflected the bold aesthetic and integration of image into text in then-contemporary mid-century design.

37
Kay Reese and Mimi Leipzig, *Interviews with ASMP Founder: Ezra Stoller*, 1991, https://asmp .org/resources/about/history /interview-founders/ezra-stoller/.

38
R. Roger Remington, *Lester Beall: Trailblazer of American Graphic Design* (New York: W. W. Norton, 1996), 41.

39
Daniel J. Boorstin, *The Image: A Guide to Pseudo-Events in America* (1961; reprint ed., New York: Atheneum, 1987), 189.

40
Jessica Helfand, *Scrapbooks: An American History* (New Haven: Yale University Press, 2008), xvii.

41
Marilyn F. Motz, "Visual Autobiography: Photograph Albums of Turn-of-the-Century Midwestern Women," *American Quarterly* 41, no. 1 (March 1980): 64.

42
Greg Allen, "The Enlarged Pictures Generation: Alvar Aalto's 1939 Finnish Pavilion," in the making of, October 18, 2010, https://greg.org /archive/2010/10/18 /the-enlarged-pictures -generation-alvar-aaltos-1939 -finnish-pavilion.html.

43
Ariane Pollet, "The Cavalcade of Color: Kodak and the 1939 World's Fair," trans. James Gussen, *Études Photographiques* 30 (2012).

44
The Paul Rudolph Heritage Foundation, "Paul Rudolph's Design for MoMA's 'Family of Man' Exhibition," February 1, 2019, https://paulrudolphheritagefoun dation.org/news-of-the-prhf /2019/1/29/c9wnv9711f3ywl c8g16vnr6lq8rdyo.

45
Boorstin, *Image*, 206.

46
George Lois, *George Lois on His Creation of the Big Idea* (New York: Assouline, 2008), unpaginated.

47
Marshall McLuhan, *Understanding Media: The Extensions of Man* (New York: Signet, 1964), 23.

Heiferman

INDEX

Index

Trustees

The copyright holders, photographers, and sources of visual material other than the owners indicated in the captions are listed below. Every reasonable effort has been made to supply complete and correct credits; if there are errors or omissions, please contact Yale University Press or the Jewish Museum so that corrections can be addressed in any subsequent edition. Material in copyright is reprinted by permission of copyright holders or under fair use. Images may be listed in more than one location. Page numbers are in **bold**.

Copyrights

© Abbott Historical Archives: **5, 173**. © Artists Rights Society (ARS), New York / VG Bild-Kunst, Bonn: **30**. © *Arts & Architecture*: **41 top and bottom, 186**. © David Attie Studio: **154–55**. © Richard Avedon Foundation: **6, 76 bottom (photographs), 82, 83, 191**. © Estate of Lillian Bassman: **96 bottom, 145, 146, 147**. © Estate of Erwin Blumenfeld: **8, 59**. © Josef and Yaye Breitenbach Charitable Foundation, courtesy of Gitterman Gallery: **70, 71, 137**. © Center for Creative Photography, Arizona Board of Regents: **27, 142 bottom, 144, 158, 159**. © Condé Nast: **10, 32 bottom, 42 bottom, 43, 78 left and right, 79 left and right, 80 top and bottom, 81, 157**. © Estate of Louis Faurer: **50, 106–7, 112, 116, 148, 149, 150, 151 top and bottom**. © Robert Frank, courtesy of Pace / MacGill Gallery, New York: **49 left and right, 98, 104, 105, 110 top and bottom, 111, 113, 118, 130**. © Estate of Leslie Gill: **1, 141**. Reprinted with permission of Hearst Magazine Media, Inc., and previously published in: *Harper's Bazaar* magazine: **14** (June 1940); **40** (September 1943); **6, 82** (April 1951); **83, 191** (February 1952); **142 bottom** (March 1943); **159** (September 1952); **134–35, 136** (November 1935); **140** (July 1956); *Junior Bazaar* magazine: **47 top, 185** (January 1947); **47 bottom** (June 1947); **1, 141** (March 1946); *Seventeen* magazine: **132** (February 1948). © Estate of Paul Himmel: **48**. © Iconic Images: **125**. © Johnson Publishing and successors: **89 top**. © Estate of György Kepes: **26, 60**. © William Klein: **52, 53 top and bottom, 108–9, 119 top and bottom**. © Saul Leiter Foundation, courtesy of Howard Greenberg Gallery, New York: **120, 122, 123, 162 top and bottom, 163 top left and right, 163 bottom left and right, 164,**

165. The LIFE Images Collection via Getty Images: **171**. © Estate of Frances McLaughlin-Gill, **143, 161, front cover**. © Lee Miller Archives, England 2019, all rights reserved, leemiller.co.uk: **44**. © Lisette Model Foundation, Inc. (1983), used by permission: **114, 115, 121, 152, 153**. © Estate of Martin Munkácsi, courtesy of Howard Greenberg Gallery, New York: **134–35, 136, 138, 139, 142 top**. © The Gordon Parks Foundation: **87, 89 bottom, 95, 96 top (photograph), 100, 101, 102, 103, 160**. © Irving Penn Foundation: **42 top right, 84, 85, 156**. © 1952 The Picture Collection Inc., all rights reserved, reprinted from LIFE and published with permission (text): **96 top**. © 1936 The Picture Collection Inc., all rights reserved, reprinted from LIFE and published with permission: **126**. © Ringl+Pit, courtesy of Robert Mann Gallery, New York: **61**. Used with permission of SK Film Archives and the Museum of the City of New York: **167**. © Stanford Libraries, Department of Special Collections: **62 left and right, 63 left and right, 188, back cover**. © Estate of Edward Steichen / Artists Rights Society (ARS), New York: **56, 57, 58, 187**. © Ezra Stoller / Esto: **175**. © Trunk Archive: **47 bottom**.

The Jewish Museum, New York, wishes to thank the Crisis Publishing Co., Inc., the publisher of the magazine of the National Association for the Advancement of Colored People, for the use of this image first published in the July 1923 issue of *Crisis* magazine: **92**.

Extended Credit Lines

3: Cary Graphic Arts Collection, Rochester Institute of Technology, Will Burtin Papers. **5:** Cary Graphic Arts Collection, Rochester Institute of Technology. **7:** Cary Graphic Arts Collection, Rochester Institute of Technology, Cipe Pineles papers. **27:** Collection of the Center for Creative Photography, 76.5.14. **29:** Louisiana Museum of Modern Art, Donation: The Joseph and Celia Ascher Collection, New York. **30:** Harvard Art Museums / Busch-Reisinger Museum, Gift of the artist, BR48.88. **31 bottom:** Gift of The Judith Rothschild Foundation, The Museum of Modern Art. **32 top left:** International Center of Photography, Museum Purchase, 2013 (2013.41.2). **32 top right:** International Center of Photography, Museum Purchase, 2011 (2011.7.249). **49 left:** Robert Frank Collection, Gift (Partial

and Promised) of Robert Frank, in Honor of the 50th Anniversary of the National Gallery of Art, National Gallery of Art, Washington, 1990.28.29.6. **49 right:** Robert Frank Collection, Gift (Partial and Promised) of Robert Frank, in Honor of the 50th Anniversary of the National Gallery of Art, National Gallery of Art, Washington, 1990.28.29.7. **58:** Gift of the photographer, The Museum of Modern Art. **61:** Jewish Museum, New York, Purchase: Horace W. Goldsmith Foundation Fund, 2017-27.1. **67 top and bottom:** Cary Graphic Arts Collection, Rochester Institute of Technology, Will Burtin Papers. **68–69:** Cary Graphic Arts Collection, Rochester Institute of Technology. **70:** Jewish Museum, New York, Purchase: Horace W. Goldsmith Foundation Fund, 2009-3. **71:** Jewish Museum, New York, Purchase: Horace W. Goldsmith Foundation Fund, 2009-2. **73:** Collection of Eric and Lizzie Himmel. **85:** Gift of Irving Penn, National Gallery of Art, Washington, 2002.119.32. **90:** Daniel Murray Collection, Prints and Photographs Division, Library of Congress, Washington, DC, LOT 11931, no. 11. **104:** Gift of the artist, National Gallery of Art, Washington, 2010.114.1.5. **105:** Gift of the artist, National Gallery of Art, Washington, 2010.114.1.6. **110 top:** The Museum of Fine Arts, Houston, The Target Collection of American Photography, museum purchase funded by Target Stores, 82.497. **110 bottom:** The Museum of Fine Arts, Houston, The Target Collection of American Photography, museum purchase funded by Target Stores, 83.107. **113:** The Museum of Fine Arts, Houston, The Target Collection of American Photography, museum purchase funded by Target Stores, 83.104. **114:** Gift of the Estate of Lisette Model, 1990, by direction of Joseph G. Blum, New York, through the American Friends of Canada, National Gallery of Canada, Ottawa, 35196. **115:** Jewish Museum, New York, Purchase: Photography Acquisitions Committee Fund, 2001-50. **116:** The Museum of Fine Arts, Houston, Gift of Betsy K. Karel, 2002.3562. **118:** Robert Frank Collection, Gift of the Glen Eagles Foundation, National Gallery of Art, Washington, 1992.93.8. **121:** Gift of the Estate of Lisette Model, 1990, by direction of Joseph G. Blum, New York, through the American Friends of Canada, National Gallery of Canada, Ottawa,

35227. **130, 131:** Cary Graphic Arts Collection, Rochester Institute of Technology, Cipe Pineles papers. **137:** Museum of Fine Arts, Boston, Sophie M. Freidman Fund, 2010.759. **141:** Cary Graphic Arts Collection, Rochester Institute of Technology. **144:** Center for Creative Photography, Louise Dahl-Wolfe Archive, 93.73.12. **148:** Collection of David Dechman and Michel Mercure. **149:** The Museum of Fine Arts, Houston, Gift of Lilyan and Toby Miller, 87.161. **150:** The Museum of Fine Arts, Houston, The Allan Chasanoff Photographic Collection, 91.592. **151 top:** Harvard Art Museums / Fogg Museum, Schneider / Erdman Printer's Proof Collection, partial gift, and partial purchase through the Margaret Fisher Fund, 2011.180. **151 bottom:** Jewish Museum, New York, Purchase: Gift of Judith and Jack Stern, 2000-57. **152:** Museum of Fine Arts, Boston, Sophie M. Friedman Fund, 1980.453. **158:** Center for Creative Photography, Louise Dahl-Wolfe Archive, 93.72.4. **164:** Museum of Fine Arts, Boston, Francis Welch Fund, 2006.1398. **167:** Museum of the City of New York, X2011.4.10237.40. **173:** Lester Beall papers, Cary Graphic Arts Collection, Rochester Institute of Technology. **192:** Cary Graphic Arts Collection, Rochester Institute of Technology.

Images Provided By

Alamy Stock Photo: **170**. Collection of Vince Aletti: **6, 10, 14, 24, 32 bottom, 38, 43, 47 top and bottom, 78 left and right, 79 left and 79 right, 80 top and bottom, 81, 82, 83, 125, 140, 142 bottom, 191**. Center for Creative Photography, University of Arizona Foundation / Art Resource, New York: **144, 158**. Christie's Images Limited: **59, 84, 157**. Keith de Lellis, New York: **56, 57, 187**. Display, Graphic Design Collection: **34, 41 top and bottom, 42 top left, 64 left and right, 65, 189**. Robert Koch Gallery: **26**. Manhattan Rare Book Company: **31 top, 72**. Museum of Modern Art / Licensed by SCALA / Art Resource, New York: **31 bottom, 58, 176**. The Gordon Parks Foundation: **87, 89 top and bottom, 95, 100–103, 160**. Galerie Sophie Scheidecker, Paris: **8**. Bruce Silverstein Gallery: **60, 153**. Sotheby's, Inc. / Westimage: **148**.

Photographers

Ardon Bar Hama, **115**. Sheri Blaney: **170**. George Karger / Pix Inc.: **171**.

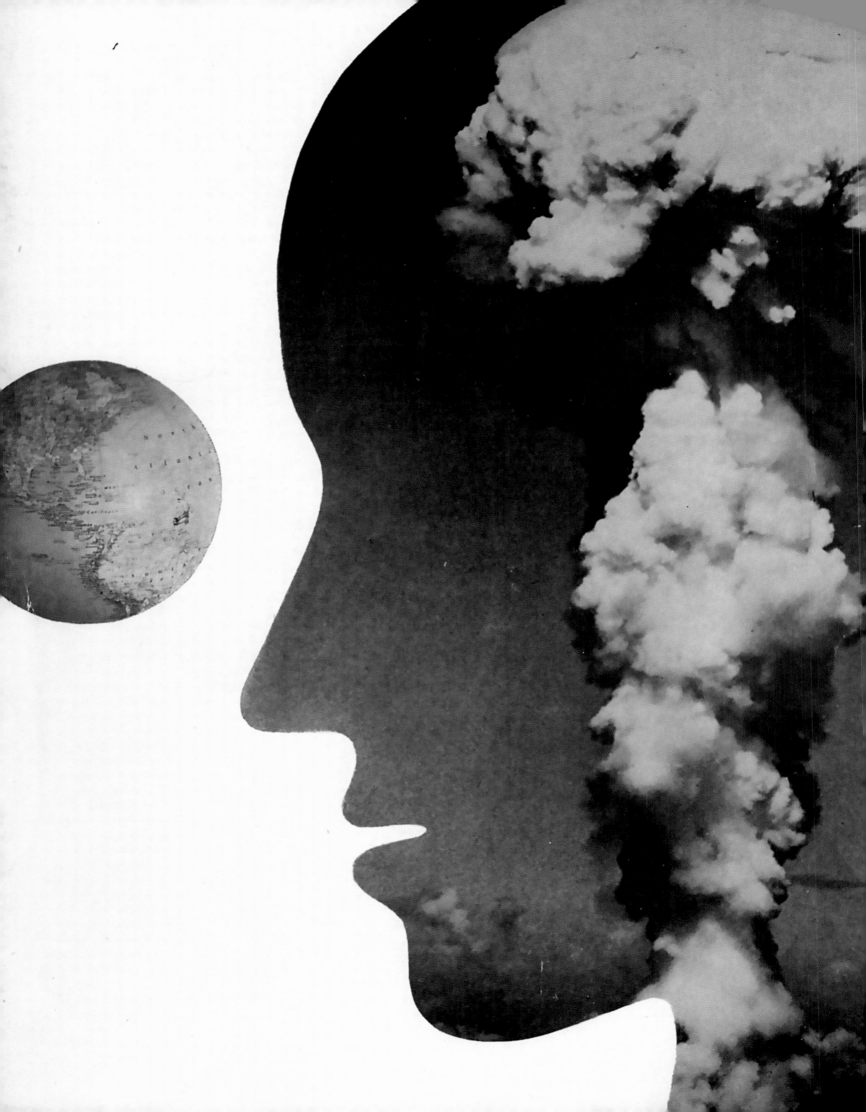

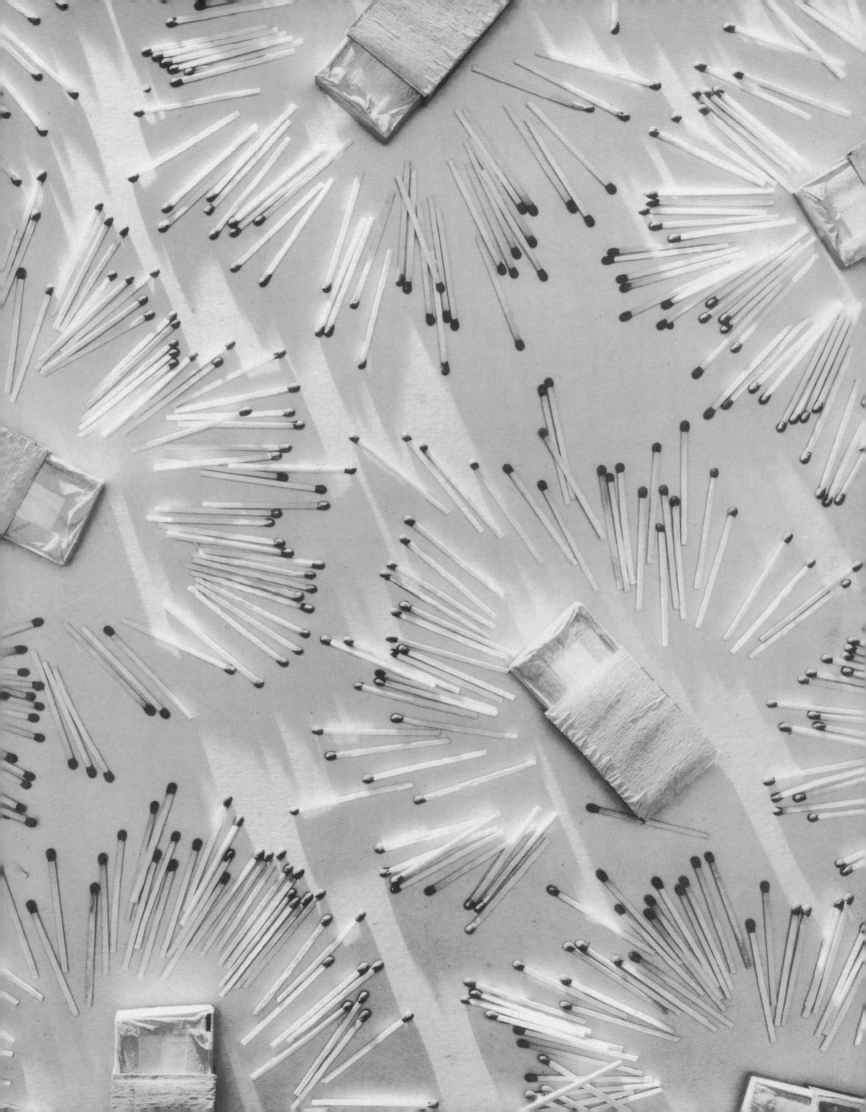

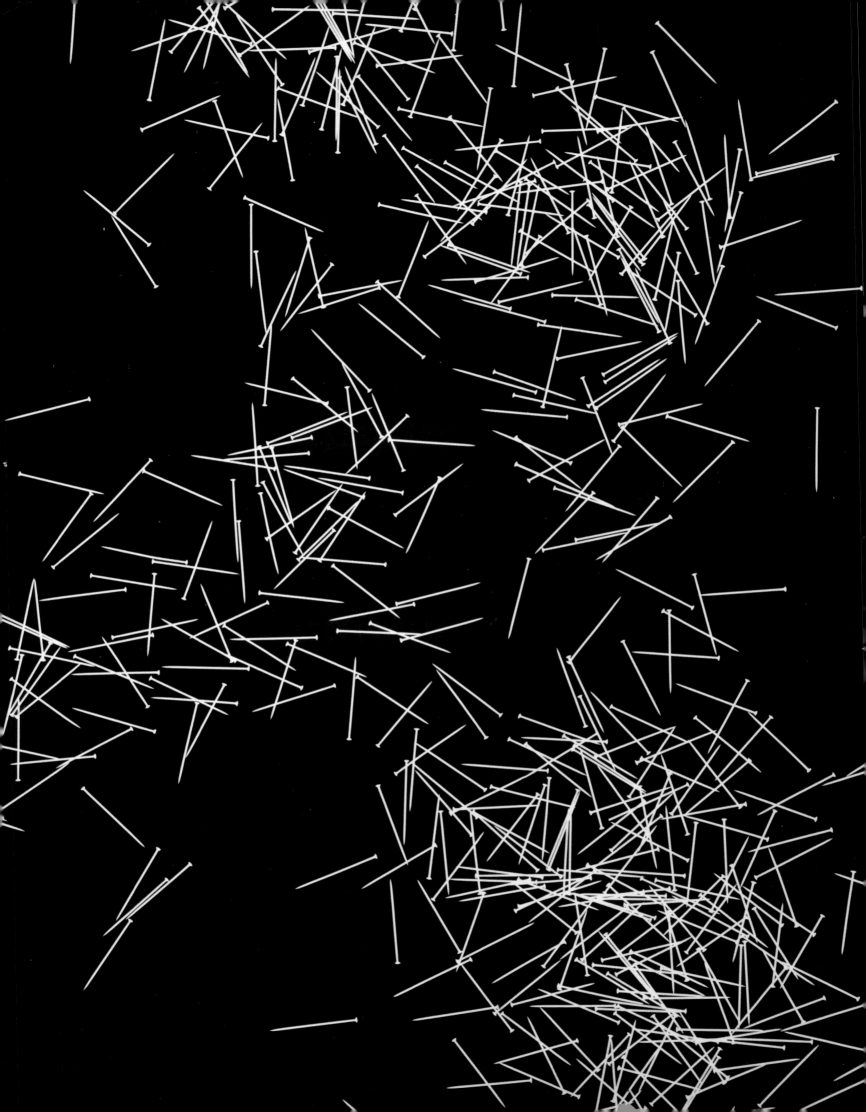